More Praise for Jeff S

BECOMING CHAR

"Sypeck describes in wonderful detail the Byzantine empire and Queen Irene, the Arab world of Harun al-Rashid, and the nation-state headed by Pope Leo III." —*The Providence Journal*

"Jeff Sypeck has given readers a vivid and marvelously readable look at the life and times of Charlemagne. The great king of the Franks and the people around him truly come to life in this wonderful story." —Philip Mitchell Freeman, author of *St. Patrick of Ireland* and *The Philosopher and the Druids*

"Debunking the myths that surround legendary figures is a tricky business, but Sypeck acknowledges the allure of the ways in which Charlemagne and his era have been romanticized, mitigating the sting and turning it into an educational opportunity. . . . Illuminates the shadowy corners of an era shrouded in the mists of legend." —*Kirkus Reviews*

© 2006 by Jenny Trucano/PhotoAssist

ABOUT THE AUTHOR

JEFF SYPECK teaches medieval literature at the University of Maryland. His writing has appeared in the *Washington Post*, among other publications. He lives in Washington, D.C.

BECOMING
CHARLEMAGNE

Europe, Baghdad,
and the
Empires of A.D. 800

JEFF SYPECK

An Imprint of HarperCollinsPublishers

First Harper Perennial edition published 2007.

Map by Paul J. Pugliese
Designed by Jennifer Ann Daddio

Library of Congress Cataloging-in-Publication Data is available upon request.

ISBN: 978-0-06-079707-2 (pbk.)
ISBN-10: 0-06-079707-X (pbk.)

HB 08.02.2022

FOR MY PARENTS

and their friends

Acknowledgments

Although rarely modest enough to say so, the figures in this book could not have built their empires without the advice and assistance of sensible counselors. Twelve centuries later, retelling their story required similar assistance, and I'm pleased to thank the following people for their support during the writing of this book: Esther Crain, whose enthusiasm never flagged; Peter C. Hansen, Karen Hyatt Cooper, and David Powell, who read early fragments and drafts and provided valuable advice; Eden Hansen, Ian and Michele Hopper, Branislav Marić, and William Nalley, for helpful conversations and challenging questions at various stages; Tom and Kathy Monchek, who generously provided a quiet place to

read and work; everyone at PhotoAssist, for patience and friendly indulgence; Mike Owens, Jenny Trucano, and Cristen Wills, for their help with photographs and illustrations; Julia Serebrinsky, Gheña Glijansky, and Emily Takoudes at Ecco, for their expertise and input; and Joëlle Delbourgo, for her indispensable guidance.

I would also like to extend my thanks to Information and Library Services at the University of Maryland University College, for uncommonly speedy research assistance.

Finally, I am deeply grateful to the scholars whose books and articles constitute the bibliography of *Becoming Charlemagne*. Their work makes books like this one possible, and they are the true heirs of Alcuin and Charlemagne.

Contents

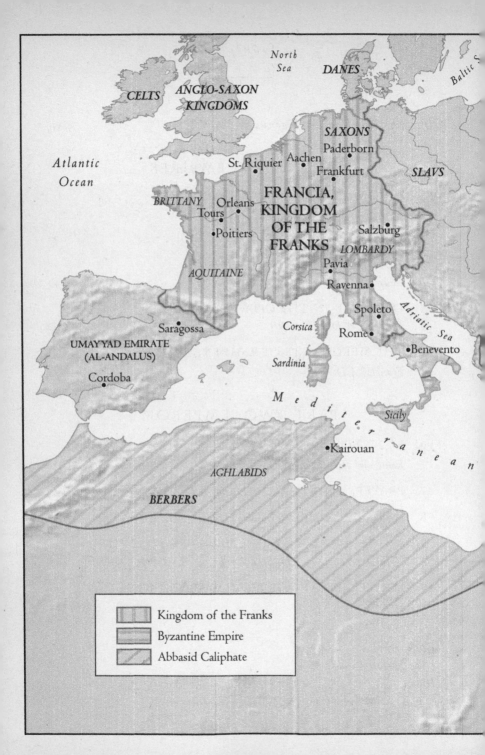

North
Sea

DANES

Baltic S

CELTS

ANGLO-SAXON
KINGDOMS

SAXONS

Paderborn

Atlantic
Ocean

St. Riquier Aachen
Frankfurt

SLAVS

BRITTANY Orleans
Tours
Poitiers

FRANCIA,
KINGDOM
OF THE
FRANKS

Salzburg

LOMBARDY

AQUITAINE

Pavia
Ravenna

Saragossa

Corsica

Spoleto
Rome

Adriatic Sea

UMAYYAD EMIRATE
(AL-ANDALUS)

Sardinia

Benevento

Cordoba

M e d i t e r r a n e a n

Sicily

Kairouan

AGHLABIDS

BERBERS

	Kingdom of the Franks
	Byzantine Empire
	Abbasid Caliphate

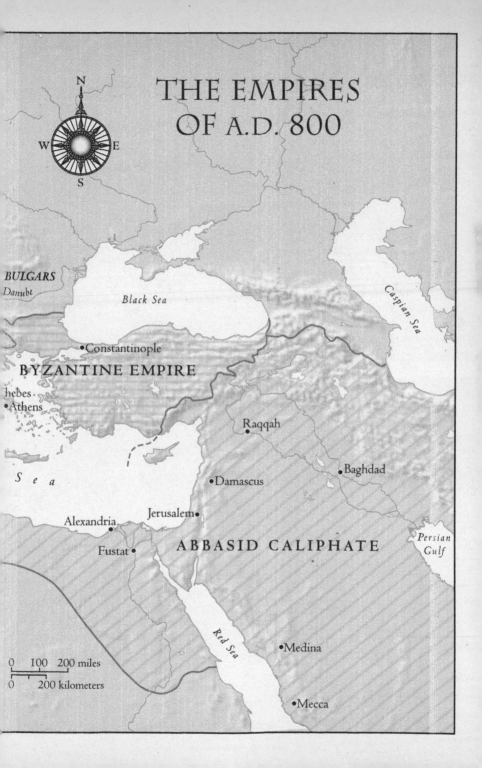

Introduction

KAROLUS MAGNUS

A foreigner had come to their city, so the Romans were curious. He wasn't one of the usual befuddled pilgrims, so easily parted from their money, who fell to their knees before the altars of Rome's innumerable churches. He was a king, and he was here on business.

On Christmas morning in the year 800, as the clergy chanted the praises of saints and kings, the pious rabble gathered beneath the rafters of Saint Peter's basilica, along with nobles from throughout Christendom, envoys from Jerusalem, countless bishops and monks, and thousands of merchants and landlords and peasants,

all straining to catch a glimpse of him. Before them all, reluctantly draped in Roman garb, stood Karl.

A ferocious blur across the medieval map: that was Karl, moving over the face of Europe like a storm and wresting new corners of his empire from the hands of his enemies while still finding time to scold his sinful monks, contribute to theological debates, and slog through muddy trenches to bark orders at canal diggers and church builders. History remembers him not merely as Karl but as Charles the Great, Karolus Magnus: Charlemagne. But on that day, he was still just Karl, king of the Franks, and this Christmas mass with Pope Leo III is one of the rare occasions when history finds him standing still.

Pope Leo was lucky to be alive. The previous year, his enemies had ambushed him in the streets, attempting to gouge out his eyes and cut out his tongue and leaving him in a bloody, naked heap. But now here he stood, able to see, able to speak—a miracle, some said, unmistakable proof that Saint Peter had come to his aid.

Few in the church that day could see what happened next, but the act was both instant and decisive: the pope placed the imperial crown on Karl's head, fulfilling years of planning in a single swift gesture. With one voice, the entire congregation acclaimed three times: "To Karl, pious Augustus crowned by God, great and peaceful emperor, life and victory!" And then, in an act of ceremonial self-abasement that would long haunt the pope, Leo knelt before Karl—the first emperor in Rome in nearly 400 years.

Meanwhile, across Europe and throughout the world were the various people who had made the coronation possible: a Saxon abbot, a Greek empress, an Islamic caliph, and a Jew named Isaac, who was slowly making his way home to western Europe from Baghdad, accompanied by an elephant named Abul Abaz.

F ame came quickly for the Frankish king. Following Karl's death in 814, the singers of tales memorialized him in legend and romance, while poets counted him one of the "nine worthies" among such rulers as David, Julius Caesar, and King Arthur. By 1100, the anonymous epic *The Song of Roland* had turned Karl into a bearded sage fighting alongside angels, a natural-born warrior of God; and by 1165 his church had made him a saint. In the Balkans, *kral*, a variant of his name, came to mean "king." Medieval Icelanders crafted a saga about the mighty "Karlamagnús," and romances about Karl's knights charmed the English well into the 1500s. The long-dead king was becoming Charlemagne, a superhuman emperor whose reputation for chivalry, piety, and power resounded to the ends of the earth. The real Karl vanished; only myth remained.

Thumb through the 1864 edition of Thomas Bulfinch's *Legends of Charlemagne*, with its frontispiece engraving of knights attending to a gryphon, and the esteemed emperor is there, more than 1,000 years after his death, still embodying an age when every moment promised fresh adventure:

> *High sat Charlemagne at the head of his vassals and his paladins, rejoicing in the thought of their number and their might, while all were sitting and hearing music, and feasting, when suddenly there came into the hall four enormous giants, having between them a lady of incomparable beauty, attended by a single knight. There were many ladies present who had seemed beautiful till she made her appearance, but after that they all seemed nothing. Every Christian knight turned his eyes to her, and every Pagan crowded round her.*

The world of this Charlemagne is flooded with chivalry and perpetual miracles. It is also sheer fantasy, a romanticized medieval kingdom with the sharp edges filed down and painted with dainty fleurs-de-lys.

In reality, eighth-century Europe was a vast and shadowy forest. The stone-and-timber fortresses that supported civilization had not yet given way to storybook castles, and the trappings of chivalry were still centuries away. Karl was only beginning to build the places where his descendants would pass their winters, reimagine Europe, and tell themselves preposterous tales about their own past.

Karl started with a small Germanic kingdom, but he expanded it in the name of Christ; doing so was a right granted by God and endorsed by royal poets. With few exceptions, he dominated the battlefields of Europe as decisively as he ruled the negotiating table, and as neighboring kingdoms fell before him he gathered each of them under his banner: Aquitaine in southern France; Lombardy in northern Italy; Bavaria; Brittany; Saxony. Popes counted on him for protection, distant warlords begged for his assistance, and far-flung pagans surrendered to his authority and paid him tribute. Feared and respected, he was a good king.

To history, Karl's high point was his coronation as emperor, when he unknowingly set Europe on a bold new path. Artists envisioned it, Napoleon admired it, and Adolf Hitler sought to emulate it, as did the architects of the European Union. In the meantime, the real Karl the Great was buried beneath his own reputation, remembered in legend, forgotten in fact.

After Karl's death, Fortune's wheel spun, and the churches and towns of eighth-century Europe passed away, sometimes wasted by

war, at other times expanded, rebuilt, or re-adorned depending on the whims of each new age. The relics of Karl's era are sadly sparse: a few buildings; some coins, cups, and artwork; and a fair number of archaeological sites—but also, most usefully, a library of several thousand books. Most of those volumes are copies of older works, cultural treasures that would have been lost if not for the diligence of Karl's monks. These manuscripts preserve the memories of those who made them in the poems, chronicles, and letters that help to tell Karl's story.

Today, the people of Karl's era are remote and ghostly figures. To discover their world in letters and lyrics is to glimpse a vast

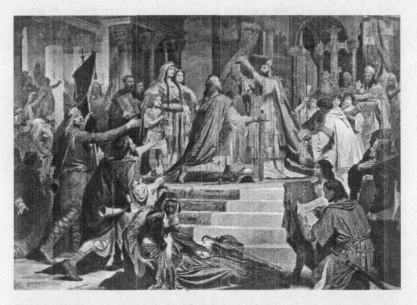

This nineteenth-century photogravure depicts the imperial coronation of Charlemagne amid swooning and suspicious glances—and a scribe who diligently writes the first draft of medieval history.

universe through a half-open door; the view is frustrating and incomplete. Karl and his contemporaries left few truly personal writings, the places they knew are gone, and accurate portraits of them are virtually nonexistent. Time swept away most traces of their lives.

But across a gulf of 1,200 years, they clamor to be heard. In history as in life, Karl emerges first: a restless, energetic warrior; protective of the papacy; overprotective of his daughters; surrounded always by brilliant men. His advisers appear next: bowing poets who flatter their king, priests and monks who offer blunt advice, hardy nobles who wage forgotten wars. Though blurry, a picture of Karl's kingdom gradually comes into view, and with patience we can see them: giggling princesses, borderland heretics, exhausted peasants, all of them praying in sunlit chapels or driving carts through market squares. In the background, perhaps surprisingly, are Jews. They immerse themselves in the labors of Karl's kingdom, enjoying the autumn of a fleeting golden age.

In the coronation on that long-ago Christmas in Rome, Karl's era comes into focus, and we can marvel at the moment that illuminates twelve centuries of history. That morning marked the birth of an institution later dubbed a Sacrum Romanum Imperium: a Holy Roman Empire that lasted for 1,000 years, shaped the borders of Europe, and inspired idealism and atrocities well into our own age. That day was also a decisive moment in the rift between east and west—a rift that still haunts modern Christians, even though few can recall the names of the men and women who caused it. Popes, priests, patriarchs, and monks did drive a wedge between western and eastern Christianity, but few know that it

happened with the aid of an illegitimate empress and, indirectly, with the assent of a reclusive Islamic caliph.

Medieval kings are easily stereotyped: brutish, barbaric, coldly provincial, simplistically Christian. But behind the storybook fictions is a man who was far too important to be left to legend, a skilled politician who knew his neighbors well. Karl's rise to emperor may begin the story of Europe, but its significance extended beyond European borders, all the way to Constantinople and Baghdad. As Karl's coronation shows, the past is rarely what it seems. The Frankish king battled Saxon pagans and cordially welcomed Muslims, Slavic pagans, and other foreigners to his Christian court while deftly conducting long-distance diplomacy with the caliph in Baghdad. The differences between Karl's world and our own become even more obvious, and more important to understand, when we see that this profound example of early diplomacy between Christians and Muslims was led by Isaac, a well-traveled European Jew.

Karl's world vanished, as his contemporaries knew it would. "In fact, just as a rainbow, which adorns the vault of heaven with dazzling colors, quickly disappears, so, to be sure, the honor of worldly fame, however much adorned for the moment, is sooner fleeting away," wrote Sedulius Scottus, a ninth-century Irishman in the court of Karl's heirs. Thanks to the writings of Sedulius and learned men like him, the world of their era's greatest king can come to light. Illuminate the coronation of Karl the Great, and the emperor himself appears, standing alongside the pope whom he never fully trusted and the bishops and abbots who orchestrated that historic day. Among these towering figures—these kings, caliphs, emperors, and popes—pass other, lesser individuals not

destined for monuments or portraits on coins: anonymous priests trudging back from Jerusalem, papal agents scheming in Rome, Mediterranean merchants bound for the east, farmers covered with mud, and obscure Jewish diplomats pining for home. These overlooked people all helped to shape their times; they also should be part of Karl's story.

It begins, unexpectedly, with the death of a pope.

Part One

EMPIRES

.1.

A ROME YET TO BE

Aachen, A.D. 796

Traveling to Aachen is not what it used to be.

Comfortably tucked into a green valley in Germany, Aachen is a short drive from the borders of Belgium and the Netherlands. The city receives its fair share of visitors, who typically arrive by train or through one of the nearby airports. Their intentions vary.

Some are here on business, rushing to meetings at high-tech firms. Others come to study at the colleges and universities or to heal their weary bodies at thermal baths. Many more are tourists, lured by their guidebooks' promise of a pleasant day trip. If they're pressed for time, they may be discouraged by descriptions of "un-

assuming Aachen" near the "unromantic Rhine" and hasten on to other cities whose names clatter more strongly with essential German-ness: Berlin, Munich, Frankfurt, Hamburg. In those places, they know that history will resound in museums and town squares and along old streets to confirm their preconceptions about Europe and its past.

But if they dutifully visit Aachen's main tourist attractions, they discover that at the core of its Gothic cathedral are pillars and stones pushed into place more than 1,200 years ago. This octagonal chapel, once connected to a walled fortress, should be more than a second-tier curiosity for backpackers who wander, cameras in hand, across Germany's castle-scattered landscape. These stones—solid, unmoving, and easily unnoticed—are the foundations of Europe itself.

At the end of the eighth century, when merchants, monks, and warriors gathered here, only the absurdly optimistic would have called Aachen a city. When the king was away, it was barely even a town. To much of the world, Aachen was a blank space on the map, a few thin acres of civilization carved from a wolf-infested forest.

It was also, for a few decades, the capital of western Europe.

I n early 796, a messenger traveling from Rome to Aachen rode briskly along the northbound road to shake off the lingering chill of winter. Merchants glared suspiciously at strangers, with good reason. When branches snapped along the roadside, hands flew to knives; when no threat appeared, travelers

clenched their teeth, mouthed grateful prayers to saints, and fixed their eyes squarely on the road ahead.

Rome was hectic, crawling with scoundrels and sinners; but it was home, and its ancient churches and well-worn streets led to familiar places. Never mind the territorial wars waged by prominent families, or the starving masses who wavered between desperation and hope; Rome shone with the light of Christ. Here in wretched Francia, the land of the Franks, a Roman saw no such faith in the faces of men. How could God's grace penetrate these weeds and this tangled wilderness? The Frankish bishops did their best, probably, but their hapless flock was beguiled by old charms and mired in superstition and sin. Centuries of pagan beliefs stuck to the masses like ticks.

And, although it was hard to believe, this place got worse. Somewhere beyond this endless forest was a dangerous new threat: the Vikings. Only three years earlier, the heathens had sailed out of the icy north to rape England and Ireland and terrorize the world. How could men live in such a godforsaken place?

The Franks were a common sight in Rome, where they strolled the streets in their outlandish tunics and hose or wandered indiscreetly around the papal palace. In private, some Romans smirked and dismissed them as barbarians. In public, the Romans treated them civilly. They had to; the Frankish king enjoyed great influence with the pope, and the king's men were the pope's defenders— skilled, disciplined, and deadly in battle. A visitor to their homeland could understand why: men bred in this environment had to be hard creatures indeed.

For most Romans, the town of Aachen was bound to be a disappointment. Unlike Rome, it was no magnificent city, encircled

by ancient walls and graced with crumbling monuments; rather, it was a glorified village of timber and stone that struggled to impress. It was an unlikely place for world-changing decisions to be made. Nonetheless, beyond the markets and merchant shacks at the outskirts, the king's ambitious plans for his capital became evident. Behind a web of scaffolding, walls and towers were rising around a palace, and lovely arches framed doorways and porches. At Aachen, Karl had found a city of clay, but he clearly intended to leave it marble.

What waited behind the palace walls was less certain. Everyone knew that the king had surrounded himself with Europe's most gifted intellects; and all had heard that theology lessons, legal disputes, or other royal business could occur anywhere: over dinner, behind the walls of the king's hunting grounds, or even in the steamy comfort of the royal baths. Aachen had a reputation for more earthy entertainments, too, from bearbaiting and bawdy songs to old men who sang the deeds of pagan heroes—dubious pastimes that made visiting monks exchange pained glances over their beer mugs and slip into polite silence.

Whatever revelry was easing the residents of Aachen through the last weeks of winter, the king was probably surprised to see a messenger from Rome, because no sane person traveled so far in wintertime or crossed the treacherous Alps without good reason. Unfortunately, the news was urgent and terrible: Hadrian, who had been the pope in Rome for more than twenty years, had died on Christmas Day.

"At God's call," wrote Hadrian's official biographer, "his life came to an end and he went to everlasting rest." Einhard, a member of Karl's inner circle, recorded his king's far less stoic response: "When the death of Hadrian, the Pope of Rome and his close

friend, was announced to him, he wept as if he had lost a brother or a dearly loved son."

In his biography of Karl, Einhard vividly describes his friend the king as a tall, thick-necked warrior with white hair, large eyes, an affable expression, and a stomach tactfully noted to be just "a trifle too heavy." But that winter, anyone who stood before this bear of a man might have been struck less by his obvious physical strength and more by the intensity of his sorrow. Karl mourned the loss of his friend and ally, but he also mourned for the church, which had lost a great leader.

And if the envoy from Rome was an educated man who knew the history of Karl's people, he may have thought with amazement: *This is not what I expected from the king of the Franks.*

"This particular race of people seems always to have followed idolatrous practices, for they did not recognize the true God," wrote Bishop Gregory of Tours two centuries before Karl's reign in his monumental *History of the Franks.* "They fashioned idols for themselves out of the creatures of the woodlands and the waters, out of birds and beasts: these they worshipped in the place of God, and to these they made their sacrifices."

The Franks first emerged from the lower Rhineland during the third century after Christ, as one of several Germanic tribes to pick through the rubble of the failing Roman empire before forcing their way into neighboring lands. Within two centuries, they had carved Francia from a sizable portion of the Roman province of Gaul, raising hardscrabble fortresses of timber and stone and making the fields and rivers their own.

A warlord named Clovis was their first chieftain to renounce his pagan idols, submitting to Christian baptism "to wash away the sores of his old leprosy," wrote Gregory, "and to be cleansed in flowing water from the sordid stains which he had borne so long." Officially rid of paganism, the Franks had adopted a muscular, Old Testament brand of Christianity. Their God rewarded them for that, making a family called the Carolingians the beneficiaries of divine grace. Named for a line of men called Karl, or Charles, or Karolus in Latin, the Carolingians rose to prominence, becoming leading nobles and eventually "mayors of the palace." The exact nature of this position is obscure, but the Carolingians were clearly the real power behind the throne. Using their influence, they engineered a palace coup, dethroned the weak Merovingian dynasty, and established themselves as kings.

Under Carolingian rule, the Franks prospered. By Karl's time, their empire had grown to include lands encompassed today by France, western Germany, the Netherlands, Belgium, and northern Italy. To the southwest, Frankish power stretched to the Pyrenees and abutted Andalusia, home to the young kingdoms of Islamic Spain. In the northeast, the border was creeping toward Scandinavia. The Frankish empire had the attention of its neighbors—and it was expanding still.

By 796, after reigning for twenty-seven years, Karl had conquered Lombardy, Bavaria, and the old Celtic land of Brittany in northwestern France. His armies were making strides against the pagan Saxons to the northeast, and the end was near for the Avars, the mysterious Asian horsemen who had terrorized eastern Europe for generations. The Frankish empire was growing, Christianity was spreading, and all thanks to a king who heard mass

every morning and prayed three times a day. On reflection, even a jaded Roman could imagine his own city of churches and smile, briefly, with optimism.

But Aachen was an unlikely place to forge a brave new Christian world; humanity was too much in evidence. In the shadows of the scaffolding that covered this half-built town, visitors encountered the medieval rabble that history barely remembers. Cackling merchants hauled casks of Rhineland wine into the palace compound, while northerners with strange accents peddled leftover furs to shivering travelers from the south. Monks from Ireland and Italy made small talk in Latin, the one language they shared. Sullen Slavic ambassadors leaned against walls and kept to themselves, awaiting the hot meal and heroic songs that signaled dinner with the king. Clerks swarmed into and out of the palace like bees. Lawbreakers with nervous faces arrived for justice; found guilty and fined, they left poorer for the encounter. Frankish nobles brushed past peasants without a glance.

After a few weeks of watching the great barbarian king ride out to hunt; or sing quietly during mass; or stride across courtyards with his counselors, eager to listen, eager to talk, a papal messenger knew what to tell the new pontiff when he got back to Rome. Although barely built, Karl's capital was *almost* civilized and unexpectedly alive: ambitious, forceful, clearly Christian, slightly cruel.

The messenger realized, on reflection, that it was just like Karl himself.

W orld capitals have often been founded for serious, even grave reasons, from convenience of trade to military necessity. Karl established his on one of the more elusive principles of his era: luxury.

"He took delight in steam-baths at the thermal springs," wrote Einhard, "and loved to exercise himself in the water whenever he could. He was an extremely strong swimmer and in this sport no one could surpass him. It was for this reason that he built his palace at Aachen and remained continuously in residence there during the last years of his life and indeed until the moment of his death." Those hot springs had also impressed the Romans, who had given the site its name, Aquisgranum. Imitating their civilized ways, Karl was satisfied to admire their impeccable Roman judgment.

After nearly thirty years of moving among his many palaces, tapping their resources and keeping his eye on the sticky-fingered counts who governed in his name, Karl had earned a few comforts. Beyond the reception halls and official ceremonies and beneath the armor was a man who loved to ride, hunt, and swim. Craving a sanctuary from politics and war, the aging king chose his favorite palace, declared it a capital, and made it his home.

In 796, Aachen was also home to Karl's many daughters. Little is known about them beyond their evocatively medieval names— the teenagers Rotrud, Berta, and Gisela; and the younger girls Theodrada, Hiltrud, and Rothaid—but history suggests that they were formidable personalities. In one revealing letter, Karl's closest counselor, Alcuin, echoes the Book of Isaiah to warn a teacher about sinful temptations at the court, especially the insistent charms of the princesses:

*May the crowned doves that fly about the rooms of the palace not come
to your windows, nor wild horses break through the doors of your room.
Take no interest in dancing bears, but in psalm-singing clergy. Let your
words be ruled by truth, your voice controlled, your silence weighed, and
think carefully to whom you speak.*

Not everyone at Aachen appears to have heeded this advice.
One adviser, a poet named Angilbert, fell in love with Karl's
daughter Berta. They had two children together, but Berta's father
hardly seems to have minded; on the contrary, Karl routinely sent
Angilbert on sensitive missions that demanded the utmost trust.
Aachen in 796 was not a genteel place, at least not behind the
scenes, and Karl's own long string of wives and mistresses defies
the modern assumption of medieval prudery. The palace swarmed
with the king's children by two deceased wives, all of them over-
seen by their stepmother, Queen Liutgard, a woman young enough
to be their sister. Meanwhile, Karl's first grandchildren were grow-
ing up alongside their adolescent aunts and uncles, and the palace
was far from placid. Several years earlier, a Lombard historian
named Paul the Deacon had fled the Frankish court to return to
the quiet routine of monastic life. He had written despairingly to
his abbot, "Compared with your monastery, the palace is a prison
to me; and compared with the great peacefulness of your commu-
nity, life here is a hurricane!"

Amid this ever-growing brood were boys, too. Karl, the king's
eldest legitimate son and his intended successor, was learning the
family business alongside his father, who heard regularly from his
other sons: the eighteen-year-old Louis, who ruled in the south-
western province of Aquitaine; and the twenty-three-year-old Pe-

pin in Italy. More children came later, living proof that their
father's famous athleticism extended well beyond his swimming
pools and game preserve.

The only soul barred from the warmth of the family circle was
the eldest half-brother, the illegitimate Pepin the Hunchback,
whose role in a failed coup had earned him a permanent home in
a monastery. The Carolingians seem to have given him little
thought. Instead, his memory was drowned out by the cacophony
of family life at Aachen: teenage princesses twirling their beaded
necklaces and making eyes at blushing clerks, or a bored prince
riding out with his friends to hunt, while harried nurses chased
naked, shrieking children past a stunned group of foreign diplo-
mats. As Karl willed it, Aachen was a place of business, but it was
also a home.

Karl himself is a difficult man to get to know. Most surviving
sources from his reign—law codes, histories, letters—chronicle
the official figure, a bronze statue idealized by his closest confi-
dants. Only the biography written by Einhard offers glimpses of
the man himself, particularly in one revealing comment on family
life at Aachen:

> *These girls were extraordinarily beautiful and greatly loved by their
> father. It is remarkable that, as a result of this, he kept them with him in
> his household until the very day of his death, instead of giving them in
> marriage to his own men or to foreigners, maintaining that he could not
> live without them.*

Einhard admits that this policy resulted in "a number of unfortu-
nate experiences," but that the king "shut his eyes to all that hap-
pened, as if no suspicion of any immoral conduct had ever reached

him, or as if the rumour was without foundation." By 796, Karl
had already buried two wives and three children. Whatever his
flaws, he wisely treasured what he had.

The king valued sharp minds as well. During the 770s and
780s he made his ever-moving court a haven for some of Europe's
brightest intellectuals, and he was committed to learning all he
could from them. Einhard says that Karl

> *paid the greatest attention to the liberal arts; and he had great respect*
> *for men who taught them, bestowing high honours upon them. When he*
> *was learning the rules of grammar he received tuition from Peter the*
> *Deacon of Pisa, who by then was an old man, but for all other subjects*
> *he was taught by Alcuin, surnamed Albinus, another Deacon, a man of*
> *the Saxon race who came from Britain and was the most learned man*
> *anywhere to be found. Under him the emperor spent much time and*
> *effort in studying rhetoric, dialectic and especially astrology. He applied*
> *himself to mathematics and traced the course of the stars with great at-*
> *tention and care.*

He adds that Karl also spoke Latin fluently and knew some Greek,
but he tactfully acknowledges an ultimate failure:

> *He also tried to learn to write. With this object in view he used to keep*
> *writing-tablets and notebooks under the pillows on his bed, so that he*
> *could try his hand at forming letters during his leisure moments; but*
> *although he tried very hard, he had begun too late in life and he made*
> *little progress.*

Few at court talked about the king's embarrassing struggles
with reading and writing, which competent scribes could disguise,

but his advisers trusted his leadership. What Karl was unable to do himself, he summoned others to do. Admitting that many of his monks and priests were scandalously illiterate, he encouraged the creation of church schools. "Letters have often been sent to us in these last years from certain monasteries," he griped in one decree, "in which was set out what the brothers there were striving to do for us in their holy and pious prayers; and we found that in most of these writings their sentiment was sound but their speech uncouth." Increased literacy was just one part of Karl's plan to reform his lapsed clergy, too many of whom ignored church law and spurned their vows. Whatever sins were acceptable behind palace walls, the king expected better from bishops, priests, and monks, who served as the public face of the church. They were to set an example for all to follow.

Meanwhile, at monasteries throughout Francia, clerks were copying books at a rate not seen in centuries, correcting erroneous editions of the Bible, and preserving ancient wisdom on the scraped skin of animals. In an act of remarkable good judgment, Karl's scribes wisely discarded the palsied chicken-scratch of earlier generations and replaced it with a clean, elegant handwriting. The clarity of this script, known as Carolingian minuscule, so impressed the first European printers 700 years later that they assumed it must be the work of the Romans and made it the basis for the lowercase "Roman" fonts used in printed books today.

Just as Aachen was a political capital, the town was also the symbolic source and center of this intellectual revival, a second Athens and a new Jerusalem in the minds of its resident scholars. By 796, most of the court's original wise men had dispersed, spreading their influence throughout the kingdom in their new roles as bishops and abbots, but at the palace a dead poets' society

continued to thrive. The nicknames of the members of Karl's inner circle, preserved in affectionate letters and poems, mingle classical references and Old Testament names: Angilbert was "Homer"; Einhard was "Bezalel," after the craftsman of Moses in the Book of Exodus; and Karl's daughters enjoyed affectionate nicknames such as "Delia," "Columba," and "Lucia."

Towering above all of them, naturally, was "David"—a comparison that Angilbert, in his poetry, took quite seriously:

> Rise, pipe, and make sweet poems for my lord!
> David loves poetry; rise, pipe, and make poetry!
> David loves poets, David is the poets' glory,
> and so, all you poets, join together in one,
> and sing sweet songs for my David!

Theodulf, one of Karl's theologians, praised the king in an outpouring of biblical allusions:

> What wonder is it if the eternal shepherd made
> so great a man His pastor to tend His flocks? Your name
> recalls your grandfather, your noble understanding Solomon's,
> your strength reminds us of David and your beauty is Joseph's own.

For Karl and his counselors, this Old Testament imagery was more than just an elaborate inside joke among palace intellectuals. Like David before him, Karl was building a new temple. He was renewing the law, and he was straightening out his priests. It called for a stretch of the royal imagination, but the king and his men could see it: the Franks were God's new chosen people. Their king had work to do.

"For everything that was written in the past," Saint Paul re-minded them, "was written to teach us, so that through endurance and the encouragement of the Scriptures we might have hope." Mindful of this admonition, monks studied grammar and rheto-ric not merely to imitate the ancient Romans, but also to unlock the multiple layers of meaning in the Bible and better understand the word of God. The books that resulted were not always reli-gious; but as monastic libraries grew, proud abbots lined their shelves with dozens or even hundreds of new volumes, all of them painstakingly copied by hand and bound with expert care. "It is better to write books than to dig vines," wrote Alcuin in a poem that affirmed this indispensable work. "One serves the belly but the other serves the soul."

Outside the monastery walls, the peasants of Francia contin-ued to dig vines, clear forests, harvest rye, and slog home in their muddy boots at sunset, flea-bitten and exhausted. Today, histori-ans speak of Karl's circle of intellectuals and praise the "Carolin-gian renaissance"; but at the time the illiterate majority rarely benefited from the king's emphasis on education. Posterity prof-ited most from monkish labors: more than 7,000 manuscripts survive from the ninth century, including language books, com-mentaries on the Bible, rare copies of ancient Roman histories, farming manuals, law codes, and Latin poems that offer intrigu-ing clues about daily life.

We can be grateful for the Christian passion that drove Karl to commission new books and preserve the works of the ancients. Men such as Alcuin, Angilbert, and Theodulf, whose names are barely remembered today, and countless scribes whose names no one remembers at all, were steady lights in a dark forest, guiding future scholars to the treasures of the past.

B ut in the meantime, at Aachen, there was feasting to be done. Along hallways cluttered with trophies of war and the treasures of conquered people, Karl welcomed friends and foreigners alike, plying them with beer, roasted meat, and a full bowl of entertainment—anything from ancient epics, rowdy and rough, to readings from *The City of God* by Saint Augustine. Visitors returned home praising the Frankish hospitality they had received at the edge of the civilized world, especially the revelry that lingered into the cold twilight hours.

They also returned to Rome with reports of Karl's stunning octagonal chapel. Looking upward from his gilded choir, Karl saw a dome depicting the majestic Christ surrounded by evangelists and elders. Across from the king, at eye level, was the altar to his Savior. The level below was for pious commoners, who gathered to pray among plain stone pillars near an altar to the Virgin Mary. The hierarchy was clear: Karl ruled over men just as God ruled over Karl and indeed over all the world. A papal envoy might have paused to wonder: *If these Franks believe that Karl and Christ are on the same level, then what, in their minds, is the place of the pope?*

The relationship between Rome and Francia had begun with Karl's father, Pepin. Pope Zacharias had supported Pepin's claim to the Frankish throne over the feeble Merovingian kings; the next pope, Stephen, had even visited Francia to anoint Pepin and his sons. In turn, Pepin had defended the papacy from the restless Lombards in northern Italy. Karl continued the partnership, conquering the Lombards and earning reciprocal favors from Pope Hadrian. When Karl had wanted

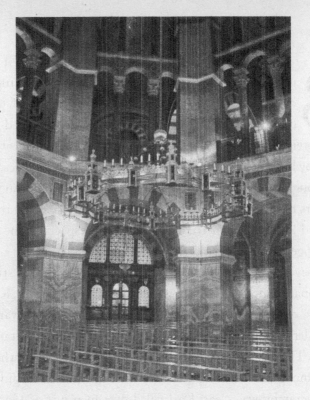

Although most of the Aachen cathedral is of more recent construction, its core is still Karl's octagonal chapel, described by one historian as a place of "concentrated magnificence."

to steal Bavaria from his cousin, a duke named Tassilo, Hadrian threatened the duke with excommunication, thus hastening Tassilo's surrender. During the 780s and early 790s, letters continually passed between Rome and Francia in which Karl and Hadrian discussed everything from dealing with upstart bishops to patching leaky church roofs. Although they met only a few times, Hadrian had been a reliable ally, godfather to the king's son, and a genuine friend.

After Hadrian died, his twenty-three-year friendship with Karl found permanent expression in marble, when the Frankish king ordered Alcuin to compose a heartfelt epitaph in his name. Inscribed on a black marble slab still visible at the rebuilt Saint Peter's in Rome, the poetic lament is the final word on the partnership between two of early medieval Europe's most influential men:

> Karl, weeping, has written you this poem;
> Father, dear friend, I grieve only for you.
> Remember me—for my mind follows you always,
> Even as you hold with Christ the blessed kingdom of heaven.
> The church and the people all esteemed you; greatly and lovingly;
> Highest pontiff, you were one dear to all.
> I join together our names with the clearest inscription:
> HADRIAN AND KARL—I the king and you the father.

Karl would never enjoy the same easy intimacy with Hadrian's successor, Leo III. In fact, by early 796 the king had reason to be wary. Something strange was happening in Rome.

At first, nothing seemed amiss. According to Frankish chronicles, in early 796 the new pope sent Karl gifts that included the symbolic keys to the tomb of Saint Peter and the banner of the city of Rome. Leo's messengers also asked Karl to send an envoy who could accept an oath of fealty from the Roman people, who considered him their earthly protector.

At the same time, Karl received word that Eric, a duke who

ruled the frontier region of northeastern Italy, had joined with a Slavic warlord to crush the Avars who plagued the Hungarian plains. The spoils of war were remarkable: more than a century's worth of hoarded treasure rolled into Aachen. "Behold with joyful heart," exulted Theodulf, "the manifold gifts which God has sent you from the realm of Pannonia."

In Rome, Pope Leo had reason for thankful prayers of his own. Karl sent the new pope a portion of the Avar treasure, an extraordinary offering to the church. It was a sign of things to come, but it did not come alone. The treasure was brought to Rome by Angilbert, and it was accompanied by a letter.

In a greeting encrusted with the overwrought language of medieval diplomacy, the king affirmed the bonds of friendship between the Franks and the papacy:

> For just as I entered upon a pact with the most blessed father who
> was the predecessor of your holy fatherhood, so I desire to establish an
> inviolable treaty of the same loyalty and amity with your blessedness,
> to the end that, by the divine grace which the prayers of your apostolic
> holiness call upon, apostolic blessing may attend me everywhere I may be
> and the most holy see of the Roman church may always, by God's gift,
> be defended by our devotion.

As the letter progresses, Karl subtly changes the terms of the historic friendship. Defense of the church, he says, requires that Leo see himself not as the king's equal, but as his subordinate—his mighty helper:

> It is our function—to the extent that divine goodness aids us—
> externally to defend Christ's holy church on every side by force of arms

*against the incursions of the pagans and the devastations of the
infidels, internally to strengthen it in knowledge of the catholic faith. It
is yours, most holy father, to aid our struggle with hands raised to God,
like Moses, to the end that, with you interceding and God guiding and
granting, the Christian people should at all times and in all places enjoy
victory over the enemies of its holy name and the name of our Lord
Jesus Christ be glorified throughout the whole world.*

Karl never would have so boldly spelled out his version of the
pope's function while his friend Hadrian lived. What suspicious
whispers had reached Aachen from Rome?

In a separate, more candid letter to Angilbert, Karl urged his
trusted counselor to deliver some pointed advice to the new pope:

*Advise our Apostolic Father diligently in regard to all honour in his own
life, and especially on observance of the canons, on the loyal governing of
the Church of God, so far as your opportunity and consent allow. And
tell him again and again how brief and passing is his own present office,
how long-lasting the reward given to him who labours well.*

Lecturing a new pope about his moral and religious responsi-
bilities was hardly routine. Rumors were spreading, and Rome
simmered with problems that even Karl dared not put in writing.

Construction continued at Aachen. The capital was ris-
ing, and Karl was pleased, even though disquieting ru-
mors about Pope Leo nagged at him that spring. Rome
was never far from his mind.

Writing more than a decade later, one poet recalls Aachen in 796 as a gloriously exaggerated metropolis rising from modest foundations. He evokes none of the frustrated grunts, weary muscles, or bloody calluses that accompanied medieval construction. Instead, the builders are contented laborers and Karl is a sort of royal foreman, directing their every effort with keen foresight and superhuman efficiency:

Pious Karl stands above them, pointing out each site from afar,
Overseeing the high walls of a Rome yet to be.
Here he orders a holy forum and a righteous senate
Where the people shall enjoy justice, law, and sacred judgments.
The team of laborers works on: Some cut hard stones
Into fitted columns to raise an imposing arch;
Others struggle to roll the stones by hand,
Or dig out storehouses, or lay deep foundations for a theater
And enclose these rooms with lofty domes.
Elsewhere, others work to find the heated springs,
Where warm streams surge easily from the rock,
And they fasten lovely seats to marble steps.

Like many poems from Karl's court, this one is pure fantasy; no one who had been to Rome could honestly rank muddy Aachen among Europe's greatest cities. But what *was* hardly concerned Karl; what *could be* preoccupied him. When he unrolled maps of Europe in the private corners of his palace, the Frankish king could share the poet's vision of *ventura Roma*—a Rome yet to be.

Karl's poets were not the only ones who dreamed of Roman laurels. Far to the east was another Roman empire, one which had

never fallen but which continued to shine long after the city of Rome had crumbled into a haven for holy relics and miraculous cures. In that other city, named for the greatest of Christian emperors, was a cunning woman of noble birth who desired, above all, to be sole empress of the Romans.

AN EMPRESS
OF BYZANTIUM

Constantinople, A.D. 797

There would have been a lot of blood.

On a Saturday morning in August in the greatest city in the world, the emperor of the Romans, Constantine VI, was brought by boat across the Bosporus to the Great Palace of Constantinople. Despite his desperate pleas, he was locked in the Porphyra, the sumptuous purple room where his mother had given birth to him twenty-six years earlier.

Later in the day, his mother's soldiers gouged out his eyes.

According to the monk Theophanes, the natural world mourned the evil of that day. "The sun was darkened for seventeen days and

did not emit its rays," he claimed, "so that ships lost course and drifted about." Meanwhile, just within the western walls at the Eleutherian Palace, the emperor's mother, Irene, waited. The distance between the two palaces was no more than a mile and a half. News would have traveled quickly.

History does not record how Irene reacted to the report that her plot had succeeded. Did she smile? Did she sneer? Did she cringe beneath the holy icons that stared at her from the palace walls, or did she return their gaze with contemptuous silence? More than twelve centuries later, Irene's emotionless portraits on the gold coins of her empire reveal nothing about what she was thinking on the day her son lay in the room where he was born, crying out in Greek as his eyes bled.

It is, however, a comforting lie to hope that Irene stood on a balcony within sight of the harbor and prayed, if only for a moment: *Heaven help me for the way I am.*

L ooking up from their own prayers on a steamy August afternoon, the priests and monks of Constantinople might have disapproved, briefly, of the unsubtle methods, but many of them were relieved to hear that Constantine VI was finished. The young emperor had failed to distinguish himself in battle, first in the east against the Arabs, who rampaged across Anatolia each summer, and also against the Bulgars in the west.

Moreover, his personal behavior had been blasphemous, even adulterous. Many years earlier he had been engaged to Rotrud, daughter of the king of the Franks—Karoulos, people called him in Greek. When the engagement failed, the boy had pouted, even

though his mother had presented him with thirteen prospective brides—beautiful women, too, not barbarian princesses from uncouth lands. Constantine VI repaid Irene's generosity by spurning the mother of his two children, taking and "marrying" a mistress, and confining his own mother to her palace.

People had called Constantine *porphyrogenitus*, "born to the purple." But after everything that had happened, this Constantine was, at best, a disappointment. He was also, as any monk who knew history could conclude, unworthy of his very name.

Even though more than 450 years had passed, the memory of the first emperor named Constantine still loomed over the city that bore his name. His imposing statue glared down from the top of a lofty column, as if from heaven, in the forum named after him; and his influence was everywhere, from the creeds recited in provincial churches to the gold coins that sustained the imperial economy. Born in the Balkans and acclaimed *augustus* in his early twenties during a military campaign in northern Britain in A.D. 306, Constantine the Great had begun his career as ruler of only a small portion of the Roman empire. Within a few years he had battled barbarian incursions from without and imperial rivals within, and soon he ruled an empire that stretched from distant Britannia to North Africa and the Middle East. The world was his; it was meant to be.

The Christian God, he believed, had led him to victory. The emperor had beheld a vision of the interlocked Greek letters chi and rho accompanied by an inscription: *In hoc signo vinces*, "In this sign, you shall conquer." The sign, the first two letters of the Greek

for *Christ*, became his military standard. Inspired, he took the city of Rome from his rival in 312; and, as the heavens had promised, the entire empire fell under his rule. No ingrate, Constantine spent the rest of his life thanking the Christian deity for his divine favor, even if he was suspiciously slow to give up his old gods, among them Mars, Hercules, and Sol Invictus, the "Unconquered Sun." His religious strategy was prudent for the times. After all, it was still a pagan world; better to be cautious, lest he be struck down by some inadvertently snubbed deity.

Constantine had seen an impressive amount of the empire, but he chose to build his capital here, on the site of an ancient Greek trading colony called Byzantion. No paragon of humility, he named the city for himself, declaring it a monument to his God-given victories. His instinct for geography was superb: *Constantinopolis nova Roma* connected north and south, east and west; and all the wonders of the world—spices, gems, silk, ivory, porcelain, textiles—passed through its ports. Clinging to the edge of Europe, Constantinople stared at Asia across a narrow strait, the Bosporus, which provided northward access from the Sea of Marmara to the Black Sea. Coastal walls deterred sea attacks, and the peninsular city could be assaulted only by land from the west, but three lines of walls held invaders back. According to legend, Constantine had traced the foundation of those walls himself. The emperors of his city would have a similarly obsessive grasp over trade and communication for centuries.

More significantly for his empire, Constantine presided over—mandated—the marriage of Christianity to Rome. Continuing the old Roman tradition of the emperor as *pontifex maximus,* or supreme priest, Constantine saw himself as equal to one of Christ's apostles. He oversaw religious councils, dictated Christian dogma,

and ran the affairs of his church with dictatorial ease. By the end of his reign, Constantine the Great had clearly done God's will. The Roman empire was at the height of its power, and its new capital was brilliant—even if, as Saint Jerome observed, Constantinople had been beautified by denuding almost all other imperial cities.

Four centuries later, Irene inherited an empire that was not what it had been. Its western half was utterly lost, overrun by Germanic barbarians and separated from the eastern empire by a wall of Slavs. North Africa and the Middle East were gone too, lost to Islam in a lightning wave of invasions. Still, the empire had survived, small but proud, and with institutions that Constantine the Great would have recognized. The old Roman political system had endured, Greek culture still predominated, and the Christian faith had eclipsed the paganism of the ancients. Modern historians have dubbed the citizens of this empire Byzantines, after the ancient trading colony that became its capital. The Franks called them Greeks, after the language they spoke and the classical culture they had inherited. The actual citizens of the empire considered themselves neither of these things. In their own Greek language they were Romaioi, "Romans," heirs to a venerable empire. Confident in their legacy, they pointed to the similarities between their current and former capitals with unshakable pride. Like the old city of Rome, the *nova Roma* of Constantinople had seven hills. It had a senate, a hippodrome, and forum after forum decorated with statues and memorial columns. It boasted magnificent harbors, beautiful churches, and elaborate palaces befitting the chosen emperors of God. Who could walk the streets of Constantinople and see anything but the worthiest successor of old Rome?

In addition, the skyline of Constantinople had one feature that the first Rome could never claim: the great church built in the sixth century by Emperor Justinian and dedicated to Hagia Sofia, "Holy Wisdom." From the outside, Hagia Sofia was a marvel; inside, the breathtaking view beneath its massive dome was, as visitors soon discovered, a spiritual empire unto itself. "It does not appear to rest upon a solid foundation," wrote the historian Procopius, "but to cover the place beneath as though it were suspended from heaven by the fabled golden chain." Emissaries of the prince of Kiev were equally overwhelmed by the glory of the great church. "[W]e knew not whether we were in heaven or on earth," they reported to their ruler. "For on earth there is no such splendor or such beauty, and we are at a loss how to describe it. We know only that God dwells there among men, and their service is fairer than the ceremonies of other nations. For we cannot forget that beauty." Justinian himself had been spurred to a moment of immodesty at the first sight of his creation. "Solomon," he was said to have cried, "I have surpassed you!"

This was the glittering empire that Irene had married into, inherited, then stolen from her son. But the empress was fortunate: unlike her boy, she had no need to live up to a famous name. Attempting to balance tradition, innovation, and scandal, she learned the ways of Constantinople on her own terms, making the city, the empire, and its people her own.

And therefore I have sailed the seas and come," William Butler Yeats wrote in the 1920s, "To the holy city of Byzantium." Yeats imagined a peaceful city of drowsy

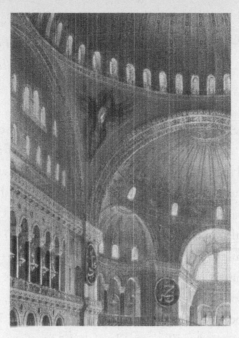

Now a museum, Hagia Sofia has astonished visitors for nearly 1,500 years. Decorative medallions with Islamic calligraphy attest to its centuries as the principal mosque of Istanbul.

emperors and Christian artisans absorbed in expressing their religion through "monuments of unageing intellect." Sailing to Byzantium herself from her home in the central Greek district of Hellas in November 769, Irene was surely as impressed by the sight of the city as first-time visitors always were. Her first thoughts might have echoed a later description by a deacon of Hagia Sofia that also applied to the skyline itself:

> *So is it new in its marvels, being so exceedingly great as it towers upwards like the mountain and leaves below all those things which art sets*

*its hands to create, and so exceedingly beautiful as it shines forth, for all
its age, as though it had been raised above time itself, and had not been
immersed in its current. How its countenance flashes forth like liquid
through the gold which is everywhere!*

As a girl in her teens, Irene would have been focused on her future
husband: the nineteen-year-old Leo IV, grandson of a Syrian sol-
dier, who had reigned as co-emperor with his father, Constantine V.
The government in Constantinople hoped to bring Hellas under
its influence, and Irene, the daughter of a prominent Greek family,
was a politically important wife.

More than twenty-five years later, it was no naive girl who
ruled the Roman empire. Any wistful recollections of that first
glimpse of Constantinople were probably long gone, and her first
elaborate procession from the harbor to the Great Palace was a
memory from another lifetime. She now had to focus on the hard
business of governance—and, above all, ruthless self-preservation.

Looking out over the harbor where merchant ships sailed into
Byzantium with spices and grain and sailed out full of silk and
gold, the adult Irene would have laughed had she known of Yeats's
Constantinople, a romanticized scene fit only for poets or starry-
eyed girls. What the empress had learned during her years at the
Great Palace was far rougher indeed.

Irene had seen that the emperor, while not above the law, still
closely controlled everything and everyone. Ministers served at his
whim. Laws were made at his command. The army marched wher-
ever he wished. He was the *basileus*—the old Greek term for a
king—but he was more than some mere monarch, and everyone in
his presence fell prostrate before him. He ruled the empire, he
ruled the government, and he ruled the church within his borders.

Like the old emperors of pagan Rome, he had something divine about him—something very nearly supernatural.

Irene, who witnessed the inner workings of the Great Palace in private, probably noticed early on that the imperial family was far from divine; in fact, the family was all too human. She also saw that it was politically expedient for people to think otherwise.

She first beheld the failings of emperors in her father-in-law, Constantine V. History remembers the fifth emperor to bear the illustrious name as a productive fellow who revived and repopulated an aging city and who successfully defended the empire against Bulgars and Arabs. Unfortunately, Constantine V was also the emperor who lost Italy, especially the vital city of Ravenna, to the invading Lombards. Seen as touchy and barbaric, he was called Copronymus, "dung-named," by his detractors—not because he let Italy slip through his fingers, but because he committed a much graver sin against the sensibilities of his subjects: he took away their icons.

Beloved by the Christians of Irene's era, icons remain vital to their heirs in Russia, Greece, and the Balkans more than a millennium later. From the Greek term *eikon*, meaning "likeness" or "image"—but also meaning "vision"—icons were not idols; as Saint John of Damascus wrote in their defense, they were simply "brief reminders" of the heavenly figures they depicted. To venerate them was not to worship chunks of wood and enamel, "just as we do not adore the matter of the Gospel book or the matter of the cross," John patiently explained, "but that which is expressed by them." Icons provided every Christian,

even the illiterate, with a visual lesson and a link to the divine. God was unknowable and ultimately beyond all understanding, but each icon, whether it depicted Christ, his holy mother, or one of the saints, was a reminder that the transcendent God had become man, and that God continued to reveal himself and his presence in all things, including glass mosaics or panels of ivory and wood. To deny the possibility of the holiness of an icon, John and others argued, was to deny that God could become man and a man could be God—the central tenet of Christianity.

Constantine V thought otherwise. His father, Leo III, had originally been a warrior named Konon on the Syrian frontier, where a more austere Christianity was already being practiced. Whether enforcing a literal reading of the Second Commandment's warning against graven images or influenced by close contact with Islam, Leo became fanatically opposed to icons in all their forms. With one edict, he ordered their widespread destruction, giving history an enduring term, "iconoclast"—meaning "icon-breaker"—and presiding over a reign of terror that culminated in the executions of monks and public officials alike. Opposed by most laymen as well as most monks and priests, iconoclasm found its strongest support among soldiers, who could not fail to notice the rampant success of the image-shunning Arabs. Likewise, as icons were destroyed, the Romans began to enjoy their own military victories. To the average soldier, the iconoclast emperors seemed to have earned the favor of God.

Unfortunately for Constantine V, God's favor proved fickle. In 775, the emperor waged war against the Bulgars. "God, however, struck him down," wrote the monk Theophanes; "he became sorely afflicted with carbuncles on his leg and was, on account of the extreme inflammation, seized by a violent fever of a kind un-

known to physicians." He died aboard a ship, "as he was crying out, 'I have been delivered to the unquenchable fire while still alive!'; and he demanded that hymns be sung to the holy Virgin, the Mother of God, whose implacable enemy he had been." When Theophanes, an icon-loving monk, noted in his chronicle that the Islamic caliph al-Mansur also died that year, he mourned neither man, likening them to each other—and to wild beasts.

Irene's husband, Leo IV, softened his father's iconoclastic policies and was involved in only one known incident of outright persecution. Calmer than his father, he was nonetheless unpopular with someone either in heaven or on earth. Irene tolerated him for about a decade. Then, fortuitously, she was relieved of him.

Memorable for little else, Leo IV suffered one of the more interesting deaths of any Byzantine emperor. "Being inordinately addicted to precious stones," wrote Theophanes, "he became enamoured of the crown of the Great Church, which he took and wore on his head. His head developed carbuncles and, seized by a violent fever, he died after a reign of 5 years less 6 days." Leo's was also one of the more suspicious deaths in Byzantine history. Exactly which of his enemies served as the instrument of God's judgment remains a mystery. Posterity, and Irene, kept conspicuously silent.

Irene was left with a nine-year-old son, a boy emperor unready to rule. Whenever an emperor was too young for the throne, it was customary to appoint his parent as regent. The Romaioi of Constantinople knew that Constantine VI needed protection; imperial politics could tear a child apart. They never suspected that his own mother, of all people, would eventually do just that.

B ut first, Irene had to tackle iconoclasm.

Since the fifth century, there had been five Christian patriarchs, each based in one of five cities: Rome, Constantinople, Antioch, Alexandria, and Jerusalem. As the resting place of saints Peter and Paul, Rome had long enjoyed special status as the "apostolic see"—a term derived from *sedes*, "seat"—and for at least 200 years the bishop of Rome had asserted primacy over all other bishops. Fortunately for Irene, Constantinople was home to the second most powerful man in Christendom, and he was traditionally selected by the emperor.

Paul, the patriarch of Constantinople, recanted iconoclasm on his deathbed. Irene replaced him with a layman, Tarasios, and called a council to discuss the question of icons. A riot brought the council to an early close, but Irene started returning icons to some of the most important churches in Constantinople. Two years later, she tried again.

In September and October of the year 787, Irene held a council at Nicaea, the ancient city where the first Constantine had convened a church council four centuries earlier. That first council, summoned to debate a heresy concerning the nature of Christ, had given the world the Nicene Creed, the fundamental statement of Christian beliefs. Comparing iconoclasts to the heretics of old, the Second Council of Nicaea presented years of research to prove that icons were not only allowable but also crucial to the faith. "And so God's Church found peace," wrote Theophanes, "even though the Enemy does not cease from sowing his tares among his own workmen; but God's Church when she is under attack always proves victorious."

Irene had destroyed heresy; her halo was forming. Her son

shared a name with the greatest Christian emperor, and some likened her to that emperor's mother, Saint Helena. God had worked at least two miracles: the Romaioi could openly venerate icons again, and Irene had learned how to make them venerate her as well.

Irene learned other political skills in the Great Palace, including the art of punishment. Although little is known about the personality of the empress, her gift for imperial justice is evident in her treatment of her enemies, a litany of punishments that was long, unsentimental, and typically Byzantine. If a military unit fomented chaos, she disbanded it, sending rebels and their families into exile. When soldiers in Asia Minor revolted, they were marched through the capital in chains, branded across their foreheads, and exiled.

When her late husband's five half brothers, each of whom had been granted the honorary title *caesar*, plotted to put the eldest on the throne, Irene dealt with their accomplices in the usual manner—banishments, monastic tonsures—but for the five caesars themselves she reserved a particularly creative punishment: she had them forcibly ordained as priests, which made them ineligible to be emperor, and ordered them to distribute communion wafers at Hagia Sofia on Christmas.

When a general named Elpidos betrayed her, it hardly mattered that he was hiding far away in Sicily. His wife and children lived in Constantinople; Irene had them whipped.

And when, at the age of nineteen, her own son—her co-emperor—tried to usurp her, exile her most trusted eunuch, and claim the throne for himself, Irene had him flogged—his entourage, too.

During the 790s, the matter of Constantine VI would have

been a heated topic of conversation, from crowded market squares to the bleachers at the hippodrome. Traveling monks returned to Italy with rueful stories of a flighty, sinful man who was in over his head, and foreign merchants spread tales of an unstable emperor who would never be known as "the great." Constantine played war games; his mother, meanwhile, had learned how the empire worked.

Politically clumsy, Constantine did little to win his subjects' hearts. In 791, after hearing of a plot to put his uncle Nikephoros on the throne, he had taken it upon himself to round up the caesars. He had Nikephoros blinded; he ordered that the others were to have their tongues cut out. Anyone inclined to dislike the emperor was now even more shocked by what he had done to his own uncles. Few cared that Irene may have encouraged him.

But on that fateful August morning in 797, as Constantine boarded the ship to return to the capital, the young emperor was already halfway broken. Earlier that year, conspirators had fed him false reports to make him believe that an invading Arab army had retreated. Denied a rare military victory, Constantine was visibly sad—and the news only got worse. Two months later, one of his children, his baby Leo, had died. Probably depressed, Constantine barely responded to a second raid by Arab forces.

Sensing where popular opinion would fall, Irene knew that polite society would be shocked, but she also foresaw that in time, the priests and monks and Romans in the street would remember her son's blasphemy, his adultery, his incompetence, and his brutality. *Well*, they would conclude, *the boy did have it coming.*

Posterity has taken the word "Byzantine" to describe absurdly complex bureaucracies, but the term is unfair: in medieval Constantinople, a city with hundreds of thousands of residents, the imperial bureaucracy probably had no more than 1,000 people, including church officials. Corruption and extortion were common, but the empire generated enough revenue—from import and export taxes, fines, tollgates, market dues, and other sources—to maintain a standing army. As harried as bureaucrats in any age, the paper-pushers of Constantinople took for granted their garish and beautiful universe of brilliant mosaics, silken curtains, ancient statues, watchful icons, and dining tables strewn with glass and gold. The luxuries of Constantinople were the envy of the world and an object of all the world's desire—if, of course, you could get in.

Although the city once ruled by Irene has changed profoundly, the empress would easily recognize Hagia Sofia on the Istanbul skyline, if not the Islamic minarets that now surround it.

Newcomers found Constantinople a city of walls. On land and around the coasts, rows of massive walls discouraged invading armies, and an enormous chain across the Golden Horn blocked unauthorized sea traffic. Merchants and sailors dreaded the sight of customs officers, who knew the contents of every ship and the agenda of every visitor. The gates of Constantinople didn't fly open for any foreigner or fortune-seeker who felt like wandering about. The city may have been the marketplace of the world and the capital of the Roman empire, but it was also Christendom's great fortress; its government treated it as such.

Once inside the outer defenses, diplomats to Constantinople encountered walls of a different kind. Liutprand, a tenth-century Italian bishop, reported that after he prostrated himself three times before the emperor, he peered up to find that the emperor's massive throne had been raised to the rafters, while a top official scurried to relay messages between the ruler and his now lowly visitors. As was always the case among the Romaioi, protocol was paramount. "The emperor at this time said nothing to me," Liutprand commented, "since, even if he had so desired, the great distance would have rendered it indecorous."

Irene appears to have liked the isolation that came with imperial power. Her otherwise incompetent son had fathered two surviving children—girls named Euphrosyne and Irene—but as females, they had little influence in palace politics. Even before that grim day in August, Constantine's family members kept to themselves, preferring to stay in other palaces, other rooms. Rarely did the empress endure the squeals of little girls echoing in her own marble hallways. Her private meetings were safe from childish disruptions, and she probably saw her granddaughters as infrequently as possible.

Instead, Irene kept close counsel with eunuchs. Only occasionally spotted outside the palace walls, the beardless members of this "third sex" were a mainstay of the government, rushing between dozens of palace workshops, offices, chapels, and residences as they kept the imperial machine functioning. Parents beamed with pride as their castrated sons rose through the ranks of the civil service, biding their time as teachers or advisers to become city prefects, transportation ministers, or even patriarchs. No longer fully male but not seen as female either, eunuchs could be fiercely jealous of each other, but they rarely posed a direct threat to the emperor. Although they sometimes led armies into battle, they were incapable of founding hereditary dynasties by fathering children, and they were forbidden by custom from occupying the imperial throne. So were the mutilated—and, as Irene well knew, the blind.

In an empire founded on ceremony and ritual, eunuchs made sure that the empress stood in the proper places, spoke the proper phrases, and wore the appropriate garb. Beyond their civic function, eunuchs were also a link to the ancient past. As Irene and her entourage walked the private corridor from the Great Palace to Hagia Sofia, she could catch a whiff of incense and scented oils and consider centuries of tradition. Bearded men in coats of silk brocade filled the sunlit church. Priests and beardless eunuchs flitted like angels from chapel to chapel, attending to the tiniest details of Christian worship. Chants and hymns rose up in Greek; the dome echoed with praise of almighty God; and from their glittering windows to heaven, Christ and his virgin mother and all the saints approved as the empress of the Romans entered her private chapel, brilliant as the morning star.

Rome, "fallen"? No—as Irene, and anyone alive in 797 could

see, here in Constantinople, where Homer and the Bible leaned on one another in an educated man's library, an empire of Romans still stood. Its citizens were pious, but they were also proud, beyond all measure, of what was past, and passing, and to come.

Meanwhile, outside the palace walls were hundreds of thousands of Romans: laborers, tax collectors, produce vendors, fishmongers, masons, weavers, and washerwomen, all living in awe of God in heaven and his godlike agents on earth. They counted on free entertainment, and maybe a glimpse of the emperor, during chariot races in the 40,000-seat hippodrome. Ethnically, they were far from homogeneous, and each family knew its ancestors. Some were Abasgians, Alans, Zichs, Vandals, Getae, or Chaldoi, tribes whose names mean little to modern minds; others were Hellenes, Assyrians, and Armenians, still familiar ethnicities today. Their skin colors varied, as did their accents, but all orthodox Christians who spoke Greek were considered citizens, even if they spoke a harsher Greek that the palace elite found utterly incomprehensible.

They knew: God's will had been done. All but the youngest Romans had heard the prophecy that had come to light sixteen years earlier:

> During this year a man who was digging by the Long Walls of Thrace found a coffin and, after cleaning it and removing its lid, he discovered a corpse inside and, engraved on the coffin, an inscription conceived as follows: "Christ will be born of the Virgin Mary and I believe in Him. O sun, you will see me again in the reign of Constantine and Irene."

Amazingly, this anonymous ancient Greek prophet had predicted not only the birth of Christ, but also the reign of Irene and his own exhumation. The coffin and corpse were on display; any disbelievers could go to Hagia Sofia and see for themselves.

But who had time for doubt? Walls needed mending; vegetables needed plucking; olives needed pressing; pale men from the north arrived with new bales of timber, while Jewish merchants docked with porcelain from the east. Some imperial procession was always tromping down the street, looking for legitimacy; pesky inspectors were always coming around, too, looking for bribes. Maintaining a shining empire took tens of thousands of people, variously called on to carry crates, drive carts, load and unload ships, feed foreign merchants, yank carrots and onions from the soil, and haul marble from island quarries. They never saw the empress, and she, even if her procession snaked down their street, never truly saw them.

But, as everyone knew, emperors came and emperors went. An empress ruling alone was a novelty, potentially a scandal, but Irene's reign barely altered day-to-day life. Legal proclamations still formulaically spoke of the *basileus,* the emperor; and coins depicting Irene used the appropriate feminine form: *basilissa.*

However, merchants and mariners did see one distinctive change to the imperial coinage: Constantine VI had disappeared. In years past, mother and son, orbs and scepters in hand, had graced opposite sides of each golden *nomisma.* Now, the mother alone appeared on both sides. No heads, no tails—no matter how a coin landed, the empress Irene always triumphed.

Throughout Constantinople, life went on. Its citizens stared east over the sea walls and across the Bosporus, and there they saw Asia. Each spring brought raids by Muslim armies, which had already stolen much of the old Roman empire. Arabs had endangered this well-defended city before, and they would do so again—but not yet. In the year 797, Islamic minarets did not yet rise over the city's side streets or market squares. Constantinople's future as Istanbul, a city engulfed and reimagined by Muslim Turks, was still 700 years away.

The empress and her advisers recognized dangers on all sides. When she looked to the east, she saw the Arabs, whose power seemed never to ebb. When she looked west, she could see no farther than the savage Bulgars or the barbaric Slavs, whose invasions had severed the road between her city and old Rome.

The *basilissa* of the Romans knew what Bulgars, Slavs, and Arabs might do to her city. Fearing enemies everywhere, she monitored her eunuchs, patronized monasteries, and tracked the movements of ambitious generals. With motherly zeal, she brooded over her fragile reign, but with limited imagination. She believed that threats to her legitimacy would come from within the palace, or from the military, maybe even from her rough and warlike neighbors.

She had little reason to think that the greatest threat would come instead from other foes: from a king, a pope, and a few nimble thinkers in the west.

SOWING THE
SEEDS OF EMPIRE

Tours, A.D. 796–798

In a monastery on the south bank of the Loire, the most brilliant teacher in Europe rose for morning prayers and quietly reshaped the world.

Alcuin was new to the monastery of Saint-Martin at the town of Tours, about 150 miles southwest of Paris. In 796, Karl asked him to bring order to the place, and that one royal gesture benefited not only the souls of his monks but generations of historians as well. As abbot of one of the greatest monasteries in Francia, Alcuin had assistants who helped run the community of the saint whose tomb lent the neighborhood its name, Martinopolis. Unfortunately, most of those men are lost to time, but their

abbot offers interesting glimpses of himself in more than 300 records, many of them far more personal than the surviving documents signed by his king. It is easy to see Alcuin, more than sixty years old, alone in the silence with his aches and pains, dipping a goose quill into a well of black pigment and writing, once again, another revealing letter.

Alcuin wrote to his friend Gisela, abbess of Chelles and sister of Karl, to thank her for the gifts she had sent: a crucifix on one occasion, books and a new cloak on another. He prepared greetings to old friends in Northumbria, the English kingdom where he had been born and raised, along with requests for clothes, paint, dyes, and wine. He sent spiritual advice to Karl's sons, words of concern to Karl's cousin Adalhard about the worldliness of their friend Angilbert, and answers to questions from far-flung pupils who puzzled over passages in the Bible.

In his letters, Alcuin dubbed himself "Flaccus," the nickname of the ancient poet Horace. His friends knew him as Albinus, and he called them by various biblical and classical nicknames. He felt no compunction about doing so, citing the highest of Christian precedents. "Nicknames often arise from familiarity," he explained in a letter to Gundrada, daughter of Karl's cousin, whom he called "Eulalia" after the Spanish saint. "Our Lord himself called Simon 'Peter' and Zebedee's sons 'Sons of Thunder.' So you can approve the practice nowadays as in older times."

Alcuin cleverly justified the names he gave his friends. But he did have cause to wonder: was this display of learning a sign of pride?

If so, doubt passed. Halting his thoughts, the tolling of a bell marked the call to the *opus Dei*, the "work of God": the singing of

prayers and psalms. As abbot, Alcuin had an example to set. It was wrong to be late.

Although Alcuin had become a deacon in his mid-thirties, he was not a priest; nor was he a monk. But he idealized the monastic life and longed for its quietude. Arguing that his life *non monasticae inferior fuit*, "was not inferior to the monastic," his anonymous biographer praised him for his adherence to fasting, prayer, mortification of the flesh, almsgiving, and his constant celebration of the psalms and the mass. Karl's wise men were trying to determine the precise role of men such as these. Confusingly, they ranked higher than canons—the laymen who lived with the monks—but lower than the monks themselves. That middle way was "a life not to be despised," wrote Alcuin, "since it is truly part of the household of God." Those who were not ordained could never become bishops, and some suspected that making them abbots did little to reform their disobedient monks; but in a world bereft of learned men, prayers would have to be offered, and compromises would have to be made.

Alcuin never could have been a true monk. That required an adherence to *stabilitas*, a life spent in one place and devoted to glorifying God; and his days were too packed with distractions. While running Saint-Martin, he was also, in absentia, abbot of six other monasteries. Each of these, like a small city, housed dozens or even hundreds of monks, as well as workers, wanderers, slaves culled from frontier wars, and children who had been sent to the brothers to receive a formal education. All these hapless souls

needed to be guided, managed, overseen, occasionally scolded, and sometimes beaten, if not by Alcuin himself, then by someone he could trust. In an age of widespread corruption and illiteracy, managing a monastery was not for the faint of heart.

At Tours, Alcuin had his work cut out for him. The community that had grown up around the tomb of Saint Martin had, strangely, never been very monastic, and the saint's various roles— soldier, bishop, enemy of paganism, patron of the poor—drew countless characters to the ancient riverside town. A mile west of the old cathedral walls were merchant shacks, hostels, and taverns that filled the empty spaces around the basilica and monastery. With so many pilgrims, tourists, and troublemakers calling on the saint, Martin's tomb was a twenty-four-hour operation. So were the brothels; and as a result, the abbot had much to trouble his mind and soul alike. As the Rule of Saint Benedict, which governed the lives of monks, reminded him:

> *The abbot should always remember that he will be held accountable on Judgment Day for his teaching and the obedience of his charges. The abbot must be led to understand that any lack of good in his monks will be held as his fault.*

History does not record whether Alcuin knew the darker corners of his town, or if he ever dragged wayward monks back from the brink of sin with his own old hands, but in letter after letter he implored his former pupils—his "brothers," his "sons"—to avoid drunkenness and debauchery for the safety of their souls. Whether at Tours or from afar, Alcuin guided their education. They began by memorizing biblical passages and the psalms before imitating late Roman traditions by studying the seven liberal arts. Devoted

to a better understanding of Christian scripture, Alcuin and his contemporaries greatly preferred the curriculum of grammar, rhetoric, and logic known as the trivium while spending less time on the quadrivium—mathematics, geometry, music, and astronomy—perhaps in the interest of speedily training new monks. Alcuin's students were destined to become Europe's next generation of teachers. They may actually have seen him as rather like the romanticized portrait imagined by Longfellow more than 1,000 years later:

> In sooth, it was a pleasant sight to see
> That Saxon monk, with hood and rosary,
> With inkhorn at his belt, and pen and book,
> And mingled love and reverence in his look,
> Or hear the cloister and the court repeat
> The measured footfalls of his sandaled feet,
> Or watch him with the pupils of his school,
> Gentle of speech, but absolute of rule.

Even more than other educated men, Alcuin took a deeply personal interest in conveying ancient wisdom to his pupils. In a letter to Offa, who ruled the kingdom of Mercia in central England, the abbot of Saint-Martin showed a touching concern for his students, revealing a sense of responsibility common to the best teachers in any age:

> Being always eager to carry out your wishes faithfully, I have sent back to you this dear pupil of mine as you asked. Please look after him well until, if God so wills, I come to you myself. Do not let him wander about unoccupied or take to drink. Give him pupils, and give strict instructions

that he is to teach properly. I know he has learned well. I hope he will do
well, for the success of my pupils is my reward with God.

But with friends and former students scattered across Europe, with hundreds of souls in his care, there was never enough time to write to everyone or to tend to everyone's needs, whether spiritual or material. Seven times a day, the tolling of a bell always marked the time for prayers. Later, Alcuin would find a moment to pray for the dearest people in his life—just as, in letter after letter, he promised he would.

Alcuin thought often of his homeland. Born to a noble family and raised in York, a center of British learning, he had twice met Karl during voyages to Europe. Persuaded by the king's charisma and his commitment to Christianity, Alcuin agreed to join the Frankish court in 782, when he was around fifty. The England he left behind held more educated men than Francia, but it was also unstable, and the balance of power between its various kingdoms was shaky at best. During Alcuin's lifetime, his homeland of Northumbria had gone through more than ten kings; most of their reigns had been truncated by coups and assassinations. The Franks looked to England for teachers and missionaries; wisely, they looked elsewhere for political guidance.

Alcuin was, as Karl knew, a "Saxon," but his baptized people in Northumbria bore little resemblance to the pagan kin they had left behind on the continent centuries earlier. Warriors who fought on the Saxon frontier saw the contrast between the serious, cul-

tured abbot, a "new" Saxon from England, and the barbaric Old Saxons—the *aldseaxe* or *antiqui saxones*—to the north. Many Franks had occasion to meet and learn from the educated Christians of England, but not everyone loved them: to the annoyance of the monks under his care, Alcuin was a prime attraction when his former countrymen found themselves in Francia. "O God, deliver this monastery from these Britons," the brothers at Saint-Martin cried, "for, like bees swarming from all around to return to their queen, thus do they all come unto him!"

Alcuin returned home only twice, but his heart stayed close to his native land. In letters that passed constantly between the continent and England, he kept up with the news, commenting on everything from royal affairs to the horrible Viking attack on Lindisfarne in 793. He was appalled by what he heard:

> The greatest danger overhangs this island and the people living in it. A pagan people habitually makes pirate raids on our shores, a thing never heard of before. And the English peoples, kingdoms and kings disagree among themselves. Scarcely anyone is found now of the old stock of kings, and I weep to say it; the more obscure their origin, the less their courage. Similarly, in the churches of Christ the teachers of truth have passed away. Almost all follow worldly vanities and hate the teaching of the religious rule, and their warriors are more interested in greed than in justice.

Alcuin could write these letters to his countrymen and their kings. He could persuade, he could scold, he could advise, and he could encourage. He could also pray. As the bell tolled and fear for his homeland gripped his heart, he hurried to do just that.

While pilgrims gathered and locals baked bread, tended gardens, made candles, and brewed beer, some monks performed the most important labors of all. They scraped the skins of animals with little round knives; applied inks and pigments to each clean surface; and then, with meticulous care, threaded the pages together. They were making books, especially Bibles and biographies of Saint Martin, presented in the Tours style, an easy-to-read layout with clear headings and subheadings.

In a poem posted at the scriptorium, Alcuin reminded his scribes that their work was not to be taken lightly:

> Here should they sit who reproduce the oracles and sacred law, that they may be guarded from any frivolous word for fear that their hands and even they themselves may lose themselves among frivolities; they should strive to render the books which they execute correctly, that their pens may follow the right road.

As Alcuin cleverly noted, a scribe never knew when he himself might need a well-copied book. "It is an excellent task to copy holy books," the abbot concluded, "and scribes do enjoy their own rewards."

But Alcuin himself was busy doing more than just copying books; he was writing new ones, especially manuals on grammar and dialectics, as well as other works, composed in simple Latin and based on ancient sources. In one dialogue on rhetoric, he portrayed himself conversing with Karl about moral virtues; in an-

other, he posed brainteasers to the king's son Pepin. By modern standards, Alcuin's works are rarely original, but eighth-century Christians were more concerned with preserving the past than with creating innovative works. To men such as Alcuin, the end of the world was nigh, but books could still be useful. As "classroom texts," modernized to suit Frankish teaching methods and tastes, they represented the cornerstone of Karl's plan to cultivate knowledge in the service of religion, the Carolingian renaissance still praised by his descendants.

Although ignorant of history's verdict, Alcuin saw early signs of success. With characteristic enthusiasm, he wrote to Karl in 796 to express confidence in his own efforts at Tours:

> I, your Flaccus, am busy carrying out your wishes and instructions at Saint-Martin's, giving some of the honey of the holy Scriptures, making others drunk on the old wine of ancient learning, beginning to feed others on the fruits of grammar, while to some I propose to reveal the order of the stars, like the painted roof of a great man's house. I become many things to many men, in order to train many for the advance of the holy church of God and the honor of your imperial kingdom, that the grace of almighty God may not be idle in me nor your generosity unavailing.

Theodulf, a witty refugee from Islamic Spain who later became bishop of Orléans, teased the more serious Alcuin about his love of "the old wine of ancient learning" in a poem that imagines the great teacher indulging his taste for a far more literal vintage:

> Let father Albinus be seated and pronounce words of wisdom,
> with pleasure taking his food in hand and mouth.
> He may order glasses of wine or of beer

to be fetched, or chance to want both of them,
to make his teaching all the better, so that his pipe has a finer tune,
if he waters the caverns of his learned heart.

Despite his prominence in Karl's intellectual circle, Theodulf was given no affectionate nickname by Alcuin, so the two men may not have been especially close. If that were the case—and so much about the personalities of Karl's confidants is hidden behind letter-writing rhetoric and formalized poetry that no one can know for sure—Alcuin may have smiled, briefly, at Theodulf's gibing. Saint-Martin left little time for grudges. Alcuin had too many intractable students under his own roof, and the world was barely ready for the books his monks were preserving. "I too, however ill equipped, battle daily against ignorance in Tours," he complained two years later in an otherwise cheerful letter to Karl.

But again, whatever doubts haunted Alcuin during his rare moments of quiet were dispelled by that familiar, comforting bell. Leaving behind his wax tablet or scrap of parchment—notes for a biblical commentary or a playful poem addressed to a friend—he hastened to join his monks in performing the work of God.

The work of God also found expression in Alcuin's political life. As an adviser to an increasingly powerful king, he watched as Karl dealt with heathens on the borderlands.

First, there were the Saxons. "No war ever undertaken by the Frankish people was more prolonged, more full of atrocities, or more demanding of effort," wrote Einhard. "The Saxons, like al-

most all the peoples living in Germany, are ferocious by nature. They are much given to devil worship and they are hostile to our religion. They think it no dishonour to violate and transgress the laws of God and man."

As a Christian teacher, Alcuin was following in the footsteps of missionaries from the Anglo-Saxon kingdoms of England who had already made inroads against the paganism of the continent. Decades earlier, the pope had given a sort of field promotion to Boniface, who had served as bishop of missionary churches and monasteries deep within pagan lands. Born with the Saxon name Winfrith in an England that had peacefully transformed its pagan shrines into Christian churches, Boniface and his companions were murdered in 754 while preparing for group baptisms in Frisia. A miraculous fountain was said to have sprung from the place of his martyrdom, and his tomb became a pilgrimage site for the diseased, the blind, and the mentally ill. His holy bones were dispersed among various churches, where their reputation for healing offered the promise of hope in an age of desperate faith.

Mindful of the legacy of Saint Boniface, and the fact that most of Britain and Francia had been pagan just a few generations earlier, Alcuin held out hope that the Saxons could become Christians. However, he opposed his king's methods and often told him so. In 785, a Saxon leader named Widukind came to a Frankish villa and submitted to baptism before Karl, marking a pause in more than a decade of bloodshed. Widukind's baptism was long remembered as a turning point in the Saxon wars, but enmity continued nonetheless. Karl was intent on safeguarding border churches and monasteries while further spreading Christianity; and his Saxon wars also had an economic purpose: the protection of Rhineland trade, which supplied

wines, wheat, and pottery to the north. But after so many years, the fight had become deeply personal and, to Alcuin's mind, counterproductive.

The wars were terrible: Frankish chronicles recount decades of carnage, describing victories over the Saxons accompanied by spectacular miracles—two angelic figures on white horses preventing a church-burning, or flaming shields wheeling through the sky—while defeats were passed over in conspicuous silence. When they could, the Saxons burned Frankish forts and ambushed enemy patrols; when the Franks had the upper hand, they flattened pagan shrines and baptized their foes into a Christian religion that these pagans had no intention of following. "Hardly a year passed," wrote Einhard wearily, "in which they did not vacillate between surrender and defiance."

Harsh new laws followed. Saxons were forbidden to gather in public, and paganism—in fact, any visible contempt for Christian customs—carried a sentence of death. Alcuin saw little hope of conversion under such conditions. "Faith, as St. Augustine says, is a matter of will, not necessity," he wrote to Megenfrith, Karl's treasurer at Aachen. "A man can be attracted into faith, not forced." In a fit of impatience, he added a pointed criticism of his king's policies:

> If the light yoke and easy load of Christ were preached to the hard
> Saxon race as keenly as tithes were levied and the penalty of the law
> imposed for the smallest faults, perhaps they would not react against the
> rite of baptism.

History records at least one massacre of Saxon prisoners, and resistance did not end until years later when Karl forcibly displaced the

Saxons from their lands. Alcuin's reluctant pessimism was prophetic. For the Saxons, the worst was yet to come.

Beyond the pagans who terrorized the borders, it appeared from Alcuin's window at Tours that madness could come from any corner. The Second Council of Nicaea, convened by Irene to restore the veneration of icons, still puzzled and enraged the Franks. Alcuin had no objections to icons per se, but he found them a flimsy substitute for deep religious understanding:

> *Men can understand things without seeing images but not without the knowledge of God. Moreover, it is a very unfortunate spirit which depends on the help of painters' pictures to remember the life of Christ and cannot draw inspiration from its own powers.*

Alcuin and other members of Karl's intellectual circle had no way of knowing it, but they had learned about the Second Council of Nicaea through a botched Latin translation. This inaccurate account led them to believe that their Christian brethren in Constantinople wanted to raise icons to the status of the Holy Trinity, and that the Greeks thought icons should be worshipped like God himself. The notion was heretical; it was also false, as the Franks would later learn.

Unfortunately, the misunderstanding widened the rift between the western church, loyal to Rome, and the eastern church, governed by the emperor in Constantinople. Reunion was unlikely: during the late 780s, Karl had refused to send his daughter Rotrud to Constantinople to marry the young emperor, even though Irene had sent a eunuch to Aachen to teach the girl the Greek language. The two empires had also scuffled over Sicily and parts of the Italian peninsula, including lands that had tumbled out of eastern

hands as Frankish power increased. In just a few decades, too much bitterness had passed between the two Christendoms. The split between Franks and Greeks, between Rome and Constantinople, would soon be beyond reconciliation.

The news that the emperor in Constantinople had been blinded and deposed—not merely by conspirators but by his own mother, who now sat illegitimately on the throne—shocked even the most jaded Franks. They had long found their Greek rivals strangely interesting and rather exotic, if inclined to certain errors. But the news of a woman claiming to be "emperor" made Alcuin's contemporaries wonder: *Have the Greeks finally lost their minds?*

On the other hand, the foolishness of the Greeks was an opportunity for the Franks. By the late 790s, Alcuin was mulling over bold new ideas for Karl and for the future. After all, with a woman claiming the right to rule, was not the imperial throne theoretically vacant?

It was a notion worth exploring—and on late, thoughtful evenings, Alcuin did explore it, making mental notes and envisioning a newer world, as he heard the call to prayer, thought of his brothers' souls, and rose.

When not pondering the Greek problem, Alcuin was dealing with heretics closer to home. During the previous decade, a Gothic cleric named Egila had become involved with Christian heretics across the mountains in Islamic Spain. Their teachings were condemned by Elipandus, the archbishop of the city of Toledo, but in the process of writing up the condemnation, Elipandus had slipped into heresy himself.

The official position of the church was that Christ had two natures. He was a man, but he was also divine—the son of God. However, Elipandus suggested that Jesus had not been the son of God until he was "adopted" by God during his baptism by John the Baptist. This unorthodox notion, which came to be known as adoptionism, was championed by Bishop Felix of Urgel, whose treatise on the matter had shocked Alcuin, Karl, and all Christians who were loyal to the teachings of Rome.

In 794, partially in response to the adoptionist heresy and with the approval of the pope, Karl held a council at Frankfurt. The agenda ranged from condemning price gouging during famines to outlawing bribery and many other sins among churchmen, but the most important matters treated by the Council of Frankfurt were intellectual and theological. In their misunderstanding, the assembled bishops and priests condemned the ruling of the Second Council of Nicaea, but only after opening the assembly by condemning adoptionism in unequivocal terms:

> Whereat, under the first and foremost head, there arose the matter of the impious and wicked heresy of Elipandus, bishop of the seat of Toledo, and Felix, bishop of Urgel, and their followers, who in their erroneous belief concerning the son of God assert adoption; this heresy did all the most holy fathers above mentioned repudiate and with one voice denounce, and it was their decision that it should be utterly eradicated from the Holy Church.

Defiant, Felix continued to promulgate his beliefs and conducted a bitter long-distance debate with Alcuin himself. Typically a voice of confidence and intellectual strength, Alcuin was especially bothered by this intractable heretic, whose ideas held

real allure on the distant Spanish borderlands. At one point, he wrote to Karl, pleading for support:

> *A reply to his book, or rather error, must be considered with great care and needs several contributors. I alone am not enough. Your Majesty must provide suitable contributors for so hard and necessary a task, that this wicked heresy may be utterly suppressed before it spreads widely through the Christian empire which divine goodness has entrusted to you and your sons to rule.*

Despite everything else he had to do, Alcuin found time to write enormous treatises condemning Felix and his heretical writings. Engaging with heretics was ugly work, but Alcuin was the right man for the job: an abbot and teacher for whom correcting others' errors, whether personal or spiritual, was one of the highest callings.

As a servant of the church, Alcuin was satisfied by the role Karl had played in condemning adoptionism; it was just one of the many burdens the king had taken on from his "Rome yet to be." As Alcuin wrote to him in 796:

> *Not only should I, the most insignificant servant of our Saviour, share the joy in your Majesty's welfare, but the whole church of God should give thanks to Almighty God in a united hymn of love, since he has in his merciful generosity given one so good, wise and just to rule and protect the Christian people in this last dangerous period of history, who is to make every effort to correct the wrong, strengthen the right and raise the holy, rejoicing in spreading the name of the Lord God of heaven through many areas of the earth and trying to light the lamp of the catholic faith in distant parts.*

To rule and protect Christendom, to suppress heresy, to strengthen the orthodox, and to spread the faith—these were directives fit not for a mere Germanic king, but for a greater, bolder, more monumental figure.

They were, in short, the responsibilities of an emperor.

I n the letters he regularly sent to Aachen, Alcuin began to refer to the "Holy Empire," and the *Imperium Christianum*, the "Christian Empire." The future, he knew, would be found in empires. Although racked by fevers and the pains of age, the abbot could yet be useful to his king and his church. "In the morning, at the height of my powers," he wrote to Karl in 796, "I sowed the seed in Britain, now in the evening, when my blood is growing cold, I still am sowing in France, hoping both will grow, by the grace of God."

But in Francia—in Europe—it was not evening. The toll of a bell marked daybreak, and with it the time for prayer, and Alcuin hurried to sing, pray, and perform the work of God with all due reverence and dignity. He had an empire to help build—but later. For now, in his own way, just like his king, he too had an example to set.

.4.

DAYBREAK IN THE CITY OF PEACE

Baghdad, A.D. 797–799

The scene was common: north of Baghdad, over one of several monasteries in the region, the sun was rising—or, as a Persian writer later put it, "fair Aurora had laid aside her veil of modesty and the sword of sunrise was drawn from the scabbard of darkness." It had been that kind of night, an evening of immodesty and poetic flourishes, but now bleary-eyed dignitaries staggered home to their fashionable estates on the Tigris. Christian monks cleaned up after them.

The monastery provided a much-needed retreat for restless, citified bureaucrats. They loved the orchards, the vineyards, the

cultivated gardens, the solace offered by a peaceful, enclosed space dedicated to the work and worship of God. At the same time, they also cherished the secrecy guaranteed by the monastery walls, which offered opportunities for an amorous rendezvous and the consumption of wine. Granted, wine was forbidden by Islam, but everyone knew that even the caliph, who ruled the Islamic empire, enjoyed a good wine party. Besides, there were rules of behavior designed to preserve the dignity of such occasions.

On mornings after these wine parties, the monks of Baghdad learned exactly what their guests thought of those rules. The mixture of wine and music is a lethal combination in any age, and the flamboyant poet Abu Nuwas admitted it. "At night," he lamented, "I have often made my camels, exhausted by travel, kneel at a wineseller's door."

As much to their amusement as to their financial benefit, the monks saw that the rowdy courtiers of Baghdad adhered to a rather interesting code. Raucous drinking parties had to take place behind private walls: in polite society, wine with dinner was terribly, irredeemably uncouth.

One could easily seek forgiveness from God, but from one's neighbors? They were an entirely different matter.

On the south side of Baghdad, the Karkh neighborhood came alive with the sound of shoppers and the jingle of silver coins. Everything was for sale in al-Karkh, from the pearls of the Persian Gulf to Chinese silk and Lebanese glassware. The market stands smelled wonderful, like the known world, with peaches from Basra, pistachios from Aleppo, rice from

the great plantations of Egypt, and other delicious edibles. Al-Karkh was the place to find home furnishings, too: clothing, soap, reed mats, Persian carpets, even glass tiles for that discerning decorator who loved the mosaics of Constantinople. At slower moments, vendors and customers alike relaxed upstairs and ate *harisa*, the favorite meat-and-flour dish of Baghdad. Below, a busier world passed by.

Many years earlier, the caliph al-Mansur had moved these markets and craftsmen outside the walls of his Round City—the better, it was said, to protect himself from butchers with sharpened knives. Commerce had hardly stalled as a result; instead, al-Karkh had grown into a dense suburb that was now a city unto itself. At least one resident took sufficient pride in the neighborhood to immortalize it in verse:

> Let the morning clouds shower
> > The dwellings of al-Karkh with
> Continuous rain and every
> > Sort of steady sprinkle,
> Mansions that contain every
> > Beauty and splendor:
> They are superior to every [other] mansion.

The poet neglected to point out the congested markets, the beggars in the back streets, and the sometimes violent feuds with Shiites in the adjacent neighborhood. Perhaps none of that mattered. On Baghdad's canals, merchants from east and west ferried spices and slaves through Jewish and Persian neighborhoods; along the Tigris, Christians swarmed into the fish markets, leaving meager pickings for seafood-loving Muslims.

One could tolerate the thieves, the pickpockets, and the grubby urchins who accosted wide-eyed foreigners. Those problems were simply part of life in a fast-growing boomtown at the center of the civilized world. From bathhouses to bookstores, God's plenty was to be found in al-Karkh. The merchants here knew it: when a man was tired of al-Karkh, he was tired of life.

I n the ritzy Harbiya suburb of northwest Baghdad, the families of soldiers started each day with expectant prayers. In summer, they awoke in their cool basement apartments, or on their rooftops within sight of the Round City, where they greeted the dome at the hub of their city.

As a boy, the current caliph, Harun, had led their fathers and husbands to the frontiers against the Rum, the so-called Romans of Constantinople, the ones whom poets called *al-asfar,* "the yellow ones." More recently, they had been paid to quash local rebellions, commanding armies in the service of the caliph. In a caliphate that stretched from northern Africa to India, there was a constant market for well-armed men. Praised by their contemporaries in story and song, these generals rarely lacked for work.

The comfortable estates of Harbiya had been built on that same military might. Only a few generations earlier, these soldiers had stormed out of the eastern province of Khurasan, bringing to power the descendants of al-Abbas, the uncle of the Prophet Muhammad, in a show of force and a flurry of black banners. The Abbasid caliphs had rewarded the Khurasanis with desirable land and jobs for their children, who now commanded the palace guards and ran the police force.

Few of them ever actually saw the caliph. They glimpsed the green dome that loomed above the palace and mosque at the center of the Round City. They saw government workers, draped in black, striding through the streets. They even heard about neighbors and friends who entered the Round City on official business. But the elite in Baghdad rarely saw Harun ibn Muhammad ibn Abdallah ibn al-Abbas, known as al-Rashid, "the upright" or "the orthodox."

For more than 1,000 years, the reign of Harun al-Rashid was enshrined in the legends and literature of the Middle East. His name became so associated with the golden age of Baghdad that even nineteenth-century Europeans knew him through his mythologized role in *The Arabian Nights*. But after the year 172—the year 789 by the reckoning of the city's Christians—Harun, *khalifat rasul Allah*, "representative of the emissary of God"; and *amir al-muminin*, "commander of the faithful," was gone. Declaring Baghdad a "steamy place," he sought new homes elsewhere, and he rarely returned.

For all practical purposes, by his mid-twenties, Harun al-Rashid had left the Round City of Baghdad behind.

I t is as though it was poured in a mold and cast," wrote the essayist al-Jahiz of the Round City. It had been built by Harun's grandfather, the caliph known as al-Mansur, "supported with victory," who had chosen a brilliant site for his new capital. The locals supported the idea of rule by the family of the Prophet, and the sparse population meant that the caliph could reward the loyal with cheap land. The area had a famously rich

soil: the *sawad*, or "black land," that other cultures—the Assyrians, the Babylonians, the Sumerians, and the Nabataeans—had found conducive to irrigation and agriculture. The site also offered easy access to and from Arabia or Khurasan by land, and one could come and go both north and south by boat along the Tigris.

Here in the year 145—762 by Christian reckoning—on the west bank of a bend in the Tigris, Mansur first traced the outline of his remarkable Round City:

> *It is said: When al-Mansur decided to build Baghdad, he wanted to see*
> *for himself what it would look like, so he commanded that its outline*
> *be drawn with ashes. He then proceeded to enter through each gate and*
> *to walk among its outside walls, its arched areas, its courtyards, all*
> *of which were outlined in ashes. He made the rounds, looking at the*
> *workmen and at the trenches that had been sketched. Having done that, he*
> *ordered cotton seeds placed on this outline and oil poured on it. Then he*
> *watched as the fire flared up, seeing the city as a whole and recognizing*
> *its full plan.*

Mansur's city was a marvel: a series of perfectly circular walls surrounded by a moat, guarded by towers, and entered through four grand gateways. At the core, beyond rows of defenses, government offices, and arcades, was an open courtyard where visitors found the central mosque and palace. Above them, the famous green dome rose high into the air. Outside the gates, the suburbs had quickly engulfed the Round City in a frenzy of commerce, land speculation, and hasty development.

Mansur called his creation the Madinat al-Salam, the "City of Peace," but the name never took hold. For centuries afterward,

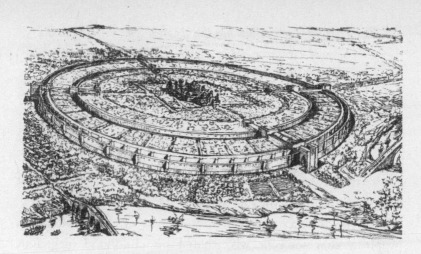

Using written descriptions by Muslim historians, illustrator Abdelmuttalib Fahema created this visual reconstruction of al-Mansur's magnificent Round City.

through invasions, civil wars, and utter destruction, the city kept its ancient name, a reminder of one of the original villages on the site: Baghdad.

The location of the new city also had historical resonance. The ghosts of the ancient capitals of Akkad and Babylon haunted the region, and the ruins of Ctesiphon, the old Persian capital, were only twenty miles southeast. By selecting such an auspicious site, Mansur ensured that his capital would evoke the authority of those ancient empires. Round cities had been common among the Sassanian Persians, and the green dome, which recalled similar domes in earlier capitals, meant that the Abbasids were now firmly in control.

The dome also had wondrous powers, according to one credulous commenter:

I heard a group of scholars mention that the green dome was surmounted
by the figure of a horseman holding a lance in his hand. If the Sultan
saw that figure with its lance pointing to a given direction, he knew that
some rebels would make their appearance from there; and before long
word would reach him that a rebel had appeared in that direction, or
something to that effect..

Later writers derided this tale as nonsense, but it was true that
Mansur had invoked the supernatural in founding his new capital.
The monks from a nearby Christian monastery had told him of a
prophecy that someone who shared his childhood nickname,
"Miqlas," would build a city nearby. Mansur had also consulted
with numerous scholars, including Masha'allah, a prominent Jew-
ish astronomer from Basra, to determine the proper date to found
the city. For Muslims, Christians, and Jews, as well as for Persians,
Arabs, and other descendants of ancient kingdoms, the message
was clear: the Abbasids had been ordained by God, by the stars,
and by history. Their rule had the mandate of heaven and of his-
tory; it was not to be questioned.

As for Mansur himself, it was said that before the founding of
the new capital, the caliph had lived in a tent. Baghdad soon be-
came a cluster of mansions and palaces, but the habits of old war-
riors die hard. Despite access to every luxury, Mansur slept in a
nearly bare chamber and kept a tent in a courtyard, stunning visi-
tors with the austerity of his surroundings.

Meanwhile, beyond the walls thrived a bustling modern capi-
tal, praised by poets:

Have you seen in all the length and breadth of the earth
 A city such as Baghdad? Indeed it is paradise on earth.

Life in Baghdad is pure; its wood becomes verdant,
 While life outside of it is without purity or freshness.

Another commenter writes:

> *In the entire world, there has not been a city which could compare with*
> *Baghdad in size and splendor, or in the number of scholars and great*
> *personalities. The distinction of the notables and general populace serves*
> *to distinguish Baghdad from other cities, as does the vastness of its*
> *districts, the extent of its borders, and the great number of residences and*
> *palaces. Consider the numerous roads [darb], thoroughfares [shari],*
> *and localities, the markets and streets [sikkah], the lanes [aziqqah],*
> *mosques and bathhouses, and the high roads [tariq] and shops—all of*
> *these distinguish this city from all others, as does the pure air, the sweet*
> *water, and the cool shade. There is no place which is as temperate in*
> *summer and winter, and as salubrious in spring and autumn.*

This was Mansur's monument, the city that his grandson Harun abandoned. The high-towered walls of the Round City looked sturdy enough to foreign eyes, but they would soon prove surprisingly fragile. It was not yet time for Harun's sons to battle each other for control of the caliphate, brother against brother. The city suffered terribly in the siege that resulted, and generations of storytellers lamented the tragic civil war.

Fleeting though they were, these glorious days of Baghdad would never be forgotten. "It reached its highest point in buildings and population during the reign of ar-Rashid," wrote one commentator three centuries later, "since there reigned quiet and the utmost prosperity in the world." The city traced in ashes and flame would soon return to both—but for now, the people of

Baghdad prospered, safe between their mosques and markets, confident even in the absence of the caliph that this golden age, this time of prosperity and peace, would last forever—God willing.

T he city Harun spurned was only thirty years old—barely as old as the caliph himself—but the caliphate that surrounded it was solidly established. In the 165 years since the death of the Prophet Muhammad, Islam had spread with miraculous speed. Impelled by jihad, Muslim armies had pushed through Africa and then into Europe by way of Spain. They had even reached Francia, only to be stopped by Karl's grandfather, Charles Martel, known as "the hammer" after Judas Maccabeus, "the hammerer" in the Old Testament. Charles Martel united squabbling warlords and famously repelled the Muslims some 200 miles southwest of Paris near Poitiers, "scattering them like stubble," wrote one Frankish chronicler, "before the fury of his onslaught."

Although European Christians had successfully defended themselves, Islam soon extended not only throughout Arabia but also to northern Africa and lands that today encompass Egypt, Syria, Iran, Afghanistan, and parts of India, bringing cities such as Jerusalem and Cairo under Muslim control. In their first great empire, the Umayyad caliphate, Muslims and Arabs had been the minority; and across the Islamic world, travelers still met Christians, Buddhists, Jews, Zoroastrians, and a few old-timers who clung to desert paganism. But Muslims were becoming a majority, and the lives of non-Muslim subjects grew increasingly inconvenient. Since the Umayyad era, Christians and Jews had been forced

to cut their hair short above their foreheads to distinguish them-
selves from Muslims. Late in Harun's reign, Christians and Jews
were ordered to wear special bands or patches on their clothing
and distinctive sandals and sashes, precursors to much worse treat-
ment in the centuries to come.

But for now, despite these policies, few people in Baghdad
cared much about their neighbors. Tolerance is easy in prosperous
times.

Expatriates from Constantinople as well as many Greek-
speaking Arabs still dwelled in Baghdad, living reminders of con-
quered lands. They had their own neighborhood, Dar al-Rum,
and many worked as translators. In early days, they had run the
Islamic bureaucracy; but it was now another conquered people, the
Persians, who kept the caliphate functioning smoothly. Arab con-
querors had crushed the Persian Sassanid empire 150 years earlier,
but the caliphs had replicated their brilliant administrative elite: a
proud, highly educated corps of secretaries known as the *kuttab*. It
helped that Muslim armies had captured Chinese paper makers
four decades earlier, allowing for the inexpensive paper that Ha-
run wisely adopted as the coin of the bureaucratic realm.

The subjects that an aspiring member of the *kuttab* needed to
master were daunting: linguistic, literary, and religious training;
geometry for land surveying; the principles of irrigation; basic
astronomy; standards of measure; bridge and waterwheel con-
struction; an understanding of the tools of artisans and con-
struction workers; and the principles of accounting. Inspired by
Mansur, they became patrons of the arts and learning, funding
translations of medical and scientific texts from Greek into Ara-
bic and holding exclusive parties to present the great poets of
Baghdad. In his treatise *A Letter to Secretaries*, the tenth-century

writer al-Jahshiyari describes the *kuttab* as "men of culture and virtue, of knowledge and discernment" who were placed in their positions of trust and authority by God Himself. One saying attributed to the Prophet Muhammad even compared skilled record-keepers to angels in heaven. As the masters of literacy in Abbasid Baghdad, the *kuttab* could ensure that their indispensability was recorded for all time and endorsed by the highest authorities.

Looming over the *kuttab*, and indeed over all of Baghdad, was one family: the Barmakids. Poets praised their authority and their generosity. They were paid to do so:

> *How can you fear any misfortune in a place*
> *which the Barmakis, the munificent ones, have encompassed with their*
> *protection?*
> *And a people who include al-Fadl b. Yahya,*
> *a group of warriors who hurl themselves into the fray and whom no*
> *other group can withstand?*

The same poet also noted, without judgment, the family's predictable ambition. "When one of the Barmakis reaches the age of ten years," he wrote, "his ambition is to become a vizier or an amir." The vizier, chief adviser to the caliph, ran the civil service and was, in essence, the government personified. Like an entire family of viziers, the Barmakids dominated the caliphate during the reign of Harun, and all of Baghdad lived in the shadow of Harun's wise old mentor, Yahya ibn Khalid ibn Barmak.

Yahya's father, Khalid, had been born to a prominent family in what is now northern Afghanistan; their surname, Barmak, was

the title granted to the protectors of a major Buddhist shrine. At some point, the family had converted to Islam and Khalid had become a major financier of the Abbasid revolution—and, soon after, the economic mastermind of the new Abbasid government. Khalid also played a major role in the construction of Baghdad, and the round, Persian-inspired design may have been his idea. His son, Yahya the Barmakid, had counseled the teenage Harun on his first summer raids against Constantinople and served as the boy's tutor and mentor. After the caliph died, the young Harun called the old man "father."

Although their story is lost in myth and poetry, the Barmakids were clearly intertwined with the Abbasids in complex ways. Yahya's sons Fadl and Jafar quickly rose to prominence. The flamboyant Jafar was the close friend who shares Harun's adventures in the pages of *The Arabian Nights;* Fadl was thought to be confident and more responsible. The brothers moved from one prestigious job to another at the whim of the caliph—governorships, military commands, the vizierate, authority over countless lives—but they also had the dubious honor of grooming the caliph's sons for succession. Most people saw them only when they needed to petition the government, but the Barmakids' wine parties and literary salons were the talk of Baghdad. Picture them in their black-tailed turbans, raising a cup of wine, laughing with their friends, enjoying a rousing musical performance, secure in the knowledge that they are the elite: feared, admired, praised, and loved.

In a few years, in an incident that will shock the average Baghdadi and forever baffle historians, Harun will destroy them all.

Yahya and his son Fadl will be arrested. Jafar will be executed in the middle of the night; his dismembered body will hang from

a bridge in Baghdad. Harun will confiscate all of the Barmakids' belongings and arrest their closest confidants. The poets they patronized so liberally will lament their downfall.

Speculation will fly. Some people will tell the improbable tale that Jafar had married Harun's favorite sister Abbasa as a formality so the girl could join their drinking parties without arousing scandal. According to this rumor, Harun became infuriated on learning that his confidant and his sister had become more than friends. Like many stories about Harun and Jafar, this one will never be confirmed, but it will be remembered and enshrined in *The Arabian Nights.*

But for now, the Barmakids were still makers of manners, feasting on delicacies by lamplight and running the Abbasid caliphate, oblivious of their fate. In the end, no one would ever know why Harun destroyed his foster father and his closest friends, except for Harun himself. And he, as usual, was nowhere to be found.

Anyone seeking Harun could follow his trail of abandoned palaces and find him, finally, in Raqqah.

Located on the Euphrates in what is now Syria, Raqqah was built atop Callinicum, an old Roman site that had merged with a newer settlement called Rafiqa, "the partner." Harun's new home was hot, especially in the summer, but its location offered easy access to Baghdad, and it was an excellent place to amass troops before summer raids against the Rum. The caliph of Baghdad scarcely expected to topple the towers of Constantinople, but he saw the summer campaigns as opportunities to demon-

strate his religiosity. His subjects could do the same; they could flock to the western frontier to spread Islam, or die trying. The bunkers that guarded the no-man's land between the Islamic caliphate and the borders of the "yellow ones" were vital military installations, but for the most fervent of holy warriors, they were also religious retreats.

Since his youth, Harun had led numerous raids against the Christian empire of Irene. Those summer campaigns obsessed him. Like his subjects, the caliph admired his Greek-speaking neighbors for their craftsmanship and technical skill. Islamic tradition suggested that the Rum were descended from Esau and thus related to Abraham, but they were, alas, infidels. Harun could take special pride in the humiliating annual payments he had wrested from Irene after his forces had lingered threateningly around the Bosporus. That campaign had earned the teenager the title al-Rashid and a reputation for doing the work of God. By the time Harun moved to Raqqah, he had made the pilgrimage to Mecca several times, and he would make it three more times before he died. He was said to have bowed in prayer 100 times a day—unless he was sick, in which case he gave money to the poor.

But sometimes, poetry called, and even the paragon of Islamic orthodoxy wandered from the straight path. His culture had mixed feelings about such entertainments. "Poets are followed by erring men," warned the Holy Quran. "Behold how aimlessly they rove in every valley, preaching what they never practice." The Prophet Muhammad had expressed mixed feelings about poets, declaring them a source of wisdom on one occasion but commenting another time that "it would be better for a man to have his belly filled with pus until it destroys him than to fill himself with poetry." The best poets spent time in the desert among the

bedouin to hone their eloquence and purify their Arabic, and sometimes the bedouin themselves came to Harun to feed his ego with words of praise. On one occasion, a poet who called him "the protective shelter of the cupola of Islam" left court with seven robes of honor—and 100,000 dirhams richer. Tales of star-crossed Arabian lovers and the Prophet's Companions were still reliable standards, but fashions shifted, and so did tastes. Salons resounded with adventures told in Persian styles; and Harun's favorite poet, al-Abbas ibn al-Ahnaf, beguiled him with tales of unrequited love.

When Harun's thoughts returned to religion, he summoned the famous hellfire preacher Ibn al-Sammak. On one occasion, the caliph requested words of religious wisdom, and Ibn al-Sammak replied:

> *"O Commander of the Faithful, fear God, the Unique One who has no partner, and know that on the morrow you will be standing before God your Lord, and then consigned to one of the two future states—there is no third one—either paradise or hellfire."* . . . *Harun wept until his beard became damp with tears.*

But such grim asceticism was not always to the caliph's tastes. Harun was noticeably irked when a poet named Abu al-Atahiyah, the "father of craziness," abandoned his bohemian lifestyle; donned coarse clothing; and composed only stark religious poetry about death, poverty, and earthly transience. Harun imprisoned him, hoping in vain to wring love songs from him again.

Such was the measure of Harun's world. He loved to hunt, play polo, and plan large-scale war games. During the summers, his afternoon naps were anything but humble; on hot afternoons, he

slept in a perfumed tent with seven slave girls. The caliph had more than 2,000 girls in his harem, two dozen of whom had borne him children. Their training in the singing schools of Medina prepared them to engage the discerning gentleman in religious discussion, a game of chess, or sport of a considerably more intimate nature.

Left to pursue his whims and to plot against the Romans, Harun had little to worry him. As long as his government could tax the provinces to pay for poets, palaces, and the Islamic navy, the caliph was content. When duty called, he rode into battle or made the pilgrimage to Mecca; otherwise, he quietly enjoyed his world of earthly delights. He delighted in the company of his pious and wealthy cousin Zubayda, who was also his favorite wife and the mother of his heir apparent. His friends all came to him, among them the physician Jubrail bin Bakhtishu, who dined with him nightly; and Ibn Abi Maryam al-Madani, a storyteller and legal expert who lazed around the palace and haunted the harem. Back in Baghdad, the bureaucracy ran itself. The army crushed rebellions wherever they arose.

His mind and body adequately occupied, the caliph probably gave little thought to the politics of Christian Europe. His western horizon ended, for all practical purposes, at Constantinople— even if he did have occasion to think, very rarely, of a far-off king named Karl.

Harun's advisers watched the west. They saw that the divide between Rome and Constantinople was widening and that the Franks were reclaiming Italy from

the emperors. Only Slavic barbarians separated the Franks from the Greek-speakers, and the two were often on the verge of war. If Karl continued to expand his holdings to his east and south, thus weakening the Rum, the Abbasids would benefit. Clever men in Baghdad safely concluded: *We and the Franks have a common enemy.*

In addition, Harun probably knew by now about the great Frankish military catastrophe of two decades earlier: how 'Abd al-Rahman, the last survivor of the Umayyad dynasty, had sought to conquer Spain from his base at Cordoba; and how Karl, seeking exotic allies, had agreed to join the rulers of Saragossa and Barcelona against him. Karl had led a massive army into Islamic Spain— al-Andalus, as it was called then—and conquered Pamplona; but by the time he arrived, the political situation had changed, and the locals no longer needed him. During the journey home through the Pyrenees, the Franks were ambushed by Basques at a pass called Roncesvalles. Karl suffered one of the worst military defeats of his life and lost several friends as well. On that day in the mountains, King Karl of the Franks learned to stay out of Spain.

Karl's failure hardly concerned Harun, but the caliph and his men knew a useful ally when they saw one. The Franks and the Abbasids had long been aware of their common concerns regarding the would-be caliphate in Andalusia. Shortly before his death, Karl's father, Pepin, had sent messengers to Harun's grandfather, Mansur. The caliph had graciously replied with gifts. Then as now, the caliphate sensed opportunity: *This Christian king is willing to deal with our rivals in Andalusia. And befriending him costs us nothing.*

Harun knew little about Karl. He had no idea that, like himself, Karl had been the favorite son of a shrewd mother and, like himself, he had become king after the suspicious death of a brother.

Just as Karl's mother had helped her son to politically isolate his brother Carloman, so had Harun's mother conspired against his own elder brother, Musa al-Hadi. Musa and Harun—"Moses and Aaron." The biblical echoes would have amused Karl, and probably Alcuin as well.

Conducting foreign policy in the eighth century was slow and uncertain. Kings, caliphs, and emperors never met; and even though Harun had beheld the walls of Constantinople with his own eyes, Irene glimpsed him only from a far-off window or rampart, if she saw him at all. Rulers relied on messengers and diplomats, despite the difficulty of travel and the risk of miscommunication. "How much blood has been unlawfully shed because of ambassadors!" the ancient Persian ruler Ardashir I was said to have lamented. "How many armies have been slaughtered, troops routed, women violated, riches looted and covenants broken because of the treachery and falsehood of ambassadors!"

Imagine the impossible: a meeting between Karl the Great and Harun al-Rashid, two distant and inscrutable figures, both of them destined for storybooks. At first, Harun is unimpressed by this Germanic king from the jungles of Europe—for what civilized man speaks so roughly and wears a moustache with no beard?—but after too much wine at a lush monastery, a few shared tales of hunting and war, and commiseration over family politics, border defenses, and the competing demands of scholars and merchants and monks, even the shy and pious Harun concludes: *This barbarian, this Karl—he and I have much to talk about.*

The reality was less romantic. Harun was settling into his mid-thirties at Raqqah, draping himself in golden-figured garments, playing chess, planning wars, and taking fine meals with his friends. He barely noticed as African slaves lavished the dinner table with spiced meat, cups of his favorite gazelle milk, or sherbet made from ice brought down from mountain peaks.

Why think of Europe? The caliph's mind was on slave girls and summer raids, on his next two-month pilgrimage to Mecca, on his next game of polo and the poets of the moment. He had no reason to bother with Frankish kings or conflict in foreign lands.

Unless, of course, a messenger arrived.

.5.

THE MERCHANTS
OF ASHKENAZ

Francia, A.D. 797–799

The rivers of Europe flow down from the mountains and out to the seas. The Rhine, alive with legend and myth, runs north through Germany and then west through the Netherlands, where it meets the North Sea. The Saône flows southward through France to connect with the Rhône, which ends at the open Mediterranean. Even the Danube rolls eastward, through Bavaria and Austria and into eastern Europe, its final destination the Black Sea and the immensity of Asia beyond.

By the third century after Christ, against the push of rivers, Jews came to western Europe, making new homes in the old

Roman province of Gaul. When armed legions marched through the river valleys, Jews came with them, some serving as soldiers, far more following as merchants and traders. They endured as Christians came and Rome crumbled into kingdoms. They lived through the invasions of Germanic tribes, and they dealt with chaos before the conquest of the Franks. They saw Gaul become Francia and they saw Francia change hands, too. Now, at the end of the eighth century, they watched from the riverbanks as the ships and their king, Karl, sailed swiftly past.

Isaac, Karl's Jewish envoy to Baghdad, probably lived along one of those rivers. He certainly lived among Germanic-speaking Christians, perhaps in Cologne, Mainz, Trier, or Aachen. He dressed and talked like his neighbors, and he looked like a Christian to unaware foreigners. Perhaps he wore a beard, as clean-shaven churchmen and mustachioed nobles would not—but then, beards were common among Christian merchants and farmers. In Francia, in public, he certainly seemed comfortable in his homeland.

But in private, with his family, Isaac did not call his homeland Francia at all. Mindful of the name of a descendant of Gomer in the Book of Genesis, and for reasons that later generations would never be able to explain, he and other Jews called northwestern Europe by another name entirely. Today, the millions of Jews descended from Isaac, his family, and a few thousand Carolingian Jews still know it: the land of Ashkenaz.

Jews surely appear less often in eighth-century records than they did in real life, surfacing briefly in letters, proclamations, biographies, and law codes. A few archaeological finds—a fourth-century tombstone in a Jewish cemetery at Mainz, or ninth-century Hebrew tomb inscriptions in southern Italy—offer tangible re-

minders of their distant lives. In later centuries, Jews created books and letters that lasted into the present; but so little Judaica survives from Karl's reign that at first glance his era seems like a dark age for European Jews. In reality, the opposite was true: Karl's era was as near to a golden age as they would ever be able to enjoy.

A n eighth-century merchant, hauling his wares through the mountains or steering his barge around bends in the Rhine, lived in the best of times, although he hardly thought so. Like most people in any era, he was focused on the things he couldn't do. As a Jew, he was nagged by the authorities, who demanded that he run his business in public rather than from his home. At a time when human beings were commodities from Britain to Baghdad, he was forbidden to own Christian slaves. He was also discouraged from working those slaves, the ones he couldn't own, on Sundays.

He would meet other merchants in small-town markets, where they swapped tales of trouble and pondered trade prospects. As importers and exporters, they profited from international stability, but they expected uncertainty—and in 797, they were right to do so. To the south across the Pyrenees in Spain grew increasingly powerful Muslim kingdoms, and these kingdoms' own future was far from clear. With northern Africa ruled by the Abbasid caliphate in Baghdad—"Persians," the Franks called them—Mediterranean commerce was stifled and sparse. To the northeast were the Saxons, the bane of Karl's existence; and travelers from colder climes told of Viking ships that cast grim shadows on northern coasts. The south had problems of its own, as stories spread about Leo,

the new pope. The rumors from Rome were vague, but their tone was consistent. Something about this pope was odd.

Even within Francia, the day-to-day grind could be tense, tedious, or fraught with ethnic strife. The clergy dreamed of a kingdom united in Christ, but a Jewish trader saw the reality. Karl's empire was a dizzying assortment of tribes and ethnicities, among them the Lombards, the Bavarians, the Alemannians in southeast Germany, and the Frisians along the northern coast; and each group clung faithfully to its own laws. Not all justice was tribal: in the south of France, where the memory of Rome was powerful, many still lived by the laws of the fourth-century emperor Theodosius.

Across Europe, the cracks were already beginning to show. In Aquitaine, the courtiers of Karl's son Louis conversed in a Romance dialect descended from Latin and destined to become French. Elsewhere, the Germanic languages that would evolve into Dutch and modern German were taking firm root. A ninth-century phrasebook offers colorful evidence of the difficulty encountered by Romance-speakers when they traveled in Germanic-speaking lands. Phrases such as *Guar is tin quenna?* ("Where is your wife?") and *Gueliche lande cumen ger?* ("Which country do you come from?") clearly reflect genial, practical conversations. Others, such as *Undes ars in tine naso* ("A hound's ass up your nose") suggest that not all encounters were quite so polite.

All educated men, few though they were, spoke Latin; but a Carolingian Jew, the unknowing witness to the birth of Europe, might have wondered in what sort of "empire" could travelers from opposite ends scarcely understand each other. Jewish merchants carried leather from Andalusia, haggled over Egyptian ivory at Arles, and bartered for wheat in Frisia; yet wherever they went they

saw the faces of merchants, warlords, abbots, and slaves. All of them were officially subject to Karl; none of them trusted their neighbors.

An idyllic place? The merchants would have chuckled. How could such contentious times ever be considered a golden age?

I n Baghdad, if not in Europe, observant men noticed that European Jews were prosperous and well traveled. In *The Book of Ways and Kingdoms,* an early ninth-century writer, Abu al-Kasim Obaidallah ibn Khordadhbeh, explained the practices of the Jewish merchants he called al-Rhadaniya:

> *These merchants speak Arabic, Persian, Roman (i.e. Greek and Latin), the Frank, Spanish, and Slav languages. They journey from West to East, from East to West, partly on land, partly by sea. They transport from the West eunuchs, female slaves, boys, brocade, castor, marten, and other furs, and swords.*

Ibn Khordadhbeh describes how the Rhadaniya sailed to Egypt and then traveled by camel to Islamic cities such as Medina and Jeddah en route to India and China:

> *On their return from China, they carry back musk, aloes, camphor, cinnamon, and other products of the Eastern countries to al-Kolzom and bring them back to Farama, where they again embark on the Western Sea. Some make sail for Constantinople to sell their goods to the Romans; others go to the palace of the King of the Franks to place their goods.*

Ibn Khordadhbeh also claims that some of these "Radanite" merchants conducted the entire journey by land, traveling through the Slavic territories of eastern Europe all the way to the Far East. Remarkably, the term he uses hints at the fact that these Jewish merchants originated not in Asia or the Middle East, but in Europe. The Arabic *al-Rhadaniya* was probably a translation of the Latin *Rhodanici*—the people of the Rhône.

One anecdote about Karl offered by a monk named Notker the Stammerer shows the extent of Jewish trade in and around Francia. The story itself is highly questionable, but Notker's background details suggest that eighth-century seas were filled with traders—Jews and others—and with dangers as well:

> *Once, while Karl was traveling, he came unannounced to a certain coastal town on the southern shores of Gaul. While he was taking his supper in disguise, a raiding party of piratical Northmen made for the port. When they saw those ships, some said that they were Jewish merchants, others that they must be African or British, but upon observing their formation and their speed, wisest Karl knew that they weren't merchants but enemies. He said to them: "Those ships do not carry wares, but they do bring murderous foes."*

Jews did live along the Mediterranean coast in towns such as Narbonne and Marseilles. They also lived in southern Italy, where they had thrived after leaving the Middle East during the first two centuries of the Christian era, either voluntarily as entrepreneurs or as captives after failed revolts.

Stories such as Notker's conjure up stirring scenes of mariners steering their spice ships through sheets of foam while dodging Vikings and pirates, or of Germanic-speaking Jews

guiding camel trains through mountain passes toward exotic markets in China. The image is romantic, if misleading; not every European Jew was a Radanite. Although the church's control of landholding limited Jewish involvement in agriculture, the Jews of Francia served in the army alongside Lombards and Saxons and other eighth-century ethnicities. They bought the staples of their diet from Christian merchants, and Christians bought wine from them, sometimes for religious rituals. Jews managed the estates of bishops and abbots; they owned businesses such as orchards and mills; and they were involved in a wide range of essential pursuits, from the curing of leather to the practice of medicine. At the end of the eighth century, the Jews of Ashkenaz lived with Christians, and the Christians of Francia lived with them. They were crucial to the economy and vital to Frankish culture.

A thousand years of European history would overshadow their perfectly average lives.

Today, we can only imagine the bustle of medieval Aachen or the eerie stillness of an eighth-century night. Likewise, many of the activities of Jews in Karl's kingdom are lost to history. If they came to Aachen as merchants, vintners, or rabbis, they left few traces. Only small stories offer thirdhand glimpses of how they lived and who they may have been.

One legend credits Karl with inviting an Italian rabbi named Kalonymus to settle in Mainz, where his descendants became some of the most prominent Jews of later centuries. The Talmud, which codified Jewish law and moral teachings, would be unknown

in Francia for two more centuries, so Ashkenazi Jews relied on the Latin Bible and oral tradition. Little by little, a Hebrew renaissance in southern Italy was pushing north. Karl may have even encouraged it.

In a more specific story meant to show Karl as the conscience of the church, Notker tells of a bishop who was duped by a Jewish merchant—at Karl's request:

> There was a certain vainglorious bishop who was overly attached to all sorts of inane things. The most sagacious Karl learned of this. He instructed a Jewish merchant, who often visited the Holy Land and was accustomed to return from afar by sea with many precious things, to deceive and amuse himself with the bishop however he pleased.
>
> Understanding his intent, the merchant embalmed a house mouse with various spices and then brought it to the bishop for sale, claiming that he had brought from Judea this most precious creature that had never been seen before. The bishop was so filled with delight that he offered three pounds of silver in order to buy this incredibly valuable thing.

Feigning outrage and a need to recover procurement costs, the Jewish merchant raised the price of the mouse several times until the bishop parted with a pile of silver. The merchant then delivered the silver to Karl, who chose a fine time to make an example of his proud and greedy bishop:

> Not long afterward, the king called all the bishops and nobles of that province to a council. After many unavoidable delays, the king commanded all the silver to be brought and placed in the middle of the palace. Then he made this pronouncement, saying: "You fathers and caretakers of our church, yours is to minister to the poor, or rather to

Christ through the poor, not to cleave to inane things. But now, on the contrary, you turn your thoughts to luxuriousness and greed even more than other mortals do."

Then he added: "One from among you has given this much silver to a Jew for one simple, painted house mouse."

That bishop who had been so shamefully deceived threw himself at the king's feet and begged forgiveness for what he had done. The king gave him the scolding he deserved and then let him wander away perplexed.

Like many of Notker's stories, written seventy years after Karl's death, this anecdote seems implausible, and the monk is curiously unwilling to name names. However, the tale does hint at a close working relationship between Karl and the Jews of his kingdom. The story is also an embryonic version of the stereotype of the crafty Jew, which would soon become all too common in Europe, with tragic results. Three centuries after the immigration of Kalonymus and his family, many of the rabbi's descendants were murdered in the anti-Jewish riots of the First Crusade. The later Middle Ages would not be kind to European Jews; nor would the centuries that followed.

In the relative safety of the eighth century, not even the most pessimistic rabbis foresaw that dire future for Frankish Jews. Tight-knit communities flourished in Karl's kingdom, where Jews worshipped in their own synagogues and ran their own schools, health clinics, bakeries, and courts. A rabbi oversaw each *kehillah*, or community, hearing civil cases and serving as an authority on religious law. Just as Lombards, Saxons, Bavarians, and other non-Franks lived by their own laws, so did Jews, who had the additional benefit of their ancient pedigree as Romani, citizens of the long-gone Roman empire.

Near the end of his reign, when Karl devised methods for settling disputes between groups that followed different laws, he formulated special mechanisms for Jews. When a Jew appeared in a Frankish court after the year 809, he wrapped himself in a cloak, gripped the Torah, and recited—preferably in Hebrew, but possibly in Latin—a customized oath:

> So God may help me, the God who gave the law to Moses on Mount Sinai, and so that the leprosy of the Syrian Naamen may not come upon me as it came upon him, and so that the earth may not swallow me up as it swallowed up Dathan and Abirom, in this case I have done no evil against you.

Accommodation of Jewish culture runs contrary to modern assumptions about medieval Europe, but for eighth-century Christians, Jews were simply a fact of life. Judaism appears to have aroused more curiosity than hostility in the average Frank, and some Christians preferred the eloquent sermons of local rabbis to their regular priests, much to the annoyance of European bishops. They also knew that Jews enjoyed a genuine feast every Friday and actual rest on the Sabbath, two highly attractive prospects to bone-weary laborers. The Jews of Francia circulated books critical of Christianity and sometimes won over converts, from among not only their own servants but also their neighbors, giving Christian clergymen persistent heartburn.

Some conversions were surprisingly prominent. In 839, during the reign of Karl's son Louis, an imperial chaplain named Bodo shocked the court when he suddenly converted to Judaism and ran off to Spain. One Frankish chronicler lamented Bodo's scandalous behavior:

He had himself circumcised, allowed his hair and beard to grow long,
changed his name, and boldly assumed the name of Eleazar instead.
He girded himself moreover with a soldier's belt and joined himself in
marriage with the daughter of a certain Jew. His nephew, who has been
mentioned, also went over to Judaism after pressure had been brought to
bear on him.

To any observer in eighth-century Francia, Judaism seemed to have a bright future in northwestern Europe. Writing a generation after Karl's reign, Archbishop Agobard of Lyon was especially perturbed by this prospect, as well as by signs that conversions in Francia were a decidedly one-way affair:

While we, with all the humanity and goodness which we use toward
them, have not succeeded in gaining a single one to our spiritual beliefs,
many of our folk, sharing the carnal food of the Jews, let themselves be
seduced also by their spiritual food.

Agobard made it his mission to preach against the sins of Jews in his diocese: their purchases of Christian slaves, their working the slaves on Sundays, their feasting with Christians during Lent, and their sale of food and wine to Christian neighbors. He was not alone. Around 770, Pope Stephen had written to the archbishop of Narbonne to complain about the city's wealthy Jewish population, who were accused of slandering the faith of their Christian servants.

"Can light consort with darkness?" the pope asked, echoing the second letter of Paul to the Corinthians. "Can Christ agree with Belial, or a believer join hands with an unbeliever? Can there be a compact between the temple of God and the idols of the heathen?"

The recently deceased Pope Hadrian had also cited scripture to insist that Christians not gather at the dinner table with Jews, and he tended to use the term "Jews" to mean heretics in general. In Rome and elsewhere, the vilification of Jews was commonplace, a consequence of early Christian writings that resonated, to dire effect, for centuries.

In practice, the attitude of the Frankish nobility toward Jews was far more pragmatic. Whatever their dogmas or prejudices, the behavior of most Christians accorded with the sentiment expressed in a royal charter of protection issued for Jews in Septimania, the future south of France, by Karl's son Louis:

Although apostolic teaching reminds us especially to do good for our brethren in the faith, it does not prohibit us from doing kindnesses also to all the rest. But it exhorts, rather, that we pursue humbly the course of Divine mercy.

Even Agobard of Lyon, famous for his anti-Jewish writings, leavened his message with a genuinely Christian caveat: that "since they [the Jews] live among us we should not be hostile to them or injure their life, health, or wealth."

After all, as any Frank could tell you, their Christian ruler was often likened to an Old Testament king. The Jews of Aachen heard these sentiments in the poems of Angilbert:

Rise, pipe, and make sweet poems for my lord!
David loves poetry; rise, pipe, and make poetry!
David loves poets, David is the poets' glory,
and so, all you poets, join together in one,
and sing sweet songs for my David!

Frankish Jews may have been reassured by these Latin songs. In private, they may not have been thrilled by how this Christian king was recasting their own history, or by incidents of bigotry; but Karl's fondness for the Jews of the Old Testament ensured that, unlike many medieval rulers, he remained nearly as fond of the living Jews in his own kingdom.

To some Franks, their Jewish neighbors represented the final footsteps of ancient Rome. Under the Romans, their privileges had included freedom of worship, military service, and access to public office. The historians of Karl's court, and perhaps even the king himself, might have wondered if the Jews were not an integral part of ancient Rome, the legacy of an empire that all hoped might rise again.

P robably numbering only a few thousand, the Jews of Francia seemed a somewhat foreign presence in the midst of Germanic Christians, but only the occasional bigot or bishop actually found them a present danger. To Karl and his inner circle, true foreigners—Greeks, Saxons, Andalusians—were a far more pressing concern. The world beyond the borders demanded immediate attention, and its representatives were starting to acknowledge the power of the Frankish king.

Between 797 and 799, Karl's court swarmed with diplomats from foreign lands. Recalling the Frankish victory over the Avars, the poet Theodulf imagined all of Karl's conquered enemies paying him tribute:

> The heathen peoples come prepared to serve Christ;
> you call them to Him with urgent gestures.

Behind the Huns with their braided hair come to Christ,
once fierce savages, now humbled in the faith.
Let them be accompanied by the Arabs. Both people have long hair:
one of them plaits it; may the other let it flow loosely.
Cordoba, send swiftly your long-amassed treasures
to Charlemagne who deserves all that is fine!

Theodulf flattered his king with this elaborate fantasy, but the poem captures something of the scene at Aachen during these years. Foreign diplomats were a regular part of palace life, and Karl was well aware of their motives. Like the Jewish merchants of his day, Karl played politics on a much larger game board than history often acknowledges.

The nuances of Andalusian politics can baffle modern historians, but Karl kept a close watch on the affairs of his Muslim neighbors in Spain. Zaid, the governor of Barcelona, visited in 797, as did Abdallah, a rebellious noble from Cordoba. The following year, an envoy from Alfonso, who ruled the Christian kingdoms of Galicia and Asturias in northwestern Spain, visited Karl while he campaigned in Saxony.

The scene must have been colorful: the Frankish king, accompanied not only by Abdallah but also by his own two sons—the Romance-speaking Louis and the Germanic-speaking Pepin—greeted the envoy of a Christian king while he allied himself with a group of pagan Slavs against rebellious pagan Saxons. In some frontier fortress along the Weser River, at least five cultures and four religions found themselves facing each other in a moment that was not atypical of the times. Twelve centuries later, from one Frankish historian, we know only one trivial detail: that King Alfonso's envoy presented Karl with "a most beautiful tent."

That winter, after Alfonso plundered Lisbon, he sent Karl additional tribute: armor, mules, and Moorish slaves. Karl's one major military foray into Spain twenty years earlier had been a humiliating failure, but he had learned from the experience. Now he cultivated allies, not enemies, on the far side of the Pyrenees.

Relations with Constantinople were thawing as well. In 797, an envoy named Theoctistos arrived from Sicily with a letter from Constantine VI. The content of the letter is unknown, but according to the writer of one Frankish chronicle, the following year Karl returned from a winter of warfare in Saxony to find a message from Irene:

> When he arrived at the palace of Aachen, he received an embassy of the Greeks sent to him from Constantinople. The envoys were Michael, former governor of Phrygia, and the priest Theophilus. They carried a letter from Empress Irene, since her son, Emperor Constantine, had been arrested and blinded by his people the year before. But this embassy was only concerned with peace.

Hit hard by Harun al-Rashid to her east, Irene hoped to keep her western front as quiet as could be.

Against this backdrop of Christians and Muslims; Franks, Greeks, and Saxons; tribes, kingdoms, and distant cities, Karl saw his own kingdom growing in influence and becoming an empire, the *ventura Roma* proclaimed by court poets, the *Imperium Christianum* of Alcuin's letters—almost.

Looking to the future, Karl found a man called Isaac from among his Jewish subjects and sent him on a crucial mission with two Franks named Lantfrid and Sigimund. Like their king and his advisers, the diplomatic mission set its sights on Bagh-

dad. Isaac, Lantfrid, and Sigimund—three utterly obscure figures in the drama of their times—represent a remarkable moment: a joint Christian-Jewish embassy to the heart of the Islamic world. In later centuries, when relations between the three religions were marked by mutual animosity, and when wild romances about Charlemagne battling pagans were used to promote the crusades, these early contacts would be all but forgotten.

But for now, Karl was concerned with enlarging Christendom, not with distant Islamic threats. He kept an eye on the Spanish border, and he spilled pagan blood in Saxony. Constantinople worried him, but neither he nor his wise men, Alcuin included, foresaw that their biggest problem would be another great city, a closer one held by allies and already blessed with innumerable Christian churches.

The rumors began early. Karl and Alcuin had already sent Angilbert to Rome with pointed advice for Leo, the new pope. Leo was not, they reminded him, the Frankish king's superior, but only his righteous helper. Conflicting reports about Pope Leo had reached Aachen, and Karl probably knew more than his letters let on.

Alcuin kept watch on the situation as well. In late 798, he heard from his good friend Arno, archbishop of Salzburg, who had recently come from Rome. In a letter playfully addressed to his friend "the eagle," Alcuin was relieved by Arno's reassurance that all seemed well in Rome:

To the noblest of birds, the eagle, the goose cackles its greeting.

When I heard you were flying across the Alps to the sweet peace of your nest, my anxiety about you suddenly was stilled and it was as if my mind had escaped from crashing storms to a quiet haven. . . .

You wrote to me about the religious life and righteousness of our lord the Pope and the outrages he suffers from the children of discord. I confess it warms my heart that the father of the churches earnestly serves God with a faithful, sincere and good spirit.

Busy imposing law, literacy, and Christianity on northwestern Europe, Karl was probably buoyed by Arno's news. In Tours, Alcuin could relax, catch his breath, and reshuffle his priorities. Too many matters needed his attention: monks, Saxons, Slavs, the heresies of Felix, and the bizarre Greek empress and her icon-crazy people. It was good to know that the new pope, at least, was a man they could count on.

That was the state of Karl's world in 797, when Lantfrid, Sigimund, and Isaac left Francia on a 3,500-mile mission to the court of Harun al-Rashid.

And that was the state of Karl's world on April 25, 799, when rumor became reality, and an incident on a public street made the city of Rome explode.

Part Two

EMPEROR

.6.

BLOOD OF
THE MARTYRS

Rome and Paderborn, A.D. 799

On a November morning in 799, a party of travelers rode briskly along the southbound road to shake off the relentless chill of winter. Before them was Rome, a dear destination for every Christian. The very buildings told the story: if an ancient ruin had not been converted to a monastery, then it was a *diaconia*—a welfare center where monks provided food and beds—or it was a church. The Pantheon was now Santa Maria Rotunda, and the old senate house and other buildings in the forum were also churches, just two of hundreds that served a city of martyrs and monks.

From a distance, however, the skyline was dominated not by

church spires but by dozens of timber towers looming over the houses and shops. Those towers existed not to repel outside invaders but to mark the territory of noble families—and to defend it if necessary.

The band of travelers had business in Rome, but those who had never been there were also eager to see the sights. All Christians yearned to pray at the resting place of Saint Peter in the basilica by the walls, to explore the catacombs and graveyards, and to see the basilica that sheltered the tomb of Saint Paul, just half a day's walk down the Via Ostia. To Christians, Rome was the Eternal City, blessed by God and destined to endure as long as the world itself.

Rome embodied the timeless dangers of the world as well. Seedy Venetians prowled the markets in search of slaves to sell in Africa. In public squares outside the basilicas, locals offered lodging to travelers and hawked relics of dubious origin. Tourism meant exposure to other temptations, too: The missionary Boniface had decried visitors to Rome as "sex-hungry and ignorant Swiss, Bavarians, or Franks"; and northern Italy was known for its prostitutes, many of them from England.

But for most pilgrims, the sight of the city inspired loftier thoughts. After a battering by the Lombards and years of neglect, Rome was reborn. In the peace and safety of Frankish protection, Pope Hadrian had repaired walls, rebuilt aqueducts, beautified churches, and revived farming at church-owned plantations. In 799, a pilgrim could echo the wonder of Fulgentius, a sixth-century African bishop who beheld the city and cried, "O brothers, how beautiful must be the heavenly Jerusalem, if earthly Rome can shine with such brilliance!" Like Fulgentius, or like a later

Latin poet, visitors addressed the city, *O Roma nobilis,* in the most
Christian of terms:

> *O noble Rome, mistress of the world,*
> *Most excellent of all cities,*
> *Red with the rosy blood of the martyrs,*
> *White with the snowy lilies of the virgins,*
> *We greet thee above all others,*
> *We bless thee: hail throughout the ages.*

That November, the band of travelers had little to fear. Their
company included Arno, archbishop of Salzburg, who knew this
highway well. Arno had been to Rome the previous year, when he
had come before Pope Leo to receive the pallium, a symbolic cloth
band. His city thus became the first archbishopric in Bavaria, and
Arno himself now had the authority to govern over other local
bishops. But this year, Arno and his companions were not jour-
neying to see the pope. The Holy Father, his face scarred, was al-
ready with them.

God and his saints smiled on the archbishop. Surely they pro-
tected the pope as his train of horse carts, provided by Karl, wound
through mountain passes and rolled southward toward Rome. But
just to be safe, the retinue that came with Leo and Arno probably
included a sizable contingent of soldiers. Faith in the protection of
saints was a given; but taking them for granted, as this pope could
tell you, was foolish.

It had been nearly seven months since the attack. On April 25, 799, Pope Leo had been leading a procession, the "major litany," through the streets of Rome. The ceremony had ancient roots, but it had been Christianized, and its purpose now was to secure God's blessing on the spring crops.

Crowds gathered to see the pope, but not everyone was moved by piety. According to the *Liber Pontificalis*, the "Book of Popes," two relatives of the previous pope lurked nearby. Hadrian's nephew Paschalius was employed as *primicerius*, the official in charge of the papal secretariat. Another relative, Campulus, served as *sacellarius*, one of two men in charge of papal finances. Dressed as aristocrats rather than clergy, the two plotters joined the procession and approached Pope Leo along the way.

Paschalius begged the pope to forgive him for not wearing his chasuble, the special clerical garment for ceremonial occasions. He claimed that he had recently been ill. Then, Campulus engaged the pope in small talk.

The *Liber Pontificalis* describes what happened next:

> *Meanwhile, some malign, wicked, perverse and false Christians, or rather heathen sons of Satan, full of wicked scheming, devilishly came together on the route, in front of the monastery of SS [Saints] Stephen and Silvester which the former lord pope Paul had founded, and secretly waited there under arms. They suddenly leapt out of their place of ambush so as to slay him impiously, as has been said. Showing him no respect they rushed at him, while in accordance with their iniquitous plot Paschal stood at his head and Campulus at his feet.*
>
> *When this happened, all of the people round him, who were unarmed and ready for divine service, were scared of the weapons and turned to flee. The ambushers and evil-doers, just like Jews, with no*

respect for God or man or for his office, seized him like animals and threw him to the ground. Without mercy they cut his clothes off him and attempted cruelly to pluck out his eyes and totally blind him. They cut off his tongue and left him, or so they thought, blind and dumb in the middle of the street.

Back in Francia, one chronicler recorded conflicting information about the location of the attack, but the anonymous monk vividly confirmed its brutality:

When Pope Leo in Rome was riding on horseback from the Lateran to the church of the blessed Lawrence, which is called At the Roast, to participate in the litany, he fell into an ambush set up by the Romans near this church. He was thrown from his horse, his eyes, as it appeared to some observers, gouged out, and his tongue cut off; they left him lying in the street naked and half-dead. On the order of those responsible for this act he was then taken to the monastery of the holy martyr Erasmus, seemingly to recover there.

The news reached Constantinople, where the monk Theophanes noted the attack with a hint of Christian triumph at the pope's survival:

In the same year some Roman relatives of the blessed pope Hadrian incited the people to rebel against pope Leo. They overcame and blinded him, but were not able to quench his light forever, as the men who blinded him were charitable and had mercy.

The "mercy" of Leo's attackers is debatable. The *Liber Pontificalis* continues:

But afterward, like really impious heathens, they dragged him to the con-
fessio in that monastery's church and in front of the venerable altar itself,
again for the second time they cruelly gouged his eyes and his tongue yet
further. They beat him with clubs and mangled him with various inju-
ries, and left him half-dead and drenched in blood in front of the altar.

After this second attack inside the church, the conspirators brought the pope to the Greek monastery of Saint Erasmus. Betrayed and mutilated, Leo was, the *Liber Pontificalis* says, kept "in strict and close confinement."

No one knows whether Leo expected the attack, or if he was as stunned as Rome's many pilgrims. They had come to Rome for the saints—for dead saints—but as stories began to circulate, at least a few of them must have wondered if they were witnessing a living saint, a martyr in the making.

B y day, at martyrs' tombs, pilgrims mingled with other Christians from many lands. At night, they returned to hostels or inns that catered to their own nationalities. On that April evening, whether in Latin, in Greek, or in dozens of dialects of Germanic or Romance, every hall was abuzz with confusion and shock.

Why in God's name had this happened? The previous pope had been praised for restoring the infrastructure of Rome. In all corners of the city, altars and tombs glittered with gifts that had been endowed by Hadrian himself: golden candles, glorious arches, silver statues, bronze doors, every treasure a man could imagine, all of them made to glorify God. By all accounts, Pope Leo had contin-

ued this fine work. Were they not all Christians? Who but the worst sort of heathens attacked a pope?

What the locals understood—and what tourists, with heads full of *O Roma nobilis*, did not—was that the late Pope Hadrian had belonged to one of the city's powerful families, the type that fortified its watchtowers against bellicose neighbors. The uncle who had raised Hadrian had been a consul and a duke and later served as *primicerius*, the position now held by Paschalius, Hadrian's nephew. Paschalius had served on diplomatic missions to Francia, and, from his visits to Karl's kingdom, he may have been acquainted with the late pope's allies. Such a man would have wanted a pope in the family. Backed by Frankish power for half a century, the popes now ruled central Italy like kings. The church had long assumed many functions of city government, and on behalf of Saint Peter, the papacy reaped the economic benefits of numerous plantations and estates throughout the region.

By contrast, Pope Leo was the son of a Roman family, but apparently not a noble one. His father was called Atzuppius, a name that may have been of Greek, southern Italian, or even Arabic origin. Leo was no outsider, but unlike Hadrian, he was a priest by vocation and a bureaucrat by training. His primary loyalty was to the clergy rather than to noble families like Hadrian's. Leo had been elected and consecrated pope unusually quickly—in just two days. The clergy may have been afraid that Rome's powerful families would try to appoint their own pope—or violently rebel if they failed to get their way. If the attack on Pope Leo was the latest battle in a war between the nobility and the clergy, then previous skirmishes had probably taken place behind closed doors, away from gawking tourists. Leo's attackers later made strong and specific charges against

him—adultery and perjury—but in April 799, some unknown flash point finally brought the conflict onto the streets and made it a reason for bloodshed.

Gossip moved quickly along the usual pilgrimage and trade routes, but one poet of the day insisted that the news reached Karl with miraculous speed. He pictures the Frankish king at Aachen, settling in for the evening after a busy day but unprepared for a remarkable dream:

> *Now the sun flees, and the night seizes the daylight in shadows.*
> *His weary limbs long only for placid sleep—*
> *But sadly, in his dreams, the king sees a vision, monstrous, unspeakable:*
> *Leo, highest pontiff of the city of Rome,*
> *Stands before him, sheds his mournful tears,*
> *His eyes befouled, his face all smeared with blood,*
> *His tongue mutilated; he bears many horrendous wounds.*

Beyond the grisly depiction of Leo's wounds, the anonymous poet, writing with the benefit of hindsight, includes one prophetic detail. To the poet, Karl is not merely the king of the Franks, a monarch whose fate is intertwined with the life of Pope Leo. This Karl—noble, idealized, very nearly perfect—is already an emperor.

In some stark chamber on the Caelian Hill in southeastern Rome, Pope Leo languished for weeks, but eventually healed. Leo had survived the attack with his eyes and tongue intact—a miracle, some claimed, and many Romans agreed.

Although some nobles supported them, the conspirators were in a bind: they had failed to incapacitate the pope. There was now no discreet way to kill him; nor was there any way to replace him—killing him was unthinkable, replacing him impossible. If the charges of perjury and adultery were true, then the conspirators needed to fight the tide of public opinion. If their charges were false, a cover for some less lurid grudge, then they were only digging themselves a deeper hole. Paschalius and Campulus probably had a hard time figuring out whether or not they had even succeeded. Perhaps they reassured each other in some secret, candlelit room: *Well, at least we have the pope, and time.*

But they had neither. The pope had cultivated a loyal staff, and the story of his miraculous recovery inspired further support. Leo's allies were much more competent than his attackers, if the story of his rescue in the *Liber Pontificalis* is true:

> When almighty God in his customary mercy displayed this great miracle through his servant, it was his divine will that faithful Christian men—Albinus the chamberlain with others of the God-fearing faithful—secretly rescued him from that cloister and brought him to St. Peter's, where the apostle's holy body is at rest.

The story told by a Frankish annalist is more candid, if less dignified: "But through the efforts of Albinus, his chamberlain, he was lowered over the wall at night."

Eighth-century chroniclers are interested in one fact: Leo's late-night jailbreak was a stunning success. They omit the most exciting parts and leave the details to our imagination: Albinus the

chamberlain sneaking along a cloister in the dark or bribing a guard to look the other way; the pope, accustomed to fine robes and flattery, being lowered over the wall like a latrine bucket; and the furious Paschalius and Campulus berating their flunkies at daybreak while wondering, with growing desperation, what in God's name they were going to do next.

The pope hurried to the basilica of Saint Peter in the Vatican district, where he was met by Winigis, duke of Spoleto, a longtime ally of Karl. Fearing the worst, Winigis had hurried south with his army, but what he found cheered him. According to the *Liber Pontificalis*, "When he saw that the supreme pontiff was able to see and speak, he received him reverently and took him to Spoleto, glorifying and praising God who had manifested such wonders in him."

But Spoleto was merely a way station on a much longer journey. Leo knew: half a century earlier, Karl's father had been dubbed "patrician of the Romans" after battling the Lombards who threatened the city. After fifty years of allegiance between the Franks and the papacy, Karl had personally sworn to continue that strategic partnership. A meeting between Karl and Leo was inevitable—and urgent.

Fortunately for the pope, gathering an entourage was easy. As the *Liber Pontificalis* points out, his miraculous recovery had inspired the faithful, and numerous bishops, priests, clerics, and nobles offered aid as he set out to see Karl.

History records one last, pathetic consequence of Leo's rescue. When the conspirators discovered that Albinus had helped the pope escape, they demolished his house. As Leo's supporters began the journey to the heart of pagan Saxony, many of them must have been terrified. Their loyalty to the pope had cost them every-

thing. With Rome in the hands of violent nobles, they had no assurance that they could ever return home.

That spring, as Frankish farmers prepared the soil and put livestock out to pasture, messengers with heavy burdens skulked across Europe. When news of the attack reached Alcuin at Tours, he wrote to Karl to express his concern. The church, he said

> has been cast into disorder by the manifold wickedness of the ungodly, besmirched by acts of abominable audacity by men of the greatest evil; and these men are to be found not just among the ordinary people but among the greatest and highest. This is an extremely frightening situation.

Alcuin's letter included few of his usual quips, and he got right to the point:

> Has not the worst impiety been committed in Rome, where the greatest piety was once to be seen? Blind in their hearts, they have blinded their own head. There is no fear of God there, or wisdom, or love. If they feared God, they would not have dared; if they had wisdom, they would not have willed it; if they had love, they would never have done it. These are the perilous times foretold in Scripture.

Reflecting on the attempted coup in Rome and the blinding of Emperor Constantine VI in Constantinople, Alcuin arrived at a startling conclusion. With the Greek emperor and Pope Leo both

incapacitated, the Frankish king was now the most important man
in the world:

> *There have hitherto been three persons of greatest eminence in the world,*
> *namely the Pope, who rules the see of St. Peter, the chief of apostles, as*
> *his successor—and you have kindly informed me of what has hap-*
> *pened to him; the second is the Emperor who holds sway over the second*
> *Rome—and common report has now made known how wickedly the*
> *governor of such an empire has been deposed, not by strangers but by his*
> *own people in his own city; the third is the throne on which our Lord Je-*
> *sus Christ has placed you to rule over our Christian people, with greater*
> *power, clearer insight and more exalted royalty than the aforementioned*
> *dignitaries. On you alone the whole safety of the churches of Christ de-*
> *pends. You punish wrong-doers, guide the straying, console the sorrowing*
> *and advance the good.*

Despite Alcuin's insistence that Karl's new role was extraordinary,
the king's summer plans were predictable: another campaign
against the Saxons. Still opposed to converting the Saxons by
force, Alcuin implored his king to turn his full attention to Rome.
"Guard your own fold," he advised, "against the ravening wolf."

But like any leader, Karl was beset by conflicting demands. The
king hardly scorned Alcuin's advice, at least not openly. He simply
had his own plans for how to punish wrongdoers, guide the stray-
ing, and advance the good. Besides, Alcuin was right about some-
thing else: Did not Karl have greater power, clearer insight, and more
exalted royalty than anyone in Rome or Constantinople?

That summer, Karl would confront his Saxon problem. The
other problem would come to him.

Meanwhile, Christian travelers wandered southward, bound to a world of fragrance and sunlight. They had taken to the road for the reasons that have always prompted pilgrims to travel. Some were humble tourists intent on fulfilling religious duties. Others were merchants hoping to peddle their wares or find trinkets to sell in northern markets. A few were itinerant swindlers. Others were ill; they hoped to be healthy when they returned.

They were rattled from their road daze by a clamor: horses, the groaning of wagon wheels, the clash of armor, and the cries of ironclad men. The pilgrims were bemused, curious, maybe unsettled, as the priests, soldiers, and high-riding nobles passed them. Unlike their small caravan, this army wasn't going to Rome; in fact, it was headed in the opposite direction. *Strange*, the pilgrims must have thought, *that everyone is heading north these days. Didn't we bump into envoys from King Pepin a few miles back?*

The pilgrims assumed that they were witnessing the journey of a very important person, some noble who had completed a pilgrimage of his own—but who it was, exactly, they couldn't quite tell. As they thought ahead to their arrival in Rome, they had no way of knowing that they had passed history on a northern Italian road, or that they had come close to obtaining the personal blessing of the Holy Father himself.

Alerted to Leo's intentions, Karl set out from Aachen, arriving in Saxony and pitching camp at Paderborn. Once merely a frontier outpost, Paderborn was growing. By 799, a palace and church compound were proof that Karl had started to spread Christendom, or at least its representative buildings, into this pagan land.

With him was his intended successor, his son Karl. The elder Karl dispatched his namesake with a large portion of the army; their mission was to negotiate with nearby Slavs in preparation for battle against the Saxons. For King Karl and the Franks, a summer of warfare and diplomacy was only beginning.

For Pope Leo, the most difficult journey of his life was about to end. He had rarely if ever been outside Rome, and those 900 miles of weeds and wilderness could not have been pleasant to behold. The pope had crossed the Apennines and the Alps, entered the Rhineland, and traveled through northern Europe into Saxony. A man who had power over all the souls of Rome spent weeks at the mercy of others, and he was probably relieved when he and his entourage encountered Archbishop Hildebald of Cologne and a count named Ascheric, both sent by Karl to greet him.

Karl's son Pepin, king of the Lombards, also met the pope along the route. He led Leo into the royal encampment, beginning the first stage of his formal reception. Karl was ready for him.

In the eighth century, it was strange for a pope to be wandering through northern Europe, but this was not without precedent. In 754, Pope Stephen II had come to western Germany

to seek the help of Karl's father, Pepin, against the Lombards. On that occasion, a very young Karl made his first appearance in written history as the pope's escort to a royal villa. Even so, the presence of a pope on a military frontier deep within pagan lands was bizarre by almost any standard. Karl may have vaguely remembered the protocol involved in receiving a pope, racking his brain to recall the court ceremonies of nearly fifty years earlier.

Or, with a fresh army behind him, perhaps he improvised. In epic language that echoed the poetry of Virgil, one Frankish poet described the awesome reception that awaited Leo at Paderborn:

> *Then they gathered spear-shafts in hand, and breastplates thrice-twined,*
> *Broad shields, arrows, and helms. The bronze shields resound.*
> *The cavalry line looks ready to charge; dust clouds darken the sky.*
> *The ominous trumpet rumbles from its lofty place.*
> *The battle signals sound. The open fields are dense*
> *With crested soldiers; the whole army shines.*
> *Spear blades glimmer, too, and raised banners flash.*
> *Fresh soldiers march, while daring youths*
> *Revel on horseback. Thirsting for battle, they burn deeply*
> *As they listen—and Karl, leading his army, glows with joy.*
> *A golden plume protects his brow. His countenance shines before all,*
> *This noble general borne on a mighty steed.*
> *Before the whole encampment stand the priests.*
> *Divided into three choirs, they wear their long vestments*
> *And raise the holy banners of the bountiful Cross.*
> *The clergy and their eager people—all await his coming.*

Except for its Christian priests, this army could have marched right past Rome 1,000 years earlier. Frankish strategists had studied

Roman military manuals and had adapted tactics such as the pha-
lanx formation, a tight mass of locked shields and long spears. Part-
time levies and professional soldiers alike were trained to march.
They drilled continually, and this practice showed.

On that day at Paderborn in June 799, Leo saw archers, spear-
carriers, and swordsmen. He saw cavalry on trained warhorses, the
forerunners of later knights. He saw scouts, spies, technicians, and
specialists, some of whom, if asked, could build and operate an-
other legacy of the Roman empire: machines to besiege cities. The
pope could also see, in the eyes of individual soldiers and in their
collective confidence, a real esprit de corps. These men knew what
they could accomplish. They could point to a tradition of victory
against the Lombards, the Avars, and eventually the Saxons, a tra-
dition that no one could deny. The sight, grander than any militia
the Romans could muster, surely warmed Leo's heart.

*In a ninth-century manuscript known as the Golden Psalter, King David's general Joab
and his cavalry ride into battle wearing the armor of Karl's era.*

The poet further describes the historic meeting between the pope and the king:

> Now Pope Leo approaches from without and moves among the troops:
> So many customs, languages, clothes, and arms!
> He marvels at these people from diverse parts of the world.
> At once Karl hastens to give reverent greetings,
> Embracing the great pontiff and offering gentle kisses.
> Mutually they join hands, and together they go,
> Exchanging many words of goodwill along the way.
> All the army prostrates itself three times before the high priest:
> Three times the massive crowd kneels and adores him,
> Three times the pope offers prayers for them from his heart.
> The king, father of Europe; and Leo, highest pastor in the world,
> Walk together, mutually discussing many things.

The *Liber Pontificalis* adds that Karl met Leo amid hymns and chants and concludes with a dramatic touch: "They greeted and embraced each other in tears."

Karl and Pope Leo spent the summer in Paderborn, where the poet describes them holding "golden bowls overflowing with Falernian wine" as they dined and flattered each other in a tapestry-draped chamber. No records or personal recollections survive from that summer, but this meeting between two of Europe's most masterful politicians was surely far less festive than the poet makes it sound. Confronted by an endless stream of priests, bishops, and nobles, the two men needed to get to know each other. Their common future depended on it.

Leo could use to his advantage the traditional relationship between the Franks and the papacy, a partnership that Karl had reiter-

ated in writing only three years earlier. Karl himself had a trickier task, especially as bad news continued to roll in from Rome. The *Liber Pontificalis* claims that the conspirators tried "to lay false charges after the holy pontiff and send them after him to the king, charges they could never have proven, as it was they who were causing these unspeakable things through their own plotting and wickedness." Rome was divided. Stories about Leo were lurid and inconsistent. The charges were serious, the accusers were dangerous, and the whole business was wrapped in a miracle that Leo himself never did confirm or deny.

Karl needed eyes in Rome. He needed to benefit from this crisis. But before that, while this controversial pope was in front of him, he needed to know exactly what he was getting himself into.

I n July, after a brief trip to a trading post on the English Channel, Alcuin returned to Tours to find a letter from Karl. The abbot was pleased to read that Pope Leo had arrived safely at Paderborn, but he was less thrilled by a request from his king. In his reply, he said so:

> As for the long and wearisome journey to Rome, I do not think it at all possible for my frail body, weak and broken by daily suffering, to complete it. If I could, I would have wished it. So I beg you in your fatherly generosity to allow me to assist your journey in faithful and earnest prayers with God's servants at St. Martin's.

Although Alcuin was unfit to travel to Rome, the king sent a reliable substitute: Alcuin's friend Arno, archbishop of Salzburg, the "Eagle" whose letters he loved.

With the arrival of autumn, as Frankish peasants sowed seeds in muddy fields, Karl went back to Aachen. In the company of protectors, servants, and royal investigators, Pope Leo returned to Rome.

The pope was in Italy by late November. Supporters cheered him along the way, especially on November 29, when he and his Frankish retinue arrived outside Rome. The *Liber Pontificalis* sets the scene: chanting clergymen, nuns, deacons, nobles, and others, all greeting Leo with standards and banners at the Milvian Bridge, where centuries earlier, Constantine the Great beheld the vision that prompted him to embrace the Christian God.

First, Pope Leo went to the basilica of Saint Peter to celebrate mass. The next day he celebrated the feast of Saint Andrew. Then he entered the city walls and—presumably with the aid of some persuasive Franks—recaptured the Lateran, the papal palace on the east side of town. Arno and other foreign dignitaries, including Archbishop Hildebald of Cologne, five bishops, and three Frankish counts, promptly made themselves at home.

In a letter to Alcuin, Arno suggested that Rome was unsafe for friends of the pope. That winter, despite the danger, he began his investigation. What he found was not encouraging.

The charges of adultery and perjury may not have been false; Arno raised the possibility in a letter to Alcuin. The letter does not survive, but Alcuin's reply does, and

it suggests that his friend the archbishop had uncovered a true Roman scandal:

> The previous letter, which reached us in your name—with some complaints about the behavior of the Pope and your personal danger there because of the Romans—was brought to me by Baldricus (whom I take to be your priest) with a cloak sewn in Roman style, a garment of linen and wool. I did not want the letter to get into other hands, so Candidus was the only one to read it with me, and then it was put into the fire, lest any scandal should arise through the carelessness of the man who keeps my correspondence.

Whatever Arno found in the course of his investigation, his letter was neither flattering to Leo nor helpful to Karl.

Alcuin, hardly an impulsive man, immediately consigned it to the flames.

PRAYERS AND PLOTS

Francia, A.D. 799–800

The workdays were shorter, but the nights were growing longer, and the laborers around Aachen could hardly be thankful for that. Abbots and merchants posted night watchmen in their vineyards, where they stood guard during the bleakest of hours, shooing away foxes and scaring off the more cunning two-legged thieves. On those endless nights, superstitious peasants saw goblins in every shadow and heard devilish cackles in every rustling vine.

But in the autumn of 799, even the poorest farmers could look up from sowing wheat and be grateful for a welcome sight: Karl and his men were riding back from Saxony. Aware of rumors,

Frankish peasants may have wondered whether it was true that the pope had been to barbaric Saxony. Did the Holy Father really have, across his eyes, a scar as pure and white as any dove? Perhaps they paused in their work—hard days of August spent harvesting, a September spent sowing rye and winter wheat—to mutter half-hearted nonsense about foreigners. Strange men continually visited the king, but after all this time, few were exotic enough to concern the locals. There was too much work to do.

For peasants, the autumn of 799 was, like every autumn, a dull blur of scattered seed and blistered hands. For Karl, it was a time of diplomacy. From Andalusia came an envoy of Hassan, the emir of Huesca, whose gifts included the keys to his city. Around the same time, a monk arrived with gifts from the Christian patriarch of Jerusalem. Karl was known to send alms to poor Christians in Africa and the Middle East, but it was remarkable for the highest Christian authority in Jerusalem to respond with relics from the Church of the Holy Sepulchre. Formerly aligned with the emperors in Constantinople, the patriarchy of Jerusalem was now under the control—or, as some saw it, the protection—of the Abbasid caliphate. It was prudent of the patriarchs to direct gestures of friendship toward Karl rather than toward Irene, who was the enemy of Karl and Harun al-Rashid alike.

The monk from Jerusalem would have been able to respond to several pressing questions that no Frankish chronicler ever saw fit to answer: Had Lantfrid, Sigimund, and Isaac arrived safely in Baghdad? Was this gift of holy relics an independent offering from the patriarch of Jerusalem, or did it come with the blessing of Harun al-Rashid?

When the monk returned to Jerusalem, Karl's priest Zacharias went with him. His mission involved more than just gifts; he had

much to discuss with the patriarch on behalf of Karl—more than the Frankish farmers who watched them travel east could imagine.

More allies came to court. Tired of being the prey of pirates, the Balearic Islands along the Spanish coast requested Karl's protection, which the king granted, while a count named Wido put down a local revolt on the borderlands of Brittany. According to the Frankish annals, when Karl returned to Aachen that fall, "Wido presented to him the weapons of the leaders who had surrendered with their names inscribed on them. Each of these delivered his land, his people and himself to the Franks and the whole province of Brittany was subjugated by the Franks, something which had never happened before."

Unfortunately, amid this stream of visitors and victories, Karl soon found himself in mourning. That year, he lost two of his greatest heroes.

The first was Eric, duke of Friuli in northeastern Italy. Eric had been a loyal ally; three years earlier, he had conquered the Avars and sent Karl their treasure, but now he was gone, killed in a Croat ambush while campaigning along the Adriatic. Gerold, count of Bavaria, was also killed that year while preparing to deal with Avar holdouts. Poets wrote epics about men like these, and Frankish boys imagined themselves killing "Huns" and riding home with carts full of gold. As the world slowed down for the winter, the Franks mourned the fallen heroes and remembered their noble deeds.

As the year turned, the king looked forward to travel. But more death was to come.

Winter in Francia was a dreadful time: dreary, painfully cold. The monk Wandalbert of Prüm wrote that the leanness of winter:

> *Wastes and shrinks the enfeebled limbs of the beasts*
> *Nor is it easy to commit seed to the tilled land.*
> *Everything withers in frost, and a terrible hardness stiffens the fields.*

But even in the season of frozen soil and bone-dead trees, Francia did not shut down. Few found rest even when the days were dark and cold. Monks and priests still performed the work of God, while peasants bore the brunt of the punishment ordained by the fall of man. Even the illiterate had heard those rueful verses from Genesis:

> *Cursed is the ground for thy sake; in sorrow shalt thou eat of it all the*
> *days of thy life. Thorns also and thistles shall it bring forth to thee; and*
> *thou shalt eat the herb of the field. In the sweat of thy face shalt thou eat*
> *bread, till thou return unto the ground; for out of it wast thou taken;*
> *for dust thou art, and unto dust shalt thou return.*

For months, men, women, and children all griped and groaned through arduous labors. They felled trees to build houses and boats. They fished, foraged, and set snares for little birds. They slaughtered pigs fattened by acorns, and they smoked or salted the meat. After storms, they dug up their fields, sowed barley, and spread manure.

If all went well, Francia would be ready for spring. But there were days, even weeks, when it felt as though spring would never come.

I n March, as the peasants around Aachen broke clods of cold earth, they saw the Frankish king, his counselors, and his family ride out from Aachen on a northbound road. It was too early for warfare; the spring oats, which fed Frankish war-horses, had not yet been harvested. Besides, the king wasn't riding toward Saxony. Strangely, he was heading north, where he almost never went.

They were surprised to spot him at a northern beach, on the shores of what the Franks called the Gallic Sea. "King Karl was at the coast to go fishing" ran one rumor, recorded by a credulous monk, but the king was actually there to build a navy and create a coast guard. As Wandalbert reminded his readers, March was the month when men set sail: "At this time we first discern the great swells of the ocean surge, / With painted ships parting the surface of the sea." The poet's reveries evoke fishing boats or transport ships, but Karl was concerned with more urgent work: protecting his coastline from Vikings. When that was done, the king moved on.

I n mid-April, as they turned out flocks to graze, shepherds around the monastery of Saint Riquier saw the king, the queen, and their entourage ride down from the coast and along the Somme. The royal family was received by the abbot, Angilbert—Karl's "Homer," the friend he had entrusted to de-liver the first message to Pope Leo four years earlier.

In a way, Angilbert was also one of the family: he had fathered two of Karl's grandchildren. If the king came with the usual residents of Aachen, then his daughter, the twenty-year-old Berta, was probably present for Easter at Saint Riquier. Her affair with Angilbert was no secret, and although her lover was an abbot, his behavior was well known. His friends, including Alcuin, had expressed their concern, but what was done was done, and Alcuin was quite willing to make the 250-mile journey north from Tours that April to observe Easter with him. He and his fellow abbot had profound matters to discuss with their king.

The following month, as Frankish farmers harvested the spring wheat, Karl marched along the northern coast, turning up seventy-five miles southwest at Rouen. By late May, he had traveled the additional 200 miles to the tomb of the soldier-saint Martin.

Any monks who had been lounging in the taverns of Tours or loitering along the riverbanks had fair warning: Abbot Alcuin was back, and he was bringing the king. With them were two of the king's sons: Pepin, who had come from Italy; and Karl. The royal retinue brought ominous news: Karl's wife, Queen Liutgard, was with them, and she was ill.

As May turned to June, and teams of peasants pushed ox plows through the farm fields at Tours, they saw another arrival from the south: the king's son Louis, who rode north from Aquitaine.

Those who lived near the shrine of Saint Martin were used to visitors—pilgrims, merchants, swarms of Alcuin's friends—but

to have most of the Frankish royal family in one place like this was strange and stressful. Either something monumental was happening, or something very sad.

Queen Liutgard died at Tours on June 4, 800. Karl had been married to her for less than six years, since the death of his previous wife. A lively girl, Liutgard had been well liked by her husband's advisers. In his poem about life at Karl's court, Theodulf praised her intelligence and innate decency:

> The lovely maiden Liutgard joins their ranks;
> her mind is inspired with acts of kindness.
> Her beautiful appearance is surpassed only by the grace of her actions,
> she alone pleases all the princes and people.
> Open-handed, gentle-spirited, sweet in words,
> she is ready to help all and to obstruct none.
> She labours hard and well at study and learning,
> and retains the noble disciplines in her memory.

In a letter, Alcuin refers to "Liutgard and the children," but Liutgard herself had barely lived beyond childhood; she was younger than her stepsons and barely older than her stepdaughters. She had given the Frankish court no children and was said to have suffered frequent illnesses, possibly miscarriages, in an age when pregnancy often endangered a woman's life.

Alcuin, who considered Liutgard a friend, offered his king these words of condolence:

*Do not mourn for another's happiness. She has finished her toil among
the thorns and flown to Him who made her. Such is the condition of our
frailty after our first condemnation; we are born to die and die to live.
Is there any happier way to life than death?*

In the space of a few months, Karl had lost his warriors Eric
and Gerold; in recent years, he had lost two wives and three small
children. In June 800, he was fortunate to have his sons, his daugh-
ters, and his friends to console him while he mourned in the com-
forting presence of Saint Martin. His subjects had glimpsed him
racing across Francia, but they would never see this moment of
private grief.

In the week following Liutgard's death, Francia was hit by two
bizarre and unseasonable frosts. The crops were unharmed, but
chroniclers of the time took note of these frosts. It's hard to imag-
ine that Karl did.

From Martinopolis, the king continued his northwestern
tour, stopping first at Paris and then at Orléans for prayers
at holy shrines and counsel with mortal men. Theodulf,
bishop of Orléans, was an expert theologian with a nimble legal
mind. Just as the king had sought the opinions of Angilbert and
Alcuin that summer, he wanted to hear from Theodulf as well.

For Karl, Orléans in 800 may have been a pleasant place to
drink wine with a trusted friend while discussing politics, the past,
and the uncertain future. In a few lines of verse, the bishop him-
self scorned pilgrims who sought out bigger towns. In doing so, he
painted a lovely picture of the local scene:

You want to gawk at multitudes in Tours and Rome?
Then get up, go to Tours; go on and gape at Rome.
Here, all you'll find are farm-fields, vineyards, pastures, pens,
Mere meadows, streams, and fruit-tree groves, and rustic lanes.
But maybe, when you gaze upon these pleasing sights,
You'll think about their founder: God, who made them all.

The urbane Theodulf perhaps exempted his king from criticism. After all, some Christians had mightier, loftier callings. There were good reasons for kings to visit holy shrines, as Karl had done all summer. Relating his plans to his friend, Karl could add that there were many reasons, also, for men to go to Rome.

At the beginning of the ninth century, a monk at Salzburg illustrated a manuscript with pictures of peasant labors for each month of the year. The miniature for July shows a barefoot farmer wrapped in a red cloak and toting a large sickle. He appears content—although not nearly as happy as the pig slaughterer of December—as he mows the hay and looks forward to the next month's harvest.

At the end of June 800, Frankish peasants, who were neither as healthy nor as content as the little men in manuscripts, took iron-bladed sickles to the hayfields around Aachen. Late one afternoon, they saw the king and his family ride home—sadly, without the queen who had loved to ride and romp in the fields, but with, some said, Abbot Alcuin of Saint-Martin.

Felix of Urgel arrived around the same time. The bishop, infamous as a heretic and—from a distance—Alcuin's bitter antago-

A manuscript made at Salzburg shows the labors undertaken by ninth-century peasants during each month of the year.

nist, had come to Aachen from the Spanish borderlands at the urging of Laidrad, bishop of Lyon, who had challenged him to defend his adoptionist views in person. No farmers witnessed the heated exchange at the palace as Alcuin and Felix debated, rested, and debated again. Felix vigorously asserted that Jesus was not the son of God until he was "adopted" during his baptism, and Alcuin rebutted each point, not only with biblical quotations but also with citations from the church fathers, early Christians whose works Felix had never read.

Six days later, Felix renounced his heresy. "So, then, it was done," he later wrote, "and my beliefs were cut from me not by violence, as I have said, but by reason and truth." The defrocked bishop spent the rest of his life at Lyon, where Laidrad monitored the sincerity of his repentance. Elipandus, archbishop of Toledo, never renounced adoptionism, but Alcuin was comforted by an evident marvel: that heresy could be defeated in the halls of a great king.

While Karl's scholars watched as God's truth enlightened the heretical Goth, Frankish peasants wore their hands to the bone mowing and stacking hay. To reward themselves, they plucked the summer fruit that grew in abundance in the great orchards of Francia. If they heard about Felix, they understood none of it.

And then, a few weeks later, the king was gone.

When Karl summoned a council at Mainz that August, Frankish old-timers must have been amused. Warlords and noblemen were accustomed to the usual spring assemblies—a time to hobnob, renew loyalties, talk about business—but here they could gossip about the curious behavior of their king. Only a few years earlier, Karl had claimed that it was time to settle down, build a capital, and let the kingdom grow. Now here he was, rushing from place to place every few weeks, just like old times. That was what he had done when he was young. It was what his father and uncles and grandfather had done, always, in days gone by.

By the time powerful men met on the banks of the Rhine, the king had completed several months of good and necessary work. For years, Alcuin had reminded him that his responsibilities as

leader of the *Imperium Christianum* were to rule and protect Christendom, to suppress heresy, to strengthen the orthodox, and to spread the faith. Karl had accomplished many of these things that year. He had fortified his seacoast against pagan Vikings. He had set an example for his people by visiting shrines and seeking wisdom through contemplation and prayer. He had toured his kingdom to consult with learned men. Through the brilliance of a wise scholar, he had dealt a deathblow to a wicked heresy.

There was more to be done—but elsewhere. At Mainz in August 800, Karl announced that he intended to travel to Rome.

When the king invited Alcuin to accompany him, the abbot demurred. Agreeing to send his pupils Witto and Fredugis, he justified his own reluctance in a wry response:

> As to your wish to reproach me for preferring the sooty roofs of Tours
> to the gilded citadels of Rome, I know you have read Solomon's proverb:
> "It is better to sit in the corner of a loft than in a house shared with
> a quarrelsome woman."... And if I may say so, swords hurt my eyes
> more than soot.

But even though Alcuin declined to make the 900-mile journey to Rome, he ensured that he would be there in spirit, and not just because his protégés would go in his place. Despite his concerns about the swords of traitors, Alcuin had already sent along a much more effective weapon. Nearly a year earlier, he had provided some useful research to Arno. In a letter to the archbishop, the abbot

was bothered by speculation that the Roman conspirators might force Leo to resign the papacy:

> I understand that there are many rivals of the Pope who wish to depose
> him by scheming accusations, seeking charges of adultery or perjury
> against him and then ordaining that he should clear himself by swearing
> a most solemn oath, their secret intention being that he should resign his
> office without taking the oath and retire to some monastery. He is under
> no obligation at all to do this, nor should he agree to take any oath to
> resign his see. I would reply for him, if I stood at his side: "Let him who
> is without sin among you cast the first stone."

Moving on from his general point, Alcuin backs up his assertion with precedent:

> If I remember rightly, I once read in the canons of St. Silvester that a
> Pope should not be accused and brought to trial with less than 72 wit-
> nesses, and that their life should qualify them to stand against such an
> authority. I also read in other canons that the apostolic see is not to be
> judged but to give judgment.

Alcuin was citing two texts written at the turn of the sixth century: the Canons of Sylvester and the text of an ancient synod. Both were the creations of the supporters of another pope, Symmachus, who had been accused of fornication, squandering church resources, and celebrating Easter on the wrong date. The precedent and its conclusions were clear: only God could judge the pope.

Although Alcuin had no way of knowing it, both texts were forgeries.

Also familiar to educated Franks was a document now known as the Donation of Constantine. The Donation appeared to be a deed written by Constantine the Great during the fourth century in which the emperor, supposedly having been cured of leprosy by Pope Sylvester, gave control of Rome, Italy, and the western empire to the papacy shortly before he marched off to Byzantium to found his new capital. The Donation had first come to light around half a century earlier; the idea behind it was probably older.

Neither Karl nor Alcuin nor Pope Leo III knew that the Donation of Constantine was also a forgery. Fortunately for them, neither did the pope's accusers.

That fall, Karl crossed the Alps and arrived at Ravenna, where he learned that Duke Grimoald of Benevento was rising in revolt. The rebels seem not to have expected company so late in the year, and certainly not a visit by the Frankish king himself. Unfazed, the king sent his son Pepin to lead an army against them. Karl was in no mood for distractions; the planning took only seven days.

Back home in Francia, farmers spent August reaping the wheat they had sown earlier in the year. By September, they started to sow their winter crops: wheat and rye. A full year had come and gone, and for them the world was no younger and no less dismal; and it was once again time to post night watchmen in vineyards and await the frost and snow.

Karl hastened to Rome. It was time to reap what he and his wise men had sown—and what others had sown decades or even centuries earlier.

.8.

KARL, CROWNED BY GOD

Rome, A.D. 800

Most guidebooks to Rome will tell you where to find the *Triclinio Leoniano*—and there, if you use your imagination, you can also find Leo and Karl.

The *Triclinio* stands along the Piazza di Porta San Giovanni across from the Lateran Palace. Given to the church by Constantine the Great, the Lateran has been humbled by earthquakes, destroyed by fire, rebuilt by the historically inclined, and gaudily re-adorned according to the whims of later, louder centuries. Where ancient popes once lived and prayed and took their meals, the rebuilt palace now houses an array of papal offices. If those

long-dead popes were somehow to wander into modern Rome, dodging traffic to gape at the current Lateran, they would never know the place.

What the popes might recognize is the mosaic on the *Triclinio*. Exposed to the elements, it is now a wall with no building around it, nearly 130 feet from where the original once stood. The mosaic on its surface is the last faint remnant of the decorations commissioned by Pope Leo for his opulent triclinium, the Lateran dining hall. Only a few tiles, if any, are original. Most of the mosaic is an eighteenth-century reconstruction based on a seventeenth-century restoration, a baroque shadow of a medieval shadow from a world of dead and distant men.

But the faces on the mosaic are familiar, at least to Christians. Inside the half dome, the risen Christ sends his apostles to preach to the world. To the left of the arch, in a heaven drenched in gold, the enthroned Christ hands the labarum—the spear and banner with the symbol that inspired Constantine—to Constantine himself. Christ hands the pallium—the symbol of authority of popes and archbishops—to a figure who is either Pope Sylvester or Saint Peter.

The other side shows a remarkable scene: Saint Peter enthroned, with Pope Leo and Karl the Great both kneeling before him. To the pope, Peter hands the pallium; to the king, a banner of victory. Unlike the saint, the men have square halos, indicating that the original mosaic was made while both of them were alive. The word *rex* identifies Karl as king. He is not yet an emperor. Soon, like Constantine before him, he will be.

Leo stares straight ahead. He is round-faced, dark-haired, tonsured, sandaled. Karl stares too, with his large moustache, crown, sword, and the bands of cloth that wrap his legs in the common Frankish style.

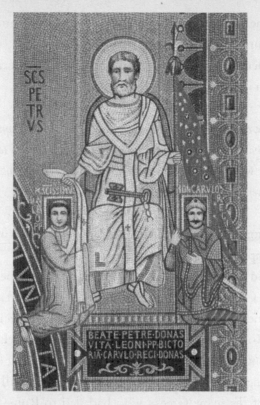

Exposed to the elements in modern Rome, the restored mosaic on the Triclinio Leoniano *may depict Karl and Pope Leo as their contemporaries saw them.*

It is tempting to imagine that both men looked exactly like this in the year 800 as they lounged on couches and drank together in the Lateran triclinium, their legs sprawled across the marble floor, their ears soothed by the rush of fountains, their eyes accustomed to the forest of porphyry columns and the mosaics that glistened around them. They could glance around the room and see, strangely, themselves, rendered in glass and gold high on

the wall, the very palace affirming their partnership and its prece-
dents in Christian history.

Both men could agree on the importance of the scriptural text
above them in the apse:

> Go ye therefore and teach all nations, baptizing them in the name of the
> Father, and of the Son, and of the Holy Ghost: Teaching them to observe
> all things whatsoever I have commanded you: and lo, I am with you
> alway, even unto the end of the world.

That mission, as Alcuin was always reminding his king, was the
work of empire.

Karl and Leo also may have chatted about the emperor, or lack
thereof, in Constantinople, and the wicked things Irene was said
to have done. They may have speculated about what a new, Latin-
speaking Roman emperor might mean for foreign relations. Per-
haps the king noticed, and mentioned to the pope, that the mosaics
in the dining hall substituted the letter B for V, a small sign of the
influence of the many Greeks who had fled to Rome during the
crisis over iconoclasm. The balance of power in Christendom was
shifting westward.

In response, Pope Leo may have touched the scars on his face
and recalled his imprisonment at a Greek monastery twenty
months earlier. Crafty and unsentimental, he dwelled not on self-
pity, but on revenge. This he kept to himself.

More than 1,200 years later, only wishful thinking assumes
that the *Triclinio Leoniano* shows Karl and Leo as they really looked,
and no evidence survives for their intimate, behind-the-scenes dis-
cussions. History records only the outward, the official, the cere-
monial: that on Saturday, November 23, 800, Pope Leo met the

Frankish king at Mentana, twelve miles outside Rome. Centuries earlier, emperors had been received there before formally entering the city.

That November, no one who remembered Roman tradition needed to be privy to secret dining-chamber meetings to know what was going to happen. Karl was entering Rome as *rex*. He was going to depart the city as something else entirely.

That evening, Karl and Leo dined, and then the pope returned to Rome ahead of the king. One annalist recorded how Leo arranged for Karl's formal entrance:

> On the next day he sent the banners of the city of Rome to meet him and ordered crowds of townspeople and pilgrims to line the streets and acclaim the king on his arrival. Standing with his clergy and bishops on the steps of the basilica of the blessed apostle Peter, he welcomed the king when he dismounted from his horse and ascended the stairs. A prayer was offered and while all were chanting the psalms the pope led the king into the basilica of the blessed apostle Peter.

It was Sunday. In Rome, everything stopped for mass.

Karl spent his first week greeting Arno of Salzburg and consulting with Theodulf, who had dutifully come to Rome, while discussing matters with Alcuin's pupils and acquainting himself with the locals and their agendas. Thirteen years had passed since his previous visit to Rome, and much had changed. Unfortunately, his business left no room for distractions, and so it is disappointing to think that the king spent little time that winter outside of

palaces and basilicas. This visit to Rome, his fourth, would also be his last.

The king's daughters and their brother, the younger Karl, had accompanied their father to Rome. The girls may have had time to see the sights, but Karl probably followed his father everywhere. As heir to the throne, he knew that something big was planned for him that winter. This young man, who had lived all his life in the shadow of a talkative, tireless king, had no way of knowing that these few weeks in Rome would make his father a legend but would obscure his own life, leaving his greatest moment forgotten by history. Had he known, he might have spent more time that winter on sightseeing.

Wherever they spent their days—in hiding, under arrest, in their homes, or safe behind the walls of a Greek monastery—Paschalius, Campulus, and the other conspirators passed a nerve-racking week. Finally, Karl called an assembly to make his intentions known; and on December 1, the most important men in Europe flocked to the basilica of Saint Peter. Karl himself presided. Pope Leo sat near him, along with the bishops and abbots. Nobles, priests, and lesser churchmen remained standing, in keeping with Frankish custom.

The synod met for nearly a month, in a flurry of testimony collected by underlings; depositions recited for the record; and innumerable motions, debates, presentations, discussions, and dismissals. The minutes of the synod are lost, but the brief summaries that survive highlight some of its most important moments, many

of which suggest an impressive and well-choreographed piece of medieval theater.

Following whatever ceremonial niceties opened the proceedings, Karl tackled the main issue on the agenda: the charges against the pope. Officially, Leo was accused of perjury and adultery, but the question had become much larger than one man's alleged indiscretions. The pope had been attacked, imprisoned, and discredited in the eyes of many, and the city of Saint Peter and Saint Paul was in turmoil. Christians needed a worthy leader; the Franks needed a reliable ally in Rome; the Romans themselves needed peace, not assassins stalking the pontiff in broad daylight—and Karl needed to set things right with as much legitimacy as the situation allowed.

Because Roman law dictated that the burden of proof fell on the accusers, the conspirators came forward to present evidence for their claims. According to one annalist who summarized weeks of business in just a few sentences, the case presented by Paschalius, Campulus, and their associates was unpersuasive:

> And there the king convened a great gathering of bishops and abbots with priests, deacons, counts, and the rest of the Christian people, and those who wished to condemn the pope came into their presence. When the king concluded that they wished to condemn the pope not for the sake of justice but out of malice, then it seemed to that most pious prince Karl and to all the bishops and holy fathers who were present that if the pope wished it, and if he requested it, he ought to purify himself not through their judgment but through his own free will.

The archbishops, bishops, and abbots then spoke with one voice. The *Liber Pontificalis* records their words verbatim:

> *We dare not pass judgment on the apostolic see which is the head of all*
> *God's churches; it is all of us who are judged by it and its vicar; just as*
> *the custom was of old, it is judged by no one. But as the supreme pontiff*
> *has decreed it, we will obey according to the canons.*

The apostolic see is not to be judged but to give judgment. Alcuin had written those words to Arno more than a year earlier as his friend prepared to travel to Rome, supporting his position with historical examples that no knowledgeable Christian could deny. Witto and Fredugis may have presented Alcuin's findings to the assembly on their mentor's behalf, or they may have convinced the bishops of the pope's immunity in more subtle ways behind the scenes. In either case, the implication was plain, and it was on the record: the pope could not be judged.

For Karl and his allies, matters were proceeding smoothly. But Paschalius and Campulus could see, with growing dread, that the synod no longer was a trial of Pope Leo but was turning into something else entirely.

Although the bishops made clear that they were not competent to judge a pope, every trial needed a judge. Karl presided over the synod, but officially he was not its judge. Leo reiterated this point, following up the bishops' decree with a statement of his own:

> *I follow the precedents set by my venerable predecessors as pontiffs, and am*
> *ready to clear myself of these false charges whose evil flames engulf me.*

Here in Leo's own words was the implicit conclusion of Alcuin's research. Like earlier popes accused of crimes, Pope Leo would have to judge himself.

As he sat through another tedious day of testimony, Theodulf of Orléans was probably restless. He knew how all this would end, God willing, and he had never been fond of Rome.

For Theodulf, the problem wasn't Rome per se, but the dubious motives that drew Christians there and their crass conduct after they arrived. As he wrote in one Latin poem:

> It is no more useful to go to Rome than it is to live correctly,
> Whether in Rome or wherever a man's life leads him.
> The way to Heaven leads not, I believe, on foot, but through moral
> behavior;
> Whatever you do, wherever you do it, from on high, God sees.

"God Should Not Be Sought in Any Place," according to the title of the poem, "but Cultivated through Piety." That was a fair belief for an early medieval Christian and a fine one to propound in verse; but during slow moments at the synod, Theodulf's assistants might have reminded him, and he might have agreed, that in the next few days something remarkable was going to happen. It had to happen here, in Rome, and it wouldn't be something that you could experience elsewhere, at home, no matter what God saw you do, and no matter how righteously you tried to live.

More than 1,200 years after the visit of the royal Franks, tourists in Rome still find much to see at Saint Peter's—more, in fact, than did their eighth-century predecessors. Since the fifteenth century, when the papacy started moving its operations west across the Tiber, popes have glorified God and honored Saint Peter through amazing works of architecture and art. Modern pilgrims gape at Maderno's ornate seventeenth-century facade, explore gorgeous sixteenth-century grottoes, and gaze upward into Michelangelo's great and glorious dome. Aesthetes, art historians, students, and the clergy admire masterful frescoes by Renaissance painters such as Botticelli and Raphael; they marvel at Michelangelo's *Pietà;* and they lose themselves in the ceiling of the Sistine Chapel.

All that was ages away. What Karl and his companions saw on the eastern slope of the Vatican Hill was "old" Saint Peter's, the basilica built by Constantine the Great to enshrine the apostle whose name it bore. When Karl entered the long, stately building, he saw the restorations he himself had endowed: the eighty-foot tree beams that spanned the ceiling, supporting 1,000 pounds of fresh lead roofing. Glancing down, the king beheld silver floor tiles near the altar; staring up, he admired a magnificent chandelier. Striding across a foundation of graves, he saw the tomb of his friend Pope Hadrian; it was inscribed with the eulogy Alcuin had composed, just as the king had ordered. Outside, Karl and his entourage could admire the Egyptian obelisk on the south grounds—but only if they were able to reach it through the cluster of stalls, shops, tents, and tables that formed an eternal city all their own. Just steps from the doors of the basilica were relic hawkers, holy men, food vendors, limping pilgrims—sights and sounds occasionally encountered north of the Alps, but rarely so blatantly, and never in such abundance.

Renowned architectural historian Turpin Bannister drew this detailed reconstruction of the original Basilica of Saint Peter, where much of the drama of A.D. 800 took place.

Despite a wintry chill and the whispers in basilican back rooms, the year 800 was a wonderful time to be in Rome. In one poem, Alcuin wrote the city off as "a great mass of cruel ruins," but his dismissal was premature. After long neglect, the Eternal City was alive again, thanks to the generosity of popes, pilgrims, and kings. Roman churches had new roofs, new mosaics, impressive new columns, and—most enticing of all—new permanent residents. After centuries of skittishness, Romans were becoming comfortable with the eastern custom of allowing saints' relics inside the city walls. Countless urban churches were now thriving tourist destinations; magnificent shrines declared their exalted status.

Nine hundred miles away, at another famous shrine, Alcuin prayed, prepared for Christmas, worked on his books, managed his monks, reviewed reports from his monasteries, and waited for spring, which would bring the news he knew would come.

For Karl, each evening in Rome brought one small relief. When he was at Aachen, he wore what most Franks wore: a linen shirt, linen trousers, bands of cloth on his legs, and a rodent-fur cape during the winter. This is the Karl who still watches modern Rome from the *Triclinio Leoniano*, the Karl who ruled a Germanic tribe, Karl as he wished himself to be remembered.

According to Einhard, this is not the Karl whom strangers saw in Rome:

> *He hated the clothes of other countries, no matter how becoming they*
> *might be, and he would never consent to wear them. The only exception*
> *to this was one day in Rome when Pope Hadrian entreated him to put*
> *on a long tunic and a Greek mantle, and to wear shoes made in the*
> *Roman fashion; and then a second time, when Leo, Hadrian's successor,*
> *persuaded him to do the same thing.*

Pope Leo had persuaded Karl to dress like a Roman. The king had done so with reluctance and apparently with discomfort. The mantle does not seem to have suited him.

On December 23, rows of robed men flowed into Saint Peter's as the archbishops, bishops, abbots, and nobles gathered for the final session of the synod. The nobles, priests, and lesser churchmen stood, as they had for days. The archbishops and bishops sat, as did Karl and Leo—but Leo did not sit for long. In front of everyone, the pope embraced the gospels and stepped up to the pulpit.

Although Paschalius and Campulus had brought charges against the pope, they had been unable to prove their case, thus failing to meet their burden under Roman law. But what happened next had little to do with Roman law. Instead, it harked back to a core concept of Frankish law and of Germanic law in general: the oath.

From his place in the pulpit, Pope Leo swore an oath in the name of the Father, the Son, and the Holy Spirit:

> *I have no knowledge of these false allegations which those Romans who wickedly persecuted me bring against me, and I know that I have not committed such crimes.*

Reciting such an oath in public should have been humiliating for a pope, but if Leo, scarred from the previous year's attack, was embarrassed or reluctant, the written sources never admit it. Before anyone in the basilica of Saint Peter could ponder the question, the assembly burst into celebratory chanting.

The pope was innocent. The synod was ended. Thanks be to God!

Paschalius and Campulus must have been flabbergasted.

Meanwhile, a priest and two monks were approaching Rome. The first act had ended. The second was about to begin.

The embassy from Jerusalem arrived the next day, on Christmas Eve. Karl already knew Zacharias, the palace priest at Aachen whom he had sent to the patriarch. Zacharias, who was probably Greek or a Greek-speaking Italian, had been given specific directives by Karl; and he would have been able to talk about serious matters with George, the Christian patriarch, in a language that both men would have easily understood.

The two monks were new to Karl. One was from the Latin-speaking, western-leaning monastery of the Mount of Olives; the other was from the Greek community of Saint Saba. Together they represented both sides of the Christian world in Jerusalem. On behalf of their patriarch, they presented the king with gifts: the symbolic keys to the Church of the Holy Sepulchre, where Christ had been entombed; and to Calvary Church, where he had been crucified. They also brought the keys to the city of Jerusalem and Mount Zion—the traditional resting place of King David and the site of the Last Supper—as well as a banner.

The keys to the Christian holy places sent a powerful message. Beyond its role in biblical history, the Church of the Holy Sepulchre was also the headquarters of the patriarch and a site of pilgrimage for western relic-seekers. It was unrealistic for George to expect the Franks to offer genuine protection across such vast distances, but with Jerusalem in the hands of the Islamic caliphate, the Christian patriarch prudently extended his friendship not to the Muslims' nearest Christian enemy, Irene, but to that enemy's

enemy. Symbolically if not actually, Patriarch George of Jerusalem was transferring his loyalty from Constantinople to the Franks. By contrast, the keys to the city of Jerusalem and the banner represented not a Christian offering by George, but a second, more explicit political statement. These sorts of gifts, especially the banner, went beyond the prerogative of the patriarch of Jerusalem. They required the approval of the caliph, Harun al-Rashid.

Today it is unclear whether this gesture made Karl the honorary governor of Jerusalem, or whether it made him Harun's subordinate, or whether the caliph was honoring the king as an equal. Even in 800, there was no real precedent to explain the patriarch's actions. What was evident to Karl from George's gesture was that three years after its departure, the embassy of Lantfrid, Sigimund, and Isaac had arrived safely in Baghdad and had secured the friendship of the Abbasids. Mindful of his Greek-speaking enemies, Harun had heeded their saying: "Have a Frank as a friend, never as a neighbor."

Although they had just come from Jerusalem, Zacharias and the monks knew that they should seek Karl not at his palace in Aachen but here at this synod in Rome. The symbolism of their presence was profound, and their timing was remarkable. They seem to have known that the next day, December 25, would be no ordinary Christmas.

For 1,200 years, the moment has been enshrined in art: medieval manuscripts, modern lithographs, Parisian murals, American storybooks. They always show Karl with a great

gray beard that he never had in real life. He is usually solemn, as is Leo, while bystanders look on with wonder; some of them swoon. A few of these depictions may be accurate. Of the thousands of people in the basilica that day, only some were near enough to see, but legends do spread quickly.

On December 25, 800, no pilgrims gaped at the tomb of Saint Peter; few could even get near it. This was Christmas, and the nave was crowded with the faithful—bishops and archbishops, Frankish nobles, prominent Romans, monks from all across Christendom, and more rabble than anyone could count. Foreigners strained to see Karl around the towering columns that supported the upper walls, six times taller than any man. High in those walls, translucent alabaster let in the light that brightened the face of Pope Leo.

Those who pushed their way to the front, and those who could read, found a Latin inscription in the arch above: "Because under Thy leadership the world rose triumphant to the skies, Constantine, himself victorious, has founded this hall in Thy honor." Beyond the arch was the shrine to Saint Peter, flanked by spiral columns, guarded by canopies, and overhung by a lamp. Above it was a gorgeous glimpse of heaven: Christ on his throne, with Saint Peter and Saint Paul. In the space under their feet, lambs from Jerusalem and Bethlehem approached an altar and the Lamb of God. At the top of the mosaic, the hand of God blessed all the world below.

Beneath this burst of color and light, Karl rose to pray.

It happened quickly. In one swift gesture, Pope Leo placed a crown on Karl's head, and history was made. With one voice, the congregation exclaimed three times: "To Karl, pious Augustus crowned by God, great and peaceful emperor, life and victory!"

Then, Leo knelt before the new emperor—just as the patri-arch of Constantinople would have done at Hagia Sofia.

For the first time in nearly 400 years, an emperor had returned to Rome.

Einhard later wrote that if Karl "had known in advance of the pope's plan, he would not have entered the church that day, even though it was a great feast day." The emperor's friend flattered him with claims of modesty, but talk of empire had been in the air for years. Karl had convened the Roman synod as if he were an em-peror, and the congregants in the church knew what to say and when to say it, as if they had rehearsed.

On the other hand, Karl's grouchiness may have been genuine frustration at appearing beholden to the pope or regret over hav-ing staged such an elaborate Roman entanglement. Thirteen years later, when Karl passed the imperial crown to his son, he did so himself, at Aachen, and without the involvement of the pope.

That Christmas, as the chants of the faithful shook the raf-ters, any Greek monks in Saint Peter's knew this hasty ceremony to be most irregular. In Constantinople, there were specific, me-ticulous ways to do such things; the eunuchs made sure of that. And at home, the would-be emperor was acclaimed by the people and the army, and *then* he was crowned, and *then* the patriarch of Constantinople knelt before him.

Leo had reversed the order. Also, the pope was no patriarch of Constantinople. At least envoys from the patriarch of Jerusalem were there, in the crowd, somewhere. To Karl, Pope Leo, and al-most everyone assembled, it was close enough.

Two days earlier, Karl had been the king of the Franks and "patrician of the Romans." The day before, he had become, in theory, defender of the holy places in Jerusalem. Now he was an emperor—but there was one further piece of business that Christmas.

Standing near Karl was his eldest son. The emperor's namesake was nearly thirty years old, and he had followed his father around Europe waiting for this moment. After the elder Karl was crowned, the pope anointed the younger Karl, just as his father had been anointed as a child nearly half a century earlier. The gesture imitated the anointing of David in the Old Testament, a solemn act indicating that Karl's right to rule came directly from God. The younger Karl was now officially king of the Franks.

It hardly mattered. In a few years he would be dead, forgotten by his contemporaries. Most annalists pass over his proudest moment in silence.

News of Karl's highly unorthodox coronation reached Constantinople, perhaps by a ship bringing slaves from Venice, a monk returning to his homeland, or a diplomat who crept nervously into the imperial court. Faced by Islam to the east and barbarians to the west, Irene and her subjects were united in disgust. Despite a long tradition of backstabbing and factionalism, the empress and her political enemies were of one mind about this, if about nothing else: the "coronation" of the Frankish king was a joke, an insult, and a parody of Roman ceremony. It was also a threat.

The monk Theophanes speculated that the imperial title was

Karl's reward for sorting out Leo's mess in Rome; he reported that the coronation involved "anointing him with olive oil from head to foot and clothing him in the imperial regalia and crown." Theophanes wildly misunderstood the western ritual of anointing, but his confusion was more significant as proof of the widening gulf between the Franks and the Greeks. In the years that followed, diplomats, churchmen, and emperors all made overtures, but more controversies followed, both political and theological, and estrangement was inevitable. Christendom was split in half.

That year, thousands of miles away, Harun al-Rashid left his palace in Raqqah and sailed down the Euphrates to Baghdad. He punished tax cheaters, appointed a governor for northern Africa, and sent out an army to crush rebels. Except for their dealings with a few forgettable diplomats—two Franks and a Jew named Isaac—neither he nor his counselors devoted much thought to an emperor named Karl in Rome.

The pope was innocent, and Karl was emperor; but the instigators of the winter's drama did not sneak silently away. Karl was ready to exercise his imperial authority and set Rome right. A few days after Christmas, the new emperor ordered Paschalius, Campulus, and the other conspirators to stand trial. The proceedings were run according to Roman law, and the malefactors were quickly found guilty of *laesa majestatis*, an attack on the emperor or on the people and places under his protection.

In one oddly comic passage, the *Liber Pontificalis* describes how the conspirators incriminated themselves in front of the Romans and Franks:

> *Campulus turned on Paschal and rebuked him: "It was a bad moment when I first saw your face, as it was you who put me in this danger."*
> *The others did the same, each damning the other and proving their guilt.*

The conspirators were sentenced to death. No one noted that technically, Karl had not been emperor at the time of the attack.

In his final performance of the season, Pope Leo intervened on his attackers' behalf. He begged Karl to show mercy, suggesting that the emperor exempt Paschalius and Campulus not only from execution but also from any other form of mutilation or punishment. Graciously, the emperor let them live. He exiled them to Francia, where he knew his clemency would be upheld.

Fifteen years later, shortly after Karl's death, someone warned the aging pope that nobles were again conspiring to kill him. His hand no longer stayed by the prudence of a Frankish barbarian, Pope Leo had all of them executed.

Spring arrived, and Alcuin found beauty in it. Echoing ancient pastoral songs, one of his poems proclaimed his faith in renewal:

> *Say no more, Winter, you terrible squanderer of wealth.*
> *The cuckoo, sweet friend of shepherds, shall come!*

Let the seeds burst luxuriantly into bud on our hills,
may there be pasture and sweet repose in the fields for the flocks,
the green boughs offer shade to the weary,
and the goats come to pail with full teats,
let the birds greet Phoebus with their different songs!

It was springtime in Rome, and a new season was breaking across Europe.

Epic poets polished their newest phrases. Karl was a beacon; a hero; *pater Europae,* the "father of Europe." A new Europe really was being born, and its ancestors included Germanic customs, memories of ancient Rome, and a dollop of Roman law; church traditions rooted in forgeries unearthed by a Saxon abbot from England; an improvised coronation ceremony borrowed from Greek-speaking Constantinople; the smooth talk of diplomats; and the approval of the patriarch of Jerusalem—which, in turn, represented the distant nod of the Islamic caliph.

Content with the outcome, Alcuin could never imagine how profoundly the coronation on Christmas Day changed the world. Long after the deaths of Alcuin and Karl, the imperial title would endure, wandering around Europe for centuries and eventually representing the leadership of a "Holy Roman Empire"—a phrase Karl himself never heard. A millennium later, Napoleon Bonaparte would claim the emperorship of France in a ceremony mimicking the coronation of Charlemagne, his great French hero. Later, Adolf Hitler would admire *Karl der Grosse* for founding a First Reich, the inspiration for a regime destined to last, he would think, for a thousand years.

To Alcuin, the coronation had occurred out of need: the need

to shore up Christendom, the need to defend the papacy, the need to illuminate the world. But beyond its religious importance, the ceremony also had a political dimension. Karl's coronation had allowed him to restore peace in Rome, and it was a stinging rebuke to the Franks' rivals in Constantinople.

That spring, Alcuin wrote to Karl:

> *So every day I used to hang upon the words of our visitors for news of my dear lord David, anxiously longing to hear when he would come back home to his own country. At last the longed-for words rang in my ears: "He will soon be here; he has crossed the Alps, he whom you so fervently wished to come, Albinus."*

Alcuin was unaware of the troubled future that he and the rest of the European elite had bequeathed to their descendants. In the spring of 801, the abbot of Tours, counselor to kings and the wisest teacher in Europe, prayed only for his friends to return safely home.

B efore that could happen, Karl and his counselors had one final matter to settle: the exact wording of the imperial title. He had been crowned *imperator Romanorum,* "emperor of the Romans," a title that was likely to receive a cold reception from proud Frankish nobles at home. For all their talk of Roman glory and the courtly vogue for Latin poems, some ethnic Franks had mixed feelings about Roman history. The prologue to a Frankish law code from around 802 remembers the old Roman empire as a foe of the early Franks and an enemy of Christianity:

For this is the people who while small in number are great in strength.
In battle [that nation] shook off the powerful and very harsh yoke of the
Romans from its neck. And, after the knowledge of baptism, the Franks
decorated with gold and precious stones the bodies of the blessed martyrs
whom the Romans had mutilated with fire or sword or else had thrown
to the beasts to be torn.

Mulling over Karl's primary identity as king of the Franks
while acknowledging his other honorifics, the imperial counselors
concocted a mouthful: *Karolus serenissimus augustus a Deo coronatus*
magnus pacificus imperator, Romanum gubernans imperium, qui et per misericor-
diam Dei rex Francorum et Langobardum: "Karl, the most serene Augus-
tus crowned by God the great peaceful emperor, governing the
Roman Empire, king of the Franks and Lombards through the
mercy of God." The title emphasized governing an empire rather
than ruling the Roman people. Like most of the events of that
winter, it had no exact precedent.

By the time Karl returned to Aachen, his royal seal on Italian
documents already bore a bold new slogan: *Renovatio Romani imperii,*
"Restoration of the Roman Empire." Whatever the opinion in
Francia, no one in Rome doubted the truth of the sentiment. True,
the population of the city was not what it had once been—tens of
thousands where more than a million once lived, and too many
empty quarters—but were the aqueducts not flowing? Were the
fields not rich with crops? Were the city walls not restored? Were
the churches not more opulent than ever? At Saint Peter's alone,
Emperor Karl left enough golden vessels and jeweled crowns to
enrich half the world. The basilica of Saint Paul shone with fresh
silver. Throughout the Eternal City, pilgrims approached the al-
tars of churches where docents pointed to crosses, books, and

tables made of silver and said, for the first time in centuries: *Those? Those were given by the emperor and his family.*

Karl never returned to Rome. The emperor was around sixty years old, and he had recently buried another young wife. It was time to take off the Roman costume and get back to Aachen; back to fighting Saxons; back to the hot baths, the forest murmurs, the familiar chapels and churches; back to banquets in familiar rooms, the songs of Irish poets, the mimes and dancing bears. It was time to get out of Rome, away from its politics and problems, and return to a kingdom where a Frank could be a Frank—a place where, despite his many burdens, a gray-haired king could take up arms, wrap his legs in cloth, and hunt.

As the new emperor made his way home, a massive earthquake rattled Italy. Aftershocks were felt as far north as the Rhine. It was the season for such things.

AN ELEPHANT
AT AACHEN

Ifriqiya to Aachen,
A.D. 801–802

The first thousand miles were probably the worst.
Coming from Baghdad, the man known to Frankish annalists as Isaac the Jew passed through Jerusalem, crossed the Sinai, and journeyed along the Egyptian coast. As Karl was being crowned emperor in Rome amid luxury and pomp, Isaac was crossing the land known in Arabic as the Maghreb, the western edge of the Islamic world where the sun sets low behind dull, dusty hills.

"This," wrote one modern traveler, "is the land of Ifriqiyeh, now cracked by drought, now inundated by raging downpours. But it is above all a seaboard land, on which so many conquering

or outcast peoples have stumbled, foundered, and revived." Eager
for grain, fruit, and horses, the Romans put down roads along the
Mediterranean plain and built, as they always did, their aqueducts
and stadiums. They cultivated fields, dammed wild rivers, and
raised rows of columns around temples and towns. Ages later, the
Franks' descendants came here too, eager to colonize Algeria and
Tunisia, two of the countries that the Maghreb became.

But for now, in 801, this land was Ifriqiya. It had been taken
for Islam by the Abbasids in Baghdad, but its hills were haunted
by nomadic Berbers and its plains by Roman ghosts. According to
tradition, the Prophet's Companions had prayed away the snakes
and scorpions, but the tale gave little comfort to a homesick Euro-
pean, who saw the creatures everywhere, and who prized the
patches of green that occasionally graced the horizon.

As he traveled west on the 2,500-mile route from Baghdad to
the Ifriqiyan city of Kairouan, Isaac passed camel caravans head-
ing the other way, laden with hunting hawks and panthers or less
unusual commodities such as tanners' leaves and African felt. He
also saw urgent messengers, unburdened by trade, traveling fast in
either direction. That year, 184 by Islamic reckoning, an official
named Ibrahim ibn al-Aghlab had purchased Ifriqiya from Harun
al-Rashid; the price was 40,000 dinars paid annually to the ca-
liph's treasury. Baghdad could scarcely control a province on the
western edge of its caliphate, and the new emir was buying a heap
of dust and trouble: a land of willful Berber tribesmen, haughty
Arab soldiers, and strict Islamic teachers who missed no opportu-
nity to condemn their leaders' blasphemies.

This was the country Isaac dealt with as he plodded drearily
along. All caravans moved slowly, of course, but in this case the
pace was even slower, because of one of Isaac's traveling compan-

ions, a lumbering ambassador from Baghdad who was vast in size, ravenous, and prone to wander. This ambassador took no interest in Roman ruins, and he required far more maintenance than even the most pompous Persian dandy. His name was Abul Abaz, and he was an elephant—and a gift for Emperor Karl from the caliph Harun al-Rashid.

Abul Abaz ate voraciously—leaves, grass, fruit, bark, whatever his trunk could grasp. He needed around twenty gallons of water each day. He needed shade, and he rarely slept. Keeping Abul Abaz happy, and keeping him moving, was a job without end.

The sun was harsh, the earth was cracked, and Isaac was in a dead zone between the culture of Baghdad and the comforts of home. Whatever reward awaited him for leading an elephant across 3,500 miles, it could not have been enough.

L ike Isaac, Karl was going home too. Hundreds of miles north, across the Mediterranean, the emperor moved between Italian towns. In Pavia, he heard that envoys from the caliph of Baghdad had arrived by sea at Pisa. He sent messengers to meet them, and the foreign envoys soon caught up with his wandering court on the road between Vercelli and Ivrea.

Two envoys came to the emperor: one from Baghdad, the other from Ifriqiya. The Franks had seen plenty of dark-skinned foreigners and a fair number of Muslims, but according to a Frankish annalist, these two brought extraordinary news:

They reported that Isaac the Jew, whom the emperor four years earlier had dispatched with Lantfrid and Sigimund to the king of the Persians,

*was returning with large presents, but that both Lantrfrid and Sigimund
had died.*

*Then the king sent Ercanbald, the notary, to Liguria to prepare a
fleet on which the elephant and whatever else he brought along might be
transported.*

The emperor spent much of the spring making changes in
Lombard law, including harsher penalties for army deserters and
thieves. Sifting through laws was tedious, but it was an emperor's
duty. When Karl heard about the impending arrival of an amaz-
ing, exotic beast, surely he smiled. Being emperor had its privi-
leges, too.

In Ifriqiya, Isaac paused. The future of relations between the
Franks and Abbasids was in his hands. Only four years ear-
lier, he had been a subordinate, probably an interpreter hired
for his connections to Jewish communities along the route to
Baghdad. The deaths of his Frankish companions, Lantfrid and
Sigimund, had changed all that.

For the early medieval traveler, there was no shortage of ways
to die. Bandits and wild animals stalked remote areas, and written
credentials from kings and caliphs were no guarantee of food and
lodging beyond local borders. Nature posed its own perils: floods
swept away bridges, rivers froze, and ships at sea were engulfed by
storms and vanished forever. Travelers faced disease, accidents,
and random violence, sometimes from the people they were sent to
befriend. Karl knew better than to send reckless men to Baghdad,
but Lantfrid and Sigimund may have had unavoidable confronta-

tions with the locals. Pale European barbarians were odd creatures in the salons of the Abbasids; and one tenth-century account by a native of Baghdad, al-Masudi, described the Frankish people in rude and unflattering terms:

> *The warm humor is lacking among them; their bodies are large, their natures gross, their manners harsh, their understanding dull and their tongues heavy. Their color is so excessively white that it passes from white to blue; their skin is fine and their flesh coarse. Their eyes too are blue, matching the character of their coloring; their hair is lank and reddish because of the damp mists. . . . Those of them who are furthest to the north are the most subject to stupidity, grossness, and brutishness.*

One modern Saudi etiquette manual cites an anecdote about Frankish ambassadors to Harun al-Rashid who offended the caliph by removing their caps; the caliph informed them through an interpreter that in Baghdad conveying respect required keeping one's cap firmly on one's head. The story is certainly a fable, but like the offhand references to Franks loitering at court in the pages of *The Arabian Nights*, it may be a faint echo of an actual incident.

Unimpressed by their visitors, Abbasid historians said absolutely nothing about ambassadors from Aachen. Except for one biography of a Christian saint that mentions a relic-seeking monk who sighted Karl's emissaries in Jerusalem, almost nothing is known about the time Isaac spent in Baghdad, or about most of his return trip.

While waiting for the messengers to return from Italy, Isaac remained the guest of Ibrahim ibn al-Aghlab at his capital on the bleak plain at Kairouan. Here Isaac saw the great mosque built from pieces of old Roman buildings, and he heard, often, the call

to prayer, as he had in Baghdad. The three-story minaret was the tallest structure in town and in those days the only thing worth looking at in Kairouan. Modern visitors can still hear what Isaac heard, and they can still see what he saw: one of the oldest standing minarets in the world.

Ibrahim prided himself on his new dynasty, the Aghlabids. Within decades, the Muslims of Ifriqiya would control the sea; eventually, they would conquer Sicily. But despite Ibrahim's dreams of endless Ifriqiyan supremacy, in a century the Aghlabids would be gone, swept away by Shiite fanatics with the aid of Berber muscle. Kairouan became increasingly sacred, the holiest city west of Mecca, but that was a legacy for others to exploit. All empires end; in the cooler corners of the Kairouan mosque, pieces of Roman ruins silently confirmed it.

The ghosts of empires also haunted the ruins of Carthage, about eighty miles from Kairouan. "To Carthage then I came, where a cauldron of unholy loves sang all about mine ears," wrote Saint Augustine in his *Confessions,* lamenting the frivolity of his student years in the ancient seafaring city. Strolling along the waterfront and wandering down shady lanes, the future bishop and saint saw Carthage at its peak, when Rome ruled all the world. Four centuries later, visitors saw only debris, overgrown with grass and vines, the greatness of Rome fallen to pieces.

Scorched by the heat of a Tunisian summer, Isaac may have pondered the fates of past and present empires while recalling that his king's favorite book was, in fact, a work by Saint Augustine, *The City of God.* But as a practical man intent on fulfilling his mission, Isaac is more likely to have stood on the sands by the old Carthaginian wharf, looked north across the sea, and wondered: *How are we going to get an elephant to the other side of the Mediterranean?*

A long other coasts, Constantinople was a capital in disarray. The news of Karl's imperial coronation prompted official indifference, but its implications were dawning on the proud heirs of Rome. In the forum of Constantine, in the bleachers of the hippodrome, and in the chapels of Hagia Sofia, everyone talked about the messengers who had come to town. A rumor raced from the palace to the harbors and beyond the city walls, and the monk Theophanes kindly recorded it for posterity: legates sent to Irene by Karl and Pope Leo had come with a marriage invitation from the Frankish emperor, who was eager to unite east and west.

Constantinopolitans were numb to scandal. A blinding here, a coup there—at the end of the day, merchants counted coins, priests prayed, and eunuchs folded robes and snuffed out candles regardless of who served as emperor. The existence of a *basilissa*, an autonomous empress, had disturbed them, but only briefly; and even when Irene had roared out of church on Easter Monday in a chariot drawn by four white horses and steered by four patricians, tossing coins along the way—well, they had learned to live with that, too. They were accustomed to a male emperor on horseback, but coins were coins, and tradition could bend, slightly, temporarily.

Ask the customs agent; ask the onion monger: novelty held no attraction in ninth-century Constantinople, but patience did. Patience was a Roman virtue, and with it came an understanding that like every earthly thing, the reign of this empress would pass. She was well past forty and had no heir. Soon, to be sure, some

good, Greek-speaking general would be back in control after doing what needed doing.

But . . . marriage? To a Frank? Muslim military assaults shamed the empire every summer and took the lives of Christian men. Some people thought that Irene had sold out the empire to the pagan Harun. Maybe the empress couldn't stop a Frankish warlord from strutting around in a crown—but did she have to marry him?

Off went envoys, bound for Aachen. Meanwhile, a eunuch named Aetios began writing speeches, and the finance minister, a man named Nikephoros, quietly sharpened his sword.

That autumn, Karl arrived home. His bed was cold, but his baths were warm, and even if the emperor tried to sneak off for a swim, business called. The palace count was supposed to have kept the courts functioning in the emperor's absence, but many matters demanded Karl's personal judgment, especially the most dismal cases of incest, sodomy, and clerical misbehavior. Fortunately, good news trickled in from across the empire: Louis had captured Barcelona. The new King Karl the Younger had hoped to assist his brother, but he had failed to get there in time. In Italy, Pepin had defeated Beneventan rebels, and their shamed leaders were coming to the emperor for judgment.

Winter was coming too, but Aachen was a place of expectancy. Treasure and prisoners were en route, as were envoys from across the world, and the emperor's counselors were full of ideas about new laws and rules to govern the Christian empire. Like Karl, they pondered the words of Saint Augustine:

We call those Christian emperors happy who govern with justice, who
are not puffed up by the tongues of flatterers or the services of syco-
phants, but remember that they are men. We call them happy when they
think of sovereignty as a ministry of God and use it for the spread of
true religion; when they fear and love and worship God; when they are
in love with the Kingdom in which they need fear no fellow sharers;
when they are slow to punish, quick to forgive; when they punish, not
out of private revenge, but only when forced by the order and security
of the republic, and when they pardon, not to encourage impunity, but
with the hope of reform; when they temper with mercy and generosity the
inevitable harshness of their decrees.

There were times when Augustine's City of God seemed im-
possibly distant, not only in the baths or on the hunt, where it was
easy to love the world too much, but also in the law courts, a
wretched pageant of sinners. Those were the times when Karl let
himself be a simple Frank, when he paused from trying to under-
stand Augustine and wondered, curious and bemused: *How is Isaac*
going to get my elephant from the other side of the Mediterranean?

The Carthaginians had done it. In 218 B.C., they had
transported African war elephants across the Mediter-
ranean and into Spain. Hannibal, the legendary Car-
thaginian commander, had marched through 1,500 miles of enemy
territory with the terrifying creatures. He crossed the Alps with
dozens of them, and his army almost reached Rome.

Inspired by their conquered foes, the Romans had done it too.
They recruited a few elephants for warfare and military pro-

cessions, but most were imported to fight in circuses or to perform tricks for cheering crowds. In their lust for luxuries, the Romans also butchered elephants to make statues, book covers, and combs. Mosaics in Roman Africa attest to the markets and warehouses that stored elephants and ivory, and it was easy for Isaac to imagine a world once filled with them. Now, though, they were gone from northern Africa, and had been for centuries. "Of Africa and India they were natives," wrote Saint Isidore of Seville around the year 600, "but now India alone produces them." Amid the Roman ruins of Ifriqiya, the only elephant that anyone had seen in ages was Abul Abaz.

How Isaac did it is a mystery. Because Karl had authorized his secretary, Ercanbald, to prepare a fleet, a cargo ship was probably modified on the Italian side of the Mediterranean, with no expense spared. Accustomed to large, long hauls, the famous Radanites may have taken on the job. Italian mariners may have played a role as well.

When the time came, Ifriqiyan troops probably escorted Isaac and his companions to the coast. Agents of Karl and Ibrahim ibn al-Aghlab may have exchanged diplomatic pleasantries and formal farewells—or there may have been only laughter as the Ifriqiyans watched Isaac and his assistants trying to load Abul Abaz onto a boat.

A floor mosaic on Sicily, once a way station for Roman trade, shows two men pulling a reluctant elephant onto a sailing ship while a third goads the beast from behind. One Roman consul was said to have disguised his raft as a farmyard, to fool his captured elephants into thinking they were actually on land. Those days were gone, but merchants still had boats big enough to do the job; some were large enough to require dozens of crewmen, and

Venetians used them to transport slaves, wood, and weapons to the Islamic world. At the opposite end of Karl's empire, on the North Sea, merchant ships, some of them sixty feet long, could carry twenty-four tons of cargo. The technology existed; the rest was up to the elephant.

For 450 miles, as Isaac and the elephant sailed the Mediterranean, they were never far from land, but its inhabitants were not necessarily friendly. The first days of their journey exposed their starboard side to Sicily, still a western foothold for Irene and her empire, and soon they sailed past Sardinia and Corsica, favorite prey of Arab pirates. Their trip appears to have been uneventful, like the metaphorical sea voyage imagined by one Frankish poet:

> *Again, the heavy anchor summons me to sail this doubtful course,*
> *To trust this fleet of mine to fickle winds,*
> *To gird my weary limbs, which conquered storm and gale,*
> *To rest these tired arms for battles new,*
> *To take these heavy oars in conquering hands,*
> *To skim the gentle seas where light breeze calls,*
> *To use the wind to sail into the waves,*
> *To cruise with greatest speed to unknown lands,*
> *To risk their rugged cliffs in rapid course.*
> *The east wind stirs the sails; its gentle gusts*
> *Direct me now upon this arduous route,*
> *To where, with lofty light, our Europe's beacon shines.*

The poet omits the miseries of medieval sea travel: seasickness, rats, brackish water, and food barrels infested with maggots. Even the soundest ship groaned its way through wind and rain, and the addition of an elephant could make even hardened sailors

uncomfortable, beyond the sour reek of dung. A thousand pounds of salt or a hold full of half-starved slaves could do only so much damage; but an elephant made nervous by vermin or restless from confinement could cause serious trouble. Altering their usual prayers, the sailors could implore their patron to guard them in terms absurd in other contexts: *O Saint Nicholas, save us from the wind and storms—and protect us from this elephant while out to sea!*

In October 801, Abul Abaz stepped off a ship near Genoa at Portovenere, where he was the first elephant seen in Italy in centuries. For many of the sailors, this pleasant town was probably home, and they greeted the little Christian temple on its promontory with familiar prayers. Then, as today, homes and storefronts rose gently up the slope; below, merchants and fishermen roamed the narrow streets, unmoored ships, and went back out to sea.

For more than two years, Isaac had heard the call to prayer emanating from minarets, and then, for weeks, only the rush of the sea. Now he heard church bells, clear and loud. For Christians, they too were a call to prayer. For a Frankish Jew, they were simply the sound of home.

After landing in Italy, Isaac covered nearly 150 miles with Abul Abaz; but the Alps were already frozen with snow, so he stopped for the winter at Vercelli. Long ago, Hannibal and his elephants had crossed the Alps during November, but Isaac was in no shape to reenact that feat in the opposite direction. He was neither a warlord nor a fool, and after 3,000 miles he was not about to risk his precious cargo. He looked at the white peaks, he looked at the elephant, and he waited.

I t had been a year since Karl's coronation. Christmas came again, and the celebration promised to be quieter than the previous year's. The winter passed without popes, plotters, trials, or mind-numbing testimony for weeks on end. Karl appears to have enjoyed peace and quiet.

In the spring, Greek envoys appeared at Aachen. According to the Franks' official histories, their purpose was to ratify a peace treaty. If the negotiations involved details of the mysterious marriage proposal, no one will ever know; Pope Leo and Karl stayed quiet about it, and so did Frankish chroniclers. The Greek ambassadors had much to observe at Aachen, and their impressions were not positive. Compared with Constantinople, the Frankish capital was a village; you could fit the whole thing inside Hagia Sofia and still have room for a chariot track. The cathedral of this "emperor" was no bigger than a neighborhood church at home, and the Latin liturgy rang hard on Greek ears. The imperial baths were a joke; the palace—if it could be called that—swarmed with children; and the locals' grasp of Greek was equally childish. The Franks didn't even have eunuchs to conduct court ceremonies. In fact, they barely had court ceremonies at all; they had only a mustached barbarian who conducted business in the bathtub. There could be peace between Aachen and Constantinople; there could never be a marriage.

Karl sent the messengers back to Irene. With them went two of his own: Bishop Jesse of Amiens and a count named Helmgaud.

And then, on July 20, 802, the elephant arrived.

For 500 miles, everyone stared at Abul Abaz, from porters at Alpine passes to haymakers in the fields of Francia.

Although much had happened since 797—the attack on Pope Leo, the imperial coronation—to Isaac it may have seemed that little had changed in his five years away. Aachen was larger; its buildings were taller; but it was only slightly busier, despite its promotion to imperial capital. At this "Rome yet to be," the emphasis was obviously less on "Rome" and more, for now, on "yet to be."

In one courtyard in Aachen, Isaac could see a new equestrian statue. It had caught Karl's eye in Ravenna during his return trip from Rome, and he had ordered it to be brought back to the palace. Despite Karl's title and the poems that called Aachen a "second Rome," the statue did not depict a great ancient emperor; instead, it was a monument to Theodoric the Ostrogoth, who had captured and ruled Italy on behalf of Constantinople nearly 350 years earlier. Karl knew that Theodoric had adhered to a heretical strain of Christianity, but the past was the past. Theodoric had been an ally of the early Franks; and like Karl, he had been of Germanic stock. The mighty Ostrogoth now symbolically defended the palace but obscured the priorities of the new Roman empire. Although Karl had spent several months in Rome, his essential Frankishness was reasserting itself.

As emperor, Karl faced profound responsibilities to his people and to God; it was time to set his lands in order. Every ethnic group in Francia was allowed its own laws, and Karl was not about to change that practice; but those laws needed to be inspected and written down. Even Frankish law, a tangle of competing codes, needed to be reconciled. Einhard cites this legal audit as one of Karl's highest priorities:

He gave much thought to how he could best fill the gaps, reconcile the discrepancies, correct the errors and rewrite the laws which were ill-expressed. None of this was ever finished; he added a few sections, but even these remained incomplete. What he did do was to have collected together and committed to writing the laws of all the nations under his jurisdiction which still remained unrecorded.

Two by two, legal representatives known as *missi* fanned out across Francia. These teams, typically consisting of a church official paired with a layman, inspected local laws and returned them to Karl if they spotted anything unjust or unfair. They investigated complaints that came before them, and—perhaps most significantly—they oversaw the swearing of an important new oath.

The oath to the emperor was required from everyone who had formerly sworn allegiance to Karl as king, as well as everyone else older than twelve who had not yet done so. The oath was sworn to Karl as "Caesar" in the presence of holy relics. One version ran as follows:

The oath through which I promise, from this day forward, that I am faithful to my lord, the most pious emperor Karl, son of King Pepin and Queen Bertrada; that I am of pure mind, without fraudulent or evil design from my part to his part, for the honor of his kingdom, in the way that by law a man ought to be disposed to his lord. So help me God, and the relics of these holy patrons in this place, that I will thus attend and consent through my own will and through whatever sense God gave me, for all the days of my life.

In a letter distributed to the *missi*, Karl showed that he had greatly expanded the meaning of loyalty. The oath meant not only

that Frankish subjects were expected to protect the emperor, spurn his enemies, and reveal news of treason, but also that they were bound to avoid anything which thwarted justice or harmed the empire financially. In addition, the letter reminded the messengers that a man's sins betrayed God and Karl alike, regardless of whether the emperor knew about it. "Everyone on his own behalf should strive to maintain himself in God's holy service," read Karl's decree, "in accordance with God's commands and his own pledge, to the best of his ability and intelligence, since our lord the emperor himself is unable to provide the necessary care and discipline for all men individually."

It was true that Karl could never dispense justice to everyone; nor could he provide all his subjects with the fatherly care of an abbot. Unfortunately, his *missi* could never meet this goal either; and although they traveled the countryside for years, many people probably never saw them. Karl's sparsely populated empire spanned nearly 400,000 square miles of countless cultures and tongues. Saxons, Franks, and Bavarians all spoke Germanic dialects but were already talking past each other. Romance-speakers understood none of them, and Bretons and Basques spoke their own languages entirely. Local counts ran things as they saw fit, usually to their own benefit, and it was easy to keep secrets from the emperor's *missi*, especially when they were clueless outsiders with no grasp of laws that had rarely been written down in the first place.

While his subjects asserted their ethnic identities, the emperor did the same. Einhard mentions that while Karl's monks were copying Bibles, scriptural commentaries, ancient histories, and saints' lives, the emperor asked them to add other, less religiously edifying works:

At the same time, he directed that the age-old narrative poems, barbarous
enough, it is true, in which were celebrated the warlike deeds of the kings
of ancient times, should be written out and so preserved. He also began
a grammar of his native tongue.

These Frankish epics did not survive the centuries; nor did Karl's Frankish grammar. The monks who collected the old pagan songs probably had to extract them from weird old coots, and this necessity may have led them to question these strangely local obsessions of their supposedly "Roman" emperor.

Other linguistic initiatives also fared poorly. Unexpectedly, Karl renamed the months of the year, insisting on Frankish terms for each: July was *heuuimanoth,* "hay-month," when the peasants around Aachen sharpened their scythes accordingly. When a breeze blew over the fields, they noted its direction and ran through the names that Karl had given the winds: *ostroniwint,* the east wind; *sundroni,* the south wind; *sundwestroni,* the south-southwest wind; *westsundroni,* the southwest wind; *westroni,* the west wind—the list went on, but it was the rare Frank who learned all the new names and abandoned the old familiar words.

Rarer still was the Frank who dared tell Karl an obvious truth: regardless of how great an emperor was, the winds blew without his permission—and they blew no matter what he decided to call them.

L ater that year, Karl's messengers Jesse and Helmgaud found clouds over Constantinople. By repealing a wide range of taxes and customs duties, Irene had stayed popular with

her subjects, but word of the marriage alliance with the Franks, if true, was too much for them. The eunuch Aetios frequently railed against it in public speeches, and even the weather suggested trouble. "A common, unsummoned gloom and depression settled on everyone," wrote Theophanes, "so that I would be tedious were I to prolong the story, and will not write bit by bit the graceless account of this pitiful day. The weather was quite unnaturally sullen, dark, and persistently chilly during autumn."

In October 802, Karl's men in Byzantium watched as the storm broke.

Just before dawn on October 31, several patricians approached the bronze gate to the Great Palace. The tale they told the guards was creative: that Irene had summoned them, they said, because Aetios planned to force the empress to appoint his brother emperor; and that Irene's response was to proclaim the finance minister, Nikephoros, emperor instead. In fact, Irene knew none of this. Half a city away, at the monastery of Eleutherios, she awoke surrounded by guards.

By the time the people began wandering into Hagia Sofia, the empress was locked in the Great Palace. After a hasty coronation, Nikephoros visited Irene and claimed that he had been made emperor against his will. Inexplicably, and in a moment of shocking gullibility, Irene swore on the Cross to reveal the locations of all the imperial treasures. "To God, through Whom Emperors reign and dynasts rule the world, I give back what was once mine," Irene said to Nikephoros, according to Theophanes. "Now I give you reverence as Emperor, as you are pious and have been chosen by Him." In exchange, Nikephoros promised that she could keep one of her favorite monasteries.

No one in Constantinople ever saw Irene again. Nikephoros

exiled her to a convent on the nearby island of Prinkipo. Fearing her supporters, in November 802 he dispatched her to the island of Lesbos, around 250 miles west, and guarded her from visitors. Ten months later, she was dead.

The monks whom Irene had so generously supported kindly provided her with pious last words:

> O holy band of maidens and fruitful grafts of my teaching, I have fulfilled the obligation of mortals, as the balance of divine providence weighs it out, and I am withdrawing from the mortality of this corruptible life. Therefore, taking my corpse, lay it in the church of the all-pure Theotokos, in the left part, in the chapel of St. Nicholas, in the God-guarded island of Prinkipo, in the convent which I myself built with my suffering and painful heart.

These gentle thoughts hardly seem like the sentiments of the empress who blinded her own son; but Irene, who was around fifty years old, may have softened a bit before dying—although her exile so far from Constantinople suggests that the old empress still had venom in her.

The new emperor was competent enough, but he is best remembered for one gruesome posthumous detail. After nine years as emperor, Nikephoros was killed in battle on the Bulgar frontier. Krum, the Bulgar chieftain, hollowed out his skull and used it as a drinking cup.

Irene's reputation fared little better. Her five-year reign is as obscure and as lurid as the fate of Nikephoros, but the *basilissa* herself would frown at the comparison. Twelve centuries later, her influence is apparent in countless homes and churches throughout the Byzantine sphere. Irene was the empress who returned the peo-

ple's icons. For this, in the years that followed, some called her a saint.

Meanwhile, everyone remembered the elephant, even as most forgot the man who brought him from Baghdad. Already an obscure figure, Isaac has often found himself written out of history. One Egyptian novel from the late nineteenth century described the adventures of a Persian noble, not a Frankish Jew, who delivered a white elephant to Karl on behalf of Harun. Two modern children's books about Abul Abaz also eliminate Isaac; one replaces him with a boy named Selim. Perhaps modern storytellers have too little to work with, but it is sad that the world has no memory of Isaac and the details of his amazing five-year journey.

According to one story, Harun sent Karl the elephant because the emperor asked for it, but the relationship cultivated by the embassy involved much more than an exchange of gifts. Thanks to Isaac, Lantfrid, Sigimund, and other diplomats like them, Karl had received the support of Jerusalem and the friendship of Baghdad, thus shifting the balance of power in Christendom to western Europe. It was a sign of Isaac's success that five years later, another embassy from Jerusalem and Baghdad brought Karl more gifts from Harun, including a multicolored canopy, silk robes, perfumes, and an amazing brass water clock with twelve tiny horsemen and chimes to mark the hours.

Wondrous gifts made the Franks even more curious about the rest of the world, especially the east. Karl and his courtiers might have asked Isaac: *Was it true that near the Red Sea, there lived red hens that*

could burst into flame, and two-headed serpents with horns? In Egypt, were there really ants as big as dogs, and men with heads like dogs? These were the outlandish tales that people told about far-off places, but Isaac had other stories to tell about Baghdad and the bizarre Persian customs at court. Tactfully, he may have described markets teeming with luxury goods and the people who shopped there, the mid-level commanders who lived better than Frankish kings. Without insulting the notaries at Aachen, he may have praised the impressive bureaucracy he had beheld, and he could put the emperor at ease by attesting to the relative health of Christian communities in the caliphate and the fine wine they served at their monasteries.

If he needed sordid stories, he had those too. He may have described meeting, as most visitors to Baghdad did, the full array of market-square urchins, especially the ones who swallowed their tongues and claimed to have been mutilated by Greeks. To this, the Frankish royal family could laugh and nod knowingly. Members of the royal family had been to Rome; they too had seen the full range of deception and human wickedness that could occur even in the holiest of places. Now they had a story they could use to tease the next Greek envoys who happened their way.

For the Franks, 802 was indeed the year of the elephant, but the emperor had more serious matters on his mind. It was a year of synods, councils, and war against the Saxons; it was nearly time to ravage their lands, scatter them across Europe as slaves, and give their farmlands to allies and friends. At Tours, misunderstanding led to rioting when Alcuin, whose health was rapidly fading, gave sanctuary to a criminal from Orléans. Armed mobs from both towns fought in the streets, infuriating Karl, who sent an enraged letter to Alcuin and everyone at Saint Martin while ordering some of the rioters to be flogged. Meanwhile, a new generation of intel-

lectuals rose at Aachen, where a swarm of imperial grandchildren kept the palace lively and loud.

Somewhere in the midst of it all, Karl and Isaac discussed the emperor's elephant. Asked about the name Abul Abaz, Isaac could offer as many explanations as modern scholars do: that Abu al-Abbas was the name of the founder of Harun's dynasty, so the name "father of the Abbasids" was humorous; or that it meant, through linguistic leaps that Karl could scarcely follow, "elephant of the Abbasids" or, more humorously, "father of wrinkles." *God only knows,* the wise traveler could say, changing the subject to point out that elephants are excellent swimmers, as was the most excellent and honorable emperor. Everyone along Isaac's route had offered some elephant lore. Muslims spoke about the Ethiopian war elephant who knelt and refused to attack Mecca the year Muhammad was born, and Greeks swore that elephants in sixth-century Constantinople had made the sign of the cross with their trunks. Flattery was an option, too; a piece of Jewish wisdom common in Cairo was that "an elephant in a dream indicates a noble or generous, gentle, courteous and patient king."

The scene is a fine one to freeze in time: Karl, white-haired, widowed, inquisitive, vibrant, consulting ambassadors about foreign lands; his daughters and their children gathering, awestruck, to touch Abul Abaz; his sons returning from wars with prisoners and loot; his counts administering justice; his peasants farming and feeding the empire; his monks preserving the Christian faith through books and ceaseless prayer. This is Karl at his peak, the founder of a Holy Roman Empire, the "father of Europe," the man whom posterity will call Charles the Great. Deeds he never did will inspire the Crusaders, and medieval wise men will rank

him alongside Arthur and Alexander as one of the worthiest rulers ever to live.

But for now, in 802, he is a father and a Frank, the emperor who gained an elephant, a devout warrior for a new Christian order, a defender of the faith, and the most important person in Europe. Looking for precedents, as poets are wont to do, his flatterers praised him, obeyed him, and hoped that he might be, in their wonderful optimism and faith, their David. Instead, unbeknownst to them, he was becoming Charlemagne.

LITTLE MEN AT THE END OF ALL THINGS

Verdun, A.D. 843

L ate in the summer, three brothers met near Verdun.

Lothar, approaching fifty, was emperor, at least in name. He had the mustache of his grandfather, but his scheming nature was a gift from God. For a while, he had ruled Italy. Sometimes he had fought against his brothers; at other times, he fought with them against their own father. Briefly, the empire had been his. It might be again; he was sure God willed it.

Also present was his thirty-seven-year-old brother, a man with too few troops to go it alone. Monks who wrote in Latin called him Hludovicus. In the eastern empire, where he was at home, he was Ludwig in his native Germanic. To his half brother Charles,

who spoke a Latin dialect that was rapidly becoming French, he was known, like their father, as Louis.

Youthful and full of promise, Charles was heir to his grandfather's name and to many of his ambitions. Twenty years earlier, at the boy's birth, his father had been enamored of him, as he had been of the child's crafty mother. Charles had been given much of what his brothers thought was theirs. His half brother Lothar had been his godfather and his enemy; now Lothar was his partner.

The Franks were weary of these brothers, whose bickering had lasted far too long: through three years of overt civil war, and before that more than fourteen years of strife, contention, scheming, betrayal, and sin. Priests, monks, and bishops chose sides, some out of righteousness, others out of need—and that was all before one savage, horrific day.

The tension had come to a breaking point two years earlier at a place called Fontenoy, where Charles and Louis confronted Lothar and his allies, including their nephew Pepin. Armies clashed; thousands died. The carnage stunned even these battle-hardened brothers into negotiating a one-year truce.

One survivor of the fratricidal slaughter remembered the sight:

> *Wars call. On all sides, a terrible battle is born.*
> *Brother kills brother, the uncle his nephew;*
> *The son now shows his father no respect.*

> . . .

> *This crime, which I have written in this poem,*
> *I, Angelbert, saw it—I fought alongside others.*
> *Of the many on the front line, I alone survived.*

There, from the hilltop, I beheld the valley deep,
Where brave king Lothar crushed his foes
As they took flight across the little stream.

On Charles' side, on Louis' side as well,
The ground grows white with shrouds to cloak the dead,
Just as in autumn, when fields grow white with birds.

This battle owns no praise; it is not fit for song.
May east, and south, and west, and north
Lament the men who died in so much pain.

Cursed be that day. Let it be numbered not
In any calendar, but expunged from all remembrance,
Unlit by the sun, unlit by creeping dawn.

That night—that dire night—and the day after—
That night, tears and sorrow mixed,
And some men died, and others groaned, forlorn.

O mourning, lamenting: Naked are the dead.
The vulture, crow, and wolf consume their flesh.
Their corpses, vacant, stiffen; they have no tombs.

I'll tell no more of weeping or of woe;
A man should hold his tears as best he can.
For those men's souls, we beg before the Lord.

Another half brother, Nithard, fought at Fontenoy on the side
of Charles and was astonished by the sight of so many dead. The

illegitimate son of Karl's daughter Berta and his adviser Angilbert, Nithard could recall his childhood in the court of his grandfather, the big, bold man whom some already called Karolus Magnus. "He left the whole of Europe flourishing," Nithard proclaimed in his history of the times; but by the early 840s, he ruefully admitted that the Franks were nobody's exemplars. "Although I am ashamed to hear of anything bad in my people," he wrote, "it especially pains me when I have to report it." The dread of Fontenoy had set the entire cosmos out of balance; four months later, at the exact moment Nithard wrote about the battle, he beheld a solar eclipse, an ominous and disquieting sign.

Aachen had changed hands too many times to count. Civil war had killed thousands, and more than 100 henchmen were carving up the kingdoms. Arab pirates attacked from the south, Vikings preyed on the north, and Slavic tribesmen threatened the safety of the east.

Not long ago, in the time of Karl, the Franks had been God's chosen people. The increase of their Christian empire had seemed inevitable. How had it come to this?

Men like Nithard remembered the good old days, when Alcuin was still alive and Emperor Karl the Great was in his prime, and how Karl would ride out on summer hunts, healthy and strong. They remembered the threat of a Danish chieftain who vowed to march on Aachen, and how Karl rallied a vast army to meet him, bringing the elephant Abul Abaz to terrify the insolent upstarts. Some remembered the return of Muslim envoys from Baghdad, and that strange second visit by

Pope Leo to Francia one Christmas. Why he had come no one remembered. It hardly mattered now.

A few also recalled Karl's plan for the disposition of his empire. In keeping with Frankish custom, he had divided it in three among his sons Louis, Pepin, and Karl, in an agreement that emphasized mutual support and allowed for all sorts of contingencies. The future had seemed assured. The people had approved, and the pope had assented; but it hardly mattered now, not after those two terrible years.

Throughout 810 and 811, all of Francia saw the eclipses: two of the sun, two of the moon. Viking longships ravaged the northern coast. During the Danish campaign, a plague killed the cattle that were to feed the army. Then a meteor blazed across the sky, causing the emperor's horse to throw him to the ground. Sadly, the elephant Abul Abaz also died. The campaign ended peacefully when the Danish leader was murdered by one of his own, but all the signs had been unnerving.

At Aachen, Karl watched his family die all around him: first his daughter Rotrud; then his son Pepin; then his sister Gisela; then his long-estranged son, Pepin the Hunchback; then Karl, his chosen heir. Einhard witnessed his grief. "He bore the death of his two sons and his daughter with less fortitude than one would have expected, considering the strength of his character," he wrote, "for his emotions as a father, which were very deeply rooted, made him burst into tears."

Karl withdrew. He suffered from fevers; he developed a limp; and he never left Aachen.

Not even the arrival in 812 of envoys from Constantinople could change the mood at the palace. The new emperor, a man named Michael, had finally recognized Karl's title, and the Greek

messengers had acclaimed him emperor and *basileus* in his own church. At the time, the Franks found that significant. It hardly mattered now.

Educated men knew the words from Jeremiah: "Be not dismayed by the signs in the sky at which the nations shudder." But who could heed such sober counsel at the obvious end of the world? For seven days, men saw a black spot on the sun. At Aachen, a portico collapsed. Lightning struck the church. On an arch, where an inscription read *Karolus Princeps*—"Karl the sovereign"—the word "sovereign" began to fade.

Karl faded too. On January 28, 814, after reigning for forty-seven years, he passed from the earth.

To honor the late emperor, an anonymous poet composed a dirge:

> *Woe to you, Rome, and your people,*
> *The great and glorious Karl is lost.*
> Heu mihi misero!

> *Woe to you, most peerless Italy,*
> *And to your worthy, gorgeous cities.*
> Heu mihi misero!

> *Francia has dealt with wounds so dire,*
> *But never such dolor as this:*
> Heu mihi misero!

> *For our augustus, eloquent Karl,*
> *At Aachen was entombed in earth.*
> Heu mihi misero!

Heu mihi misero: "Alas to me the misery!" That refrain, while sincere, may have felt like a formality in 814 as the emperor was placed in his tomb at Aachen. Everyone had seen Karl pass into the white winter of his age. His family, his counselors, and his subjects had plenty of time to prepare for the inevitable, and Karl himself had drafted a detailed will.

As the new emperor rode up from Aquitaine, it was clear that his regime was going to be different. But even as Louis settled into his father's throne, few foresaw just how apt that refrain of misery would come to be.

D ecades had passed, but people still talked about Louis's childhood visit to his father's court. For Karl's amusement, his son had donned the flared trousers, puffy shirt, and spurred boots worn by all the boys in Aquitaine. Few men still living had seen this firsthand, but years later the anecdote found its way into official biographies. Chroniclers noted the incident with particular care, as it was one of the last times that Louis, son of Karl the Great, ever amused anyone at all.

The only legitimate son to survive the death of Karl, Louis arrived at Aachen in 814 a serious man, having spent most of his thirty-six years defending the Spanish frontier. He shared Karl's passion for hunting, but one contemporary noted that he completely lacked his father's famous warmth:

> *Never did he raise his voice in laughter, not even when on high festivals*
> *musicians, jesters, and mimes along with flutists and zither-players, who*
> *were supplied for the delight of the people, proceeded into his presence at*

the table. The people laughed a great deal . . . in his presence, but he never showed his white teeth in a smile.

The change of tone at Aachen brought a change of personnel as well. After fulfilling the terms of Karl's will, Louis ordered most women to leave the palace, including his own sisters. He had planned the expulsion for some time, but the order must have started people talking: *What sort of emperor, what son of Karl the Great, scatters his family across all of Francia?*

With every deed, Louis signaled that he was not, and did not wish to be, his father. A Romance-speaker raised in a realm that would eventually be part of France, the new emperor rejected the old Frankish stories and poems that his father had ordered to be written down in their rough Germanic tongue. He also abandoned his father's habit of referring to himself as king of the Franks and the Lombards and styled a new and ethnically neutral title, *Hludowicus Divina Ordinante Providentia Imperator Augustus:* "Louis, by Order of Divine Providence, Emperor and Augustus." Eager to please, poets cast aspersions on the moral character of his predecessor. One such poet, Walafrid the Squinter, claimed that his teacher had seen a vision of Karl in hell, gnawed by savage beasts:

> *"Explain this, I beg you!" Then said the guide: "He lingers in these*
> * torments*
> *For this reason: his good deeds he defiled with disgraceful lust,*
> *Believing that these enticements would be reduced by good conduct,*
> *And he wished to end his life accustomed to sordidness."*

For anxious Christians, the poem included the assurance that Karl would eventually redeem himself. "He will yet attain the highest

life," the guide insists, "and joyfully he shall enter the honored place that the Lord has made." Even so, the new emperor's point was made: The old days, loose and immoral, were unworthy of nostalgia.

Fortunately for Francia, Louis continued some of his father's works. He supported the creation of books and the reform of the church; he refined the system of legal auditors who roamed the counties; and he appointed *magistri*, "masters," who served as his representatives to important communities, including merchants, the poor, and Jews. Under Louis, Frankish Jews enjoyed even more protections that they had under the king who fancied himself "David." Louis granted them new privileges and refined the wording of their legal oaths. Also, he appointed them to official positions; this was the first time in centuries that Jews had received such appointments. For the sake of the economy, he also forbade markets to be held on Saturday, the Jewish Sabbath. In doing so, he incurred the wrath of at least one archbishop but probably earned the gratitude of men such as Isaac, the former envoy to Baghdad, as he and his family, whoever they were, wandered through this fleeting golden age for European Jews, into the palaces and market stalls, and then out of recorded history.

But by 843, none of that mattered. This emperor, destined to be known as Louis the Pious, could survive the criticism of the clergy. He could manage the disrepair of his father's final years. He could endure a reputation for humorlessness. Ultimately, though, Louis the Pious could not survive the schemes of his sons.

The plan, devised during the third year of Louis's reign, seemed simple enough. His son Pepin would rule Aquitaine and most of the western empire, while the youngster Louis—Ludwig—would rule most of the east. The emperor's nephew Bernard would keep Italy. To determine which son would inherit the imperial title, the emperor, his bishops, and his nobles all prayed for guidance, as if electing a pope. Their choice was unanimous: Lothar, the eldest son, who would be co-emperor with his father and then sole emperor later. The other kings would be subject to his authority, and someday, after Louis was gone, all would be right with the *Imperium Christianum*.

But nothing went right: King Bernard of Italy rebelled; he was tortured and blinded and died from his injuries. Louis sent three of his half brothers—the illegitimate sons of Karl—to monasteries, and he imprisoned his father's old friend Theodulf.

Six years later, in 823, a son was born to Louis and his new wife, Judith, the daughter of powerful Saxon and Bavarian nobles. Whatever plans Louis had for his empire, and whatever plans his sons had, they hardly mattered now. This new child was adored by his father and fiercely protected by his mother, and he had a most auspicious name: Karolus.

When young Charles turned seven, his father ignored the wishes of his other sons and the agreement of thirteen years earlier and eagerly carved out a kingdom for him. The fourteen years that followed were a blur of betrayal, bloodshed, and treason. Traditionalists wanted separate kingdoms portioned out to the sons, as the old Frankish kings had done. The clergy and the pope, Gregory IV, argued for the unity of the empire. Everyone took a side.

Lothar had himself crowned sole emperor. Judith was accused

of adultery, sorcery, and assassination; and her three stepsons joined forces against her, their father, and their favored half brother. After talking his way out of imprisonment at a monastery, Louis the Pious re-partitioned the empire, but again his sons rebelled, joining a coalition that included the pope himself. Louis was deposed and forced to undergo humiliating public penance. He then found new support and was crowned again.

Each year, the status of the kingdom shifted. Peasants couldn't be bothered to follow it; poets didn't try. Base intrigue and familial hatred were far from heroic. They were also a drain on the empire and blatantly unchristian. Pepin died, Louis died, and the world was left with three hateful sons who then turned on each other.

Imperial unity or Frankish partition? By 841, when the brothers shed their followers' blood at Fontenoy, the philosophical distinctions no longer mattered. "Christian law is violated," wrote Angelbert, "blood flows in waves." Noble goals had rotted not only into civil war, but also fratricide—and all men knew, from the first pages of their Bibles, the evil that came of that.

When the war-weary brothers met near Verdun in 843, their commissioners had already spent months touring the empire to catalog the wealth and landholdings of every monastery and villa. After Fontenoy, no one believed it was possible to bind up the empire's wounds. Malice had smothered charity, and Frankish traditionalists got their victory. Beyond bloodshed, the price was a dismantled empire.

Charles received the western portion, a territory roughly equivalent to most of modern France. Louis received everything east of the Rhine and north of the Alps, an area that comprised much of modern Germany. Placing himself between them, Lothar ruled a vast strip of land that ran from the North Sea to Italy. His possessions included Aachen and Rome, and he retained the imperial title. A decade later, when he died, his kingdom split into smaller, self-governing fragments: Provence, Italy, and a distinctive northern realm that his son and namesake called, with all due humility, Lotharingia.

For those who had dreamed of a united Europe, the treaty of Verdun was heartbreaking. Shortly after the division of the empire, a scholar, Florus of Lyon, recalled the days before Verdun—the era of Karl the Great—as a magnificent age of peace and morality:

> Flourished then an excellent realm, its crown aglow,
> And there was one prince, and one people under him.
> Both law and judge alike brought honor to each city;
> Peace preserved the people; our strength frightened our enemies.
> Our eager priests performed their healing work,
> Ministering and counseling men with piety and right.
> Across the land, salvation's Word was heard
> By priests, the people, great princes, too.
> Both near and far, our youths learned holy books,
> The hearts of boys drank in the art of letters,
> And vigilance and judgment put vile crimes to flight.
> Love called some to lawfulness, others fear.
> We worked to join with foreigners in faith,
> To impose salvation's reins on those whom we subdued.

Florus painted an unusually rosy picture of the past, but his view of the present was undeniably grim:

> *But now such greatness falls from such great heights,*
> *Just like a crown of flowers from a lowered brow,*
> *Once honored with the scent of braided herbs,*
> *Deprived now of its garland, which was trodden underfoot.*
> *Lost is the honor of empire and its name;*
> *The kingdom united has fallen to three lots.*
> *There now is no one who can be called the emperor:*
> *Petty princes for a king, royal fragments for a realm.*
> *Good laws are now undone by crowded councils,*
> *And bustling assemblies seek to harm through theft.*
> *The public good is gone: to each his own!*
> *Our selfish cares are all. Only God is forgotten.*

Florus and his generation watched as the empire collapsed into smaller kingdoms that were increasingly unable to talk to each other. The old differences in language, culture, and tribe had never disappeared, even under an emperor. From 843 on, only the pope, the church, and the shared interests of knights and nobles provided a tenuous sense of unity. Kings were more concerned with local problems and sought their own goals amid invasion and revolt. Alcuin had been dead since 804, but his humble words to one heretic summed up the sentiments of many: *Nos homunculi in fine seculi,* "We are little men at the end of all things."

Ratified at Verdun, those map lines drawn by Karl's grandsons determined the boundaries and borders of the medieval world, many of them contentious, and influenced millions of lives for centuries. What men like Angelbert and Florus of Lyon saw as the

end of the world was also, in hindsight, a beginning—which one modern historian has called the "birth certificate" of modern Europe.

A forceful, charismatic emperor had unknowingly started all this, but ironically, at the end of the ninth century, at the beginning of European history, Karl the Great literally could not be found. His grandchildren were not the only ones to blame. In 881, a Viking attack left the cathedral at Aachen damaged and defaced. Florus was right: in this new world of medieval kingdoms, the selfish demands of the day were more important than yesterday's glories, despite every good intention.

Within decades of Karl's death, no one could remember the location of his tomb.

For those who needed him, Karl himself was never truly buried. His dealings with Muslims, his wars against pagans, his Christian fervor, his imperial pretensions, his educational patronage, his respect for order, and the sheer force of his personality were all easily conflated by medieval poets to create a new, larger-than-life Karl, an idealized figure celebrated by the medieval world. To the anonymous poet of *The Song of Roland*, Charlemagne was no longer a mustached Frank with a civilizing impulse and common human failings; instead, the Old French poem portrayed the emperor as a white-bearded sage, two centuries old, counseled by twelve peers renowned for knightly deeds. Although the real king's one Spanish campaign had ended in disaster, the epic poem reimagined the incident as a massive war between Chris-

tians and pagans in which God halts the sun in the sky and responds directly to Karl's prayers:

> Straightway an angel with whom he wont to talk
> Comes, with this summons, in answer to his call:
> "Ride, Carlon, ride; the light shall not come short!
> The flower of France is fallen; God knows all;
> Thou shalt have vengeance upon the heathen horde."
> When this he hears, the Emperor gets to horse.

In 1095, when Pope Urban II rallied Christians to undertake the first of several crusades, one version of his famous speech sought inspiration in the greatest Frankish kings:

> Let the deeds of your ancestors encourage you and incite your minds to
> manly achievements: the greatness of King Charlemagne, and of his son
> Louis, and of your other monarchs, who have destroyed the kingdoms of
> the Turks and have extended the sway of Church over lands previously
> possessed by the pagan. Let the holy sepulcher of our Lord and Savior,
> which is possessed by unclean nations, especially arouse you, and the holy
> places which are now treated with ignominy and irreverently polluted
> with the filth of the unclean. Oh, most valiant soldiers and descendants
> of invincible ancestors, do not degenerate our progenitors, but recall the
> valor of your progenitors.

Karl was no longer merely a Christian king whose dealings with Muslims were pragmatic and cordial. By 1100, he had become an idol for all who went on a crusade or those who merely dreamed of it: a warlord who could summon angels, a superhero

who battled Christ's enemies and worked God's will on earth no matter the cost. His canonization in 1165 at the behest of Frederick Barbarossa, a German duke who became an emperor and claimed kinship with the Carolingians, ensured that Karl was seen as a saint at the cathedral in Aachen, if not by the entire church. Like Karl, Frederick and his dynasty fought to bring wayward regions such as Italy and Burgundy back under imperial control. By the thirteenth century, the emperors had given their enterprise a new name: *Sacrum Romanum Imperium,* the Holy Roman Empire. Karl the Great was considered its founder.

Karl the man was truly dead. But his legacy, Charlemagne—an idealized creature of books, statues, and preposterous stories—had quickly come of age.

For 1,000 years, Europeans passed around the imperial title. France and Italy, once vital to Karl and his counselors, both fell away from the empire, but new capitals thrived in cities such as Vienna and Prague. The empire that Karl founded weathered war and religious schism to transform itself into something larger, stranger, and more decadent than the Frankish king could have imagined. One seventeenth-century Dutchman surveyed the conglomeration of languages, nationalities, and religions and described the Holy Roman Empire as "a chimera and a skeleton," and Voltaire quipped that it was "neither holy, nor Roman, nor an empire"; but it endured nonetheless. What Karl began, only one of his most obsessive admirers could finally and decisively end.

Shortly before he deposed the Holy Roman Emperor in 1806,

Napoleon Bonaparte arranged to have himself crowned emperor of France. His coronation, which was meant to evoke memories of the year 800, took place at Notre Dame in Paris in the presence of the pope; one of its props was the crown supposedly worn by Charlemagne. The essentially Germanic character of Karl the Great seems not to have troubled the French emperor. While the Holy Roman Empire had taken on a distinctly German cast, Francia had become France, and Charlemagne had long been hailed as its greatest king. Monuments such as the equestrian statue of Charlemagne near Notre Dame strengthened his reputation in the public mind, and French schoolboys celebrated him as the patron of scholars each year on the anniversary of his death.

A century later, during World War I, the legacy of Charlemagne, his grandsons, and the treaty of Verdun was written in blood at the city of Verdun itself. For most of 1916, the French defended the city and its forts against the Germans. The French kept the enemy out, but at great cost to both sides: more than 162,000 dead Frenchmen and around 143,000 dead Germans; half the city reduced to rubble; and several local villages wiped from existence. The land surrounding Verdun had always been an odd intermingling of both cultures, a legacy of the ninth-century brothers who could scarcely understand each other. Known as Lorraine, the region more clearly reveals its Carolingian pedigree when called by its old Germanic name, Lotharingia.

Historians have noted that the officers of Verdun became the generals of World War II, when Europeans again invoked the name of Charlemagne and continued his grandsons' fratricide in spite of themselves. Fascinated by the legendary Germanic past, Adolf Hitler was skeptical about Karl's German-ness, particularly because of the emperor's campaigns against the pagan Saxons,

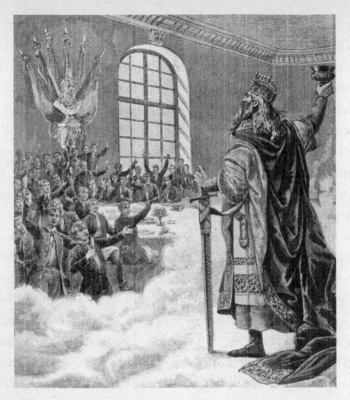

French schoolboys toast their national hero, "Le Saint-Charlemagne," in an 1892 illustration from Le Petit Journal.

whom Hitler saw as his noble Germanic forefathers. Despite his reservations, Hitler admired Karl for founding a "First Reich," and he deliberately built a home near a mountain believed to be the resting place of Karl der Grosse, who would someday rise up and conquer all of Europe. Until that day, Hitler had to settle for symbolism: in 1944, when the Nazi SS created divisions of French collaborators, it named them, with some irony, after Charlemagne.

Although occasionally cruel, Karl was no tyrant, a fact that the city fathers of Aachen take care to remember. Since 1950, officials at Karl's former capital have annually awarded the International Charlemagne Prize "for the most valuable contribution in the services of Western European understanding and work for the community, and in the services of humanity and world peace." The empire Karl built makes him a fitting symbol of unity. When the European Union was first formed as the European Community in the 1950s, the six founding countries—France, West Germany, Belgium, Italy, Luxembourg, and the Netherlands—covered the same area as his Frankish empire. Today the capital of the European Union is only eighty miles west of Aachen, at Brussels, where its government honors the *pater Europae* in the name of its headquarters: the Charlemagne Building. Just as the emperor saw himself in King David and Constantine, his heirs see themselves in him—but, like the emperor before them, they imitate their hero selectively.

In the nineteenth century, Henry Wadsworth Longfellow offered his own version of Charlemagne, a restless monarch gazing at the wintry moon:

> *That night the Emperor, sleepless with the cares*
> *And troubles that attend on state affairs,*
> *Had risen before the dawn, and musing gazed*
> *Into the silent night, as one amazed*
> *To see the calm that reigned o'er all supreme,*
> *When his own reign was but a troubled dream.*

For generations, politicians and poets have created a Karl for all seasons. Inspired by their example, we too can imagine the

white-haired emperor rising from bed to shake off a prophetic
dream. Disoriented, he beholds the Aachen built by his descen-
dants. Its skyline shines before him, dominated by a great cathe-
dral where his own church once stood. The streets and squares are
filled with dignitaries, including Romance-speakers and Germanic-
speakers, who invoke the emperor's name and the prospect of Euro-
pean unity.

In the midst of the proceedings, as lavish as any coronation,
the emperor ponders the award that apparently bears his name.
Its purpose is to promote "a voluntary union of the European
peoples without constraint, so that in their newfound strength
they may defend the highest earthly goods—freedom, humanity
and peace—and safeguard the future of their children and chil-
dren's children." He disagrees with none of that, but he is trou-
bled to find that the aspirations of this new Europe fall far short
of the *Imperium Christianum* envisioned by Alcuin. The Saxon ab-
bot advised the emperor to "punish wrong-doers, guide the
straying, console the sorrowing and advance the good." But to a
ninth-century ruler, the obligations of government extend well
beyond earthly concerns. A man of his time, Karl wonders how
his people have prospered without a Christian emperor to care
for their souls.

He will pose the problem to his scholars—but tomorrow.
Never a sound sleeper, the king retires to his hot baths for contem-
plation and prayer. He has envisioned a civilization so different
from his own that it haunts his aging mind. Karl is content to be
associated with peace, order, and European unity, but despite his
command of statecraft and his hope for a prosperous future, the
medieval emperor is baffled by one simple question: Have his de-
scendants failed—or succeeded?

During the late tenth century, a powerful Saxon family, the Ottonians, inherited Karl's imperial title. Chiefly remembered for conquering and Christianizing the people of Denmark, Poland, and Hungary, the Ottonians supported the arts and encouraged book production, just as their predecessors had done. In keeping with their reverence for Karl the Great, they also crowned their emperors at Aachen.

However, one chronicler, writing around A.D. 1025, claimed that Emperor Otto III longed for a closer connection to his forefather. In the year 1000, after some poking around in the cathedral at Aachen, the indefatigable Otto broke through a wall and found Karl's tomb, and in it a strange and peculiar sight:

> He was not recumbent like the bodies of other dead, but seated on a throne as if he were still alive. He wore a golden crown on his head; he held the scepter in his hands that were covered by gloves which his nails had torn as they had grown. Above him was a magnificent slab of limestone and marble, and when we got there, we made a hole in it as we broke it. As we came near him, there was a very strong odor.

Otto outfitted the corpse in white garments and replaced Karl's nose, the only part of him that had decayed, with gold. The emperor then sealed the tomb, but not before taking nail clippings and one of Karl the Great's teeth—relics, of course, which served as tangible reminders of Christian virtue and which increased the odds, it was hoped, for miracles.

A thousand years after Otto, such relics still attract the curi-

ous. Visitors to Aachen enter the museum treasury and gaze at a gilded bust of Charlemagne; guides tell them that it houses the emperor's skull. Their tour proceeds to the cathedral choir and past a shrine that is also said to contain Charlemagne's relics. Nearby is an ancient throne the emperor may have used, here in the great church that engulfed his own, here in the German city he could never possibly recognize.

In the early nineteenth century, the French historian Chateaubriand retold an eerie legend. Around the year 1450, the monks at Aachen decided, for some reason, to open Charlemagne's tomb. On doing so, they found what Otto III himself had seen centuries earlier: the skeleton of the famous Frankish emperor seated on a golden throne, his sword by his side, a crown on his head, a shroud hiding his decayed face.

For one fragile moment, the monks were in the presence not of Charlemagne but of Karl: the famously overprotective father; the Frankish king who loved to swim and hunt and hear heroic songs; the beneficiary of loyal counselors such as Alcuin, Angilbert, and Isaac, whom history barely remembers; the Christian who encouraged literacy in the service of the church and who defended the popes at every turn; the emperor who challenged Empress Irene and who befriended Harun al-Rashid, caliph of Baghdad; and the man who wept when death took his children and wives.

Within seconds, though, and with a single rash move, one monk ensured that Karl and his age would be forever distant, obscured by legends, veiled by myth, while only Charlemagne would live on, idealized among the shades:

"Someone touched the ghostly remains: They disintegrated into dust."

Notes

For full information on works cited here, see the bibliography.

INTRODUCTION: KAROLUS MAGNUS

xii **On Christmas morning in the year 800:** For Charlemagne's coronation in its complex liturgical context, see Kantorowicz, *Laudes regiae: A Study in Liturgical Acclamations and Medieval Ruler Worship*. For an intriguing and thorough reconstruction of old St. Peter's in Rome, see Bannister, "The Constantinian Basilica of Saint Peter at Rome."

xiv **But on that day, he was still just Karl:** Wallach, *Alcuin and Charlemagne*, p. 202: "We print Carolus and not Karolus . . . because the king's name

is spelled with a C in the *intitulatio* of extant original charters of Charlemagne, and with a K only in the documents of the imperial period after 800." In transcriptions of the oaths sworn by Charlemagne's grandchildren Louis the German and Charles the Bald in each other's language in 842, the name "Charles" is clearly rendered in Germanic as "Karl"; see Dutton, ed., *Carolingian Civilization: A Reader,* pp. 354–355.

xv **"High sat Charlemagne at the head of his vassals":** Bulfinch, *Legends of Charlemagne, or Romance of the Middle Ages,* p. 16.

xix **"In fact, just as a rainbow, which adorns the vault of heaven":** Sedulius Scottus, translated in Dutton, *Carolingian Civilization,* p. 406.

1: A ROME YET TO BE

3–4 **"unassuming Aachen" near the "unromantic Rhine":** Steves, *Rick Steves' Germany, Austria, and Switzerland 2003,* pp. 217, 228.

6 **"At God's call, his life came to an end and he went to everlasting rest":** Davis, trans., *The Lives of the Eighth-Century Popes,* p. 172.

6–7 **"When the death of Hadrian, the Pope of Rome and his close friend, was announced to him":** Thorpe, trans., *Two Lives of Charlemagne,* p. 75.

7 **"a trifle too heavy":** Ibid., p. 76.

7 **"This particular race of people seems always to have followed idolatrous practices":** Thorpe, trans., *Gregory of Tours: The History of the Franks,* p. 125.

8 **"to wash away the sores of his old leprosy":** Ibid., p. 144.

10 **"He took delight in steam-baths at the thermal springs":** Thorpe, trans., *Two Lives of Charlemagne,* p. 77.

11 "May the crowned doves that fly about the rooms of the palace": Allott, *Alcuin of York*, pp. 131–132.

11 "Compared with your monastery, the palace is a prison": Paul the Deacon, in Dümmler, ed., *MGH Epistolae Karolini Aevi II*, p. 507, lines 13–15. This translation is my own.

12 "These girls were extraordinarily beautiful ... paid the greatest attention": Thorpe, trans., *Two Lives of Charlemagne*, pp. 75, 79.

13 "He also tried to learn to write": Ibid., p. 79.

13 Few at court talked about the king's embarrassing struggles with reading and writing: For a thorough study of Charlemagne's literacy, see Dutton, "Carolus Magnus Scriptor," in *Charlemagne's Mustache and Other Cultural Clusters of a Dark Age*, pp. 69–92.

14 "Letters have often been sent to us in these last years": "De litteris colendis," in Loyn and Percival, *The Reign of Charlemagne: Documents on Carolingian Government and Administration*, pp. 63–64.

15 "Rise, pipe, and make sweet poems": Godman, *Poetry of the Carolingian Renaissance*, p. 113.

15 "What wonder is it if the eternal shepherd made": Ibid., p. 151.

16 "For everything that was written in the past": Romans 15:4 (New International Version).

16 "It is better to write books than to dig vines": Godman, *Poetry of the Carolingian Renaissance*, p. 139.

19 "Karl, weeping, has written you this poem": This excerpt can be found in "The Epitaph of Hadrian I Composed for Charlemagne by Alcuin," in Wallach, *Alcuin and Charlemagne*, p. 182. Wallach provides the Latin; this translation is my own.

20 **"Behold with joyful heart"**: Godman, *Poetry of the Carolingian Renaissance*, p. 153.

20 **"For just as I entered . . . It is our function—to the extent that divine goodness aids us"**: King, *Charlemagne: Translated Sources*, pp. 311–312.

21 **"Advise our Apostolic Father diligently"**: Duckett, *Alcuin, Friend of Charlemagne*, p. 217.

22 **"Pious Karl stands above them"**: "Karolus Magnus et Leo Papa," in Godman, *Poetry of the Carolingian Renaissance*, p. 202, lines 96–108. This translation is my own.

2: AN EMPRESS OF BYZANTIUM

25 **"The sun was darkened for seventeen days"**: Mango and Scott, trans., *The Chronicle of Theophanes Confessor: Byzantine and Near Eastern History A.D. 284–813*, p. 649.

30 **"It does not appear to rest upon a solid foundation"**: Lethaby and Swainson, trans., Procopius, *De Aedificiis*, in *The Church of St. Sophia Constantinople*, pp. 24–28.

30 **"[W]e knew not whether we were in heaven or on earth"**: *Primary Chronicle*, cited in Dmytryshyn, ed., *Medieval Russia: A Source Book, 850–1700*, 3rd ed., p. 32.

31 **"So is it new in its marvels, being so exceedingly great"**: Michael of Thessalonica, quoted and translated in Mango and Parker, "A Twelfth-Century Description of St. Sophia," in *Studies on Constantinople*, XVII:235.

33 **as Saint John of Damascus wrote in their defense**: Kartsonis, "The Responding Icon," in Safran, ed., *Heaven on Earth*, p. 60.

33 "just as we do not adore the matter of the Gospel book": Cited in Safran, ed., *Heaven on Earth*, "Introduction," pp. 5–6.

34 To deny the possibility of the holiness of an icon: Perl, " '... That Man Might Become God': Central Themes in Byzantine Theology," in Safran, ed., *Heaven on Earth*, p. 45.

34 "God, however, struck him down": Mango and Scott, trans., *The Chronicle of Theophanes Confessor*, p. 619.

35 "Being inordinately addicted to precious stones": Ibid., p. 625.

36 "And so God's Church found peace": Ibid., p. 637.

39 the imperial bureaucracy probably had no more than 1,000 people: Treadgold, *The Byzantine Revival, 780–842*, pp. 23–25.

39 their garish and beautiful universe: Ousterhout, "The Holy Space: Architecture and the Liturgy," in Safran, ed., *Heaven on Earth*, p. 82.

40 "The emperor at this time said nothing to me": Alchernes, in Safran, ed., *Heaven on Earth*, p. 30.

42 outside the palace walls were hundreds of thousands of Romans: For a review of population estimates for Constantinople, see Charanis, "Observations on the Demography of the Byzantine Empire," pp. 2–4.

42 Ethnically, they were far from homogeneous: Ibid., p. 17.

42 "During this year a man who was digging": Mango and Scott, trans., *The Chronicle of Theophanes Confessor*, p. 627.

43 no matter how a coin landed, the empress Irene always triumphed: Treadgold, *The Byzantine Revival, 780–842*, pp. 110–111.

3: SOWING THE SEEDS OF EMPIRE

45 **the community of the saint whose tomb lent the neighborhood its name:** For an interesting history of Martinopolis, see Farmer, *Communities of Saint Martin: Legend and Ritual in Medieval Tours*, pp. 13–37.

46 **"Nicknames often arise from familiarity":** Allott, *Alcuin of York*, letter 86, pp. 100–101.

47 *non monasticae inferior fuit*, **"not inferior to the monastic":** *Vita Alcuini*, ed. W. Arndt, in *Monumenta Germania Historica*, Scriptorum XV: I, p. 191, lines 17–20.

47 **That middle way was "a life not to be despised":** Alcuin, quoted in Duckett, *Alcuin: Friend of Charlemagne*, p. 286.

47 **Alcuin never could have been a true monk:** This point about Alcuin's lack of *stabilitas* is made explicitly in Leclercq, *The Love of Learning and the Desire for God: A Study of Monastic Culture*, pp. 41–42.

47 **While running Saint-Martin, he was also, in absentia, abbot of six other monasteries:** According to Riché, *Daily Life in the World of Charlemagne*, p. 85, Alcuin was abbot of seven monasteries: Ferrières, Saint-Loup, Sens, Saint-Josse, Flavigny, Cormery, and Saint-Martin of Tours.

47 **slaves culled from frontier wars:** Two interesting and related perspectives on Carolingian slavery are Bloch, *Slavery and Serfdom in the Middle Ages*; and Bonnassie, *From Slavery to Feudalism in South-Western Europe*.

48 **"The abbot should always remember that he will be held accountable":** Meisel and del Mastro, trans., *The Rule of St. Benedict*, chap. 2, p. 48.

49 **Alcuin and his contemporaries greatly preferred the curriculum of grammar, rhetoric, and logic:** Brown, "Introduction: The Carolingian Renaissance," in McKitterick, ed., *Carolingian Culture: Emulation and Innovation*, p. 37.

49 "In sooth, it was a pleasant sight": Henry Wadsworth Longfellow, "The Student's Tale: Emma and Eginhard," from *Tales of a Wayside Inn, Part Third*, in *The Complete Poetical Works of Henry Wadsworth Longfellow*, p. 295.

49 "Being always eager to carry out your wishes faithfully": Allott, *Alcuin of York*, letter 38, p. 50.

50 Warriors who fought on the Saxon frontier could note the contrast: Story, "Charlemagne and the Anglo-Saxons," in Story, ed., *Charlemagne: Empire and Society*, p. 196.

51 "O God, deliver this monastery from these Britons": *Vita Alcuini*, in *Monumenta Germaniae Historica*, Scriptorum XV:I, p. 193, lines 44–46. This translation is my own.

51 "The greatest danger overhangs this island": Allott, *Alcuin of York*, letter 50, p. 65.

52 "Here should they sit who reproduce the oracles": Riché, *Daily Life in the World of Charlemagne*, p. 207.

52 "It is an excellent task to copy holy books": This concluding couplet is from the complete translation of the poem in Godman, *Poetry of the Carolingian Renaissance*, p. 139.

53 "I, your Flaccus, am busy carrying out your wishes": Allott, *Alcuin of York*, letter 8, p. 12.

53 "Let father Albinus be seated and pronounce words of wisdom": Theodulf, "On the Court," in Godman, *Poetry of the Carolingian Renaissance*, pp. 160–161, lines 191–196.

54 "I too, however ill-equipped, battle daily against ignorance": Allott, *Alcuin of York*, letter 75, p. 92.

54 "No war ever undertaken by the Frankish people was more prolonged": Thorpe, trans., *Two Lives of Charlemagne*, p. 61.

55 **his Saxon wars also had an economic purpose:** Mayr-Harting, "Char-
 lemagne, the Saxons, and the Imperial Coronation of 800," p. 1114.

56 **"Hardly a year passed in which they did not vacillate":** Thorpe, trans.,
 Two Lives of Charlemagne, p. 62.

56 **"If the light yoke and easy load of Christ were preached":** Allott, *Alcuin
 of York*, letter 57, p. 74.

57 **"Men can understand things without seeing images":** Riché, *Daily Life in
 the World of Charlemagne*, p. 233.

57 **they had learned about the Second Council of Nicaea through a
 botched Latin translation:** For a good summary of the Frankish response
 to iconoclasm, icon restoration, and the Second Council of Nicaea, see
 Collins, *Charlemagne*, pp. 134–136.

58 **They had long found their Greek rivals strangely interesting and rather
 exotic:** Notker the Stammerer offers several anecdotes about the "Greeks"
 from a Frankish perspective, including a story about their peculiar eating
 habits and the exotic gifts they supposedly brought to Charlemagne. See
 Thorpe, trans., *Two Lives of Charlemagne*, pp. 139–140, 143.

59 **the most important matters treated by the Council of Frankfurt were
 intellectual and theological:** Loyn and Percival, *The Reign of Charlemagne:
 Documents on Carolingian Government and Administration*, pp. 56–63.

59 **"Whereat, under the first and foremost head":** Ibid., p. 57.

60 **"A reply to his book, or rather error, must be considered":** Allott, *Alcuin
 of York*, letter 79, p. 95.

60 **"Not only should I, the most insignificant servant of our Saviour":**
 Ibid., letter 8, pp. 11–12.

61 **Alcuin began to refer to the "Holy Empire," and the *Imperium Chris-
 tianum*, the Christian Empire:** For example, ibid., letter 66 (MGH letter

136). Ganshof catalogs three references to "empire" in Alcuin's letters between A.D. 796 and 797, six references in A.D. 799 alone, and others through A.D. 801–802. See Ganshof, "IV. The Imperial Coronation of Charlemagne: Theories and Facts," in *The Carolingians and the Frankish Monarchy*, pp. 41–54, especially notes 33 and 34.

61 **"In the morning, at the height of my powers":** Allott, *Alcuin of York*, letter 8, p. 13.

4: DAYBREAK IN THE CITY OF PEACE

63 **one of several monasteries in the region:** Regarding monasteries, Le Strange lists references to at least a dozen of them in and around Baghdad. See Le Strange, *Baghdad during the Abbasid Caliphate from Contemporary Arabic and Persian Sources*, pp. 209–210.

63 **"fair Aurora had laid aside her veil of modesty":** The *maqāmāt* "of Armenia" of Hamadhānī (c. A.D. 1000), quoted in A. F. L. Beeston, "Al-Hamadhānī, Al-Harīrī, and the *Maqāmāt* Genre," in Ashtiany et al., eds., *'Abbasid Belles-Lettres*, p. 131.

63 **an evening of immodesty and poetic flourishes:** During the Abbasid era, wine parties typically lasted into the early morning. See Sawa, "The Survival of Some Aspects of Medieval Arabic Performance Practice," pp. 73–86, in particular page 76.

63 **The monastery provided a much-needed retreat:** Kilpatrick, "Monasteries through Muslim Eyes: The Diyārāt Books," in Thomas, ed., *Christians at the Heart of Islamic Rule: Church Life and Scholarship in 'Abbasid Iraq*, pp. 22–27.

64 **opportunities for an amorous rendezvous and the consumption of wine:** Irwin, ed., *Night and Horses and the Desert*, p. 123. Irwin notes that monasteries were "favourite resorts of libertines" and that "drinking bouts, picnics and assignations with lovers took place in monastery gardens."

64 **Besides, there were rules of behavior:** For the rules of an Abbasid wine
 party as encoded by poet Muhammad b. ʿAbd al-Rahmān al-ʿAtawī during
 the third/ninth century, see Ashtiany et al., *ʿAbbasid Belles-Lettres*, p. 230.

64 **"At night," he lamented, "I have often made my camels":** Ashtiany et al.,
 ʿAbbasid Belles-Lettres, p. 231.

64 **in polite society, wine with dinner was terribly, irredeemably uncouth:**
 Ahsan, *Social Life under the Abbasids*, p. 164.

64– **peaches from Basra, pistachios from Aleppo, rice from the great planta-**
65 **tions of Egypt:** The various crops and products of the Abbasid caliphate
 are mentioned in passing by Ahsan in *Social Life under the Abbasids*, by Ken-
 nedy in *The Early Abbasid Caliphate: A Political History*, and by Hitti in *Capital
 Cities of Arab Islam*. For a comprehensive overview of Abbasid agriculture,
 see Watson, *Agricultural Innovation in the Early Islamic World: The Diffusion of
 Crops and Farming Techniques, 700–1100*.

65 *harisa*, **the favorite meat-and-flour dish of Baghdad:** Ahsan, *Social Life un-
 der the Abbasids*, p. 150.

65 **the better, it was said, to protect himself from butchers with sharpened
 knives:** Lassner, *The Topography of Baghdad in the Early Middle Ages*, p. 61.

65 **"Let the morning clouds shower":** ʿAbdallah Ibrahim b. Muhammad b.
 ʿArafah Niftawayh, cited ibid., p. 63. Brackets around the word "other"
 appear in Lassner's original.

65 **The congested markets, the beggars in the back streets, and the some-
 times violent feuds:** Ibid., pp. 178–179.

65 **Christians swarmed into the fish markets, leaving meager pickings for
 seafood-loving Muslims:** Ahsan, *Social Life under the Abbasids*, p. 86.

66 *al-asfar*, **"the yellow ones":** Ashtiany et al., *ʿAbbasid Belles-Lettres*, p. 43.

66 **these generals rarely lacked for work:** The Abbasid army had no regimental
 organization but consisted of small private armies hired by the government
 and paid by the caliph. See Kennedy, *The Early Abbasid Caliphate*, p. 81.

66 **their children, who now commanded the palace guards and ran the po-
 lice force:** Ibid., p. 77.

67 **Harun ibn Muhammad ibn Abdallah ibn al-Abbas:** This version of Ha-
 run's full name is given in Bosworth, trans., *The History of al-Tabarī*, Vol. 30,
 The ʿAbbāsid Caliphate in Equilibrium, p. 91.

67 **even nineteenth-century Europeans knew him through his mytholo-
 gized role:** For good overviews of Harun al-Rashid and the mythic Bagh-
 dad of *The Arabian Nights*, see the entries on the Harun-related tales on
 pp. 201–207 of Marzolph and van Leeuwen, eds., *The Arabian Nights En-
 cyclopedia*, Vol. 1, as well as the entries on Baghdad on pp. 485–487 and
 Harun on pp. 585–587 of Marzolph and Leeuwen, eds., *The Arabian Nights
 Encyclopedia*, Vol. 2. For two modern Iraqi poems that offer a sad, cynical
 perspective on the mythologized past, see Buland al-Haidari, "My Apolo-
 gies," in Abdullah al-Udhari, trans., *Modern Poetry of the Arab World*, pp. 46–
 47; and Sargon Boulus, "Remarks to Sindbad from the Old Man of the
 Sea," in Obank and Shimon, eds., *A Crack in the Wall: New Arab Poetry*. For a
 modern western novel about Harun, see Horch, *The Angel with One Hundred
 Wings: A Tale from the Arabian Nights*.

67 **Harun, *khalifat rasul Allah*, "representative of the emissary of God"; and
 amir al-muminin, "commander of the faithful":** See von Grunebaum, *Classi-
 cal Islam: A History 600–1258*. On p. 50, von Grunebaum translates the title
 Khalīfat rasūl Allāh as " 'representative' of the emissary of God." On p. 55, von
 Grunebaum states that the title *amīr al-muʾminīn*, "Commander of the Faith-
 ful," began with caliph ʿUmar ibn al-Khattab, appointed by Abu Bakr.

67 **Declaring Baghdad a "steamy place":** The term al-Tabarī uses is *al-bukhār*.
 Cited in Bosworth, *The History of al-Tabari*, *Vol. 30, The ʿAbbāsid Caliphate in
 Equilibrium*, p. 103.

67 "It is as though it was poured in a mold and cast": Lassner, *The Topography of Baghdad in the Early Middle Ages*, p. 139.

67 *al-Mansur*, "supported with victory": According to von Grunebaum, *Classical Islam: A History*, p. 50, Mansur was the first caliph to start the tradition of adopting a "theophorous throne name: al-Mansūr (bi'llāh), 'supported (by God) with victory.'"

68 the *sawad*, or "black land," that other cultures . . . had found conducive to irrigation and agriculture: Bosworth, "III: Some Remarks on the Terminology of Irrigation Practices and Hydraulic Constructions in the Eastern Arab and Iranian Worlds in the Third–Fifth Centuries A.H.," in *The Arabs, Byzantium, and Iran: Studies in Early Islamic History and Culture*, p. 78.

68 "It is said: When al-Mansur decided to build Baghdad": McAuliffe, trans., *The History of al-Tabari*, Vol. 83, *'Abbāsid Authority Affirmed*, 245–246.

69 The ghosts of the ancient capitals of Akkad and Babylon . . . and the ruins of Ctesiphon: Kennedy, *The Early Abbasid Caliphate*, p. 86, and Lassner, p. 133.

69 Round cities had been common among the Sassanian Persians, and the green dome: Wendell, "Baghdad: *Imago Mundi*, and Other Foundation-Lore," pp. 104–105, 117.

70 "I heard a group of scholars mention that the green dome was surmounted by the figure of a horseman": Al-Qādī Abū-l Qāsim at-Tanūkhī, cited in Lassner, *The Topography of Baghdad in the Early Middle Ages*, pp. 52–53.

70 The monks from a nearby Christian monastery had told him of a prophecy: Variations on the prophecies involving "Miqlas" and the establishment of Baghdad can be found in McAuliffe, trans., *The History of al-Tabari*, Vol. 83, *'Abbāsid Authority Affirmed* under the heading "The Reason Abū Ja'far Built Baghdad," pp. 237–252. According to McAuliffe, p. 239, n. 1103, the word is "the term for a camel that is growing fat in the summer" and "also the nickname of a famous thief."

70 including Masha'allah, a prominent Jewish astronomer from Basra: Roth, *"Dhimma:* Jews and Muslims in the Early Medieval Period," in Netton, ed., *Studies in Honour of Clifford Edmund Bosworth,* Vol. I, pp. 259–260.

70 "Have you seen in all the length and breadth of the earth": This poem is attributed either to 'Umārah b. 'Aqīl b. Bilāl b. Jarīr b. al-Khatafī or to Mansūr an-Namarī in Lassner, *The Topography of Baghdad in the Early Middle Ages,* p. 47.

71 "In the entire world, there has not been a city which could compare with Baghdad": Al-Khatib, cited ibid., pp. 108–109. The bracketed Arabic terms in this passage appear in the source translation.

71 "It reached its highest point in buildings and population during the reign of ar-Rashid": Ibid., p. 109.

72 "scattering them like stubble before the fury of his onslaught": Wallace-Hadrill, trans., *The Fourth Book of the Chronicle of Fredegar,* p. 91.

72 across the Islamic world, travelers still met Christians, Buddhists, Jews, Zoroastrians, and a few old-timers: Saunders, *A History of Medieval Islam,* p. 95; and von Grunebaum, *Classical Islam: A History,* p. 67.

73 Late in Harun's reign, Christians and Jews were ordered to wear special bands or patches on their clothing: Scholarship on the status of *dhimmi* is extensive, although only a few details for the reign of Harun are available. Notable works on the subject include Tritton, *The Caliphs and Their Non-Muslim Subjects;* Bosworth, "The Concept of *Dhimma* in Early Islam," *The Arabs, Byzantium, and Iran: Studies in Early Islamic Culture,* chapter 6, pp. 37–51; Roth, "16. *Dhimma:* Jews and Muslims in the Early Medieval Period," in Netton, ed., *Studies in Honour of Clifford Edmund Bosworth,* Vol. I, *Hunter of the East: Arabic and Semitic Studies,* pp. 238–266; and Ye'or, *Islam and Dhimmitude: Where Civilizations Collide.*

73 Expatriates from Constantinople as well as many Greek-speaking Arabs still dwelled in Baghdad: Gutas, *Greek Thought, Arabic Culture,* p. 17.

73 It helped that Muslim armies had captured Chinese paper makers four decades earlier: Irwin, ed., *Night and Horses and the Desert*, p. 68.

73 The subjects that an aspiring member of the *kuttab* needed to master were daunting: The famous introduction of Ibn Qutayba is quoted in Gutas, *Greek Thought, Arab Culture*, pp. 111–112.

73 Inspired by Mansur, they became patrons of the arts and learning: For fascinating and thorough studies of the translation movement in the sciences, see Gutas, *Greek Thought*; and Young et al., eds., *Religion, Learning, and Science in the ʿAbbasid Period*.

74 "men of culture and virtue, of knowledge and discernment": Al-Jahshiyari, quoted in Lewis, ed., *A Middle East Mosaic: Fragments of Life, Letters, and History*, p. 222.

74 One saying attributed to the Prophet Muhammad even compared skilled record-keepers to angels in heaven: Ibn Qutayba, cited in "Maxims on Statecraft (Seventh–Ninth Centuries)," ibid., p. 222.

74 "How can you fear any misfortune in a place": Salm al-Khāsir, cited in Bosworth, *History of al-Tabarī*, Vol. 30, p. 147.

74 "When one of the Barmakis reaches the age of ten years": Salm al-Khāsir, cited ibid.

75 the round, Persian-inspired design may have been his idea: Wendell, "Baghdad: *Imago Mundi*, and Other Foundation-Lore," p. 123.

76 this one will never be confirmed, but it will be remembered and enshrined in *The Arabian Nights*: See "Harun al-Rashid and the Barmakids, 281 (Burton from the Breslau edition)," in Marzolph and van Leeuwen, *The Arabian Nights Encyclopedia*, Vol. 1, pp. 202–203. Several tales involving Harun are covered on pp. 201–207 of this volume.

76 an old Roman site that had merged with a newer settlement called Rafiqa, "the partner": Kennedy, *The Court of the Caliphs*, pp. 66–67.

77 they could flock to the western frontier to spread Islam, or die trying:
 El-Hibri, *Reinterpreting Islamic Historiography*, p. 29.

77 but for the most fervent of holy warriors, they were also religious re-
 treats: Bosworth, "Byzantium and the Arabs: War and Peace between Two
 World Civilizations," chap. 13 in *The Arabs, Byzantium, and Iran: Studies in
 Early Islamic History and Culture*. Bosworth discusses the importance of the
 ribāt, the Islamic frontier fort and religious retreat of the period, on p. 9.

77 "Poets are followed by erring men": Quran 26: 225–226. Dawood,
 trans., *The Koran*, p. 264.

77 "it would be better for a man to have his belly filled with pus": Irwin,
 ed., *Night and Horses and the Desert*, p. 40.

78 "the protective shelter of the cupola of Islam": Bosworth, *History of al-
 Tabarī*, Vol. 30, p. 333.

78 "O Commander of the Faithful": Ibid., p. 322.

78 Harun imprisoned him, hoping in vain to wring love songs from him
 again: Ashtiany et al., *Abbasid Belles-Lettres*, pp. 153, 287. See also Irwin, ed.,
 Night and Horses and the Desert, pp. 127–128.

78 He loved to hunt, play polo, and plan large-scale war games: Ahsan, *Social
 Life under the Abbasids*, p. 255.

79 The caliph had more than 2,000 girls in his harem, two dozen of whom
 had borne him children: Harun's harem is mentioned by Kennedy, *The
 Court of the Caliphs*, p. 165; and his chap. 7 is exclusively about Abbasid
 harems. A list of Harun's children and their mothers can be found in Bos-
 worth, *History of al-Tabarī*, Vol. 30, pp. 327–328.

81 "How much blood has been unlawfully shed because of ambassadors!"
 Quotation from Ardashir I, attributed to Al-Jahiz, in Lewis, ed., *A Middle
 East Mosaic: Fragments of Life, Letters, and History*, p. 132.

82 **cups of his favorite gazelle milk:** Ahsan, *Social Life under the Abbasids*,
 p. 97.

5: THE MERCHANTS OF ASHKENAZ

83 **By the third century after Christ, against the push of rivers, Jews came
 to western Europe:** Benbassa, *The Jews of France: A History from Antiquity to
 the Present*, p. 4. Eidelberg, p. 3, points out that the earliest reports of Jew-
 ish settlers in the Rhineland date from A.D. 331 but that they may have
 been in Germany earlier than previously assumed (pp. 6–7); see Eidelberg,
 "The Origins of Germanic Jewry: Reality and Legend," in Hirschler, ed.,
 Ashkenaz: The German Jewish Heritage, pp. 3–10.

84 **He certainly lived among Germanic-speaking Christians, perhaps in
 Cologne, Mainz, Trier, or Aachen:** Glick, *Abraham's Heirs*, p. 44.

84 **Perhaps he wore a beard, as clean-shaven churchmen and mustachioed
 nobles would not:** On the indistinctive appearance of Frankish Jews,
 see Wallace-Hadrill, *The Frankish Church*, pp. 390–391. For a recent and
 unusually thoughtful examination of hair, beards, and mustaches in
 Frankish history and iconography, see "Charlemagne's Mustache," chap.
 I in Dutton, *Charlemagne's Mustache and Other Cultural Clusters of a Dark Age*,
 pp. 3–42.

84 **the land of Ashkenaz:** Eidelberg, "Evolution of the Term 'Ashkenaz,'" in
 Hirschler, ed., *Ashkenaz: The German Jewish Heritage*, pp. I–2. Eidelberg says
 that scriptural sources identify the name with ancient Assyria or Armenia.
 See also Genesis 10:2–5 and I Chronicles 1:6.

84 **a fourth-century tombstone in a Jewish cemetery at Mainz, or ninth-
 century Hebrew tomb inscriptions in southern Italy:** The tombstone at
 Mainz is mentioned by Eidelberg, "The Origins of Germanic Jewry," p. 3.
 The tomb inscriptions in southern Italy are cited by Simonsohn, "The
 Hebrew Revival among Early Medieval European Jews," p. 853.

85 **he was forbidden to own Christian slaves:** Bachrach, *Early Medieval Jewish Policy in Western Europe*, pp. 74–75.

86 **A ninth-century phrasebook offers colorful evidence:** Edwards, "German Vernacular Literature: A Survey," in McKitterick, ed., *Carolingian Culture*, p. 143.

87 **"These merchants speak Arabic.... On their return from China, they carry back musk":** Excerpts from Abu'l Kasim Obaidallah ibn Khordâdhbeh, *The Book of Ways and Kingdoms* (c. 817), from Adler, ed., *Jewish Travellers in the Middle Ages: Nineteen Firsthand Accounts*, pp. 2–3.

88 **"Once, while Karl was traveling, he came unannounced to a certain coastal town":** Haefele, p. 77. This translation is my own. For an alternative translation, see Thorpe, trans., *Two Lives of Charlemagne*, p. 158.

88 **Jews did live along the Mediterranean coast:** Benbassa, *The Jews of France*, pp. 3–5, points out the notion of Gaul as a new "chosen land" after the destruction of the Second Temple in A.D. 70 and after the Bar-Kokhba revolt in A.D. 132–135. Agus points out that many of these Jews would have migrated voluntarily to Italy first, or would have been brought there as captives after the failed revolts; see Agus, *The Heroic Age of Franco-German Jewry*, p. 2.

89 **the Jews of Francia served in the army:** Bachrach, *Early Medieval Jewish Policy in Western Europe*, pp. 69–70.

89 **They bought the staples of their diet from Christian merchants:** Glick, *Abraham's Heirs*, pp. 43–44.

89 **Jews ... were involved in a wide range of essential pursuits:** Benbassa, *The Jews of France*, p. 11.

89 **One legend credits Karl with inviting an Italian rabbi named Kalonymus to settle in Mainz:** Carlebach, "The Religious Legacy of German Jewry," in Hirschler, ed., *Ashkenaz*, p. 209. See also Bachrach, *Early Medieval Jewish*

Policy, p. 71, and p. 166, n. 22, where Bachrach writes: "Such materials as these have led scholars to agree on the importance of Jewish merchants in the Carolingian empire. It is generally believed that a Jewish quarter was established at Aachen during Charles's reign, but only further archaeological work can provide firm conclusions. By 820, however, we have written evidence for the Jews at Aachen, and the text would seem to indicate that they were not newly arrived since their warehouses and other installations were well established."

89 **The Talmud, which codified Jewish law and moral teachings, would be unknown in Francia for two more centuries:** Benbassa, *The Jews of France*, p. 12. See also Martin, *A History of Judaism*, Vol. 2, p. 88. Martin estimates that Talmudic study was established in Italy by A.D. 1000.

90 **Little by little, a Hebrew renaissance in southern Italy was pushing north:** On the importance of the Latin Bible and oral tradition, see Benbassa, *The Jews of France*, p. 5. On the late eighth-century Hebrew renaissance in southern Italy, see Bachrach, *Early Medieval Jewish Policy*, p. 81; and Simonsohn, "The Hebrew Revival among Early Medieval European Jews," pp. 831–858.

90 **There was a certain vainglorious bishop who was overly attached to all sorts of inane things:** Haefele, *Notker der Stammler*, pp. 19–20. This translation is my own. For an alternative translation of this anecdote, see Thorpe, trans., *Two Lives of Charlemagne*, pp. 108–109.

91 **A rabbi oversaw each *kehillah*:** Martin, *A History of Judaism*, Vol. 2, pp. 64–65.

92 **"So God may help me, the God who gave the law to Moses on Mount Sinai":** *MGH, Cap.*, I, no. 131, chap. 3, cited and translated in Bachrach, *Early Medieval Jewish Policy in Western Europe*, p. 77. Although other scholars do not seem to agree, Linder, ed. and trans., *The Jews in the Legal Sources of the Early Middle Ages*, p. 345, suggests that this and three other capitularies regarding the Jews have been wrongly attributed to Charlemagne and that "they are certainly later and probably spurious."

92 **Christians preferred the eloquent sermons of local rabbis:** Riché, *Daily Life in the World of Charlemagne*, p. 128.

92 **They also knew that Jews enjoyed a genuine feast every Friday and actual rest on the Sabbath:** Wallace-Hadrill, *The Frankish Church*, p. 402.

92 **The Jews of Francia circulated books critical of Christianity and sometimes won over converts:** Bachrach, *Early Medieval Jewish Policy*, p. 71.

93 **"He had himself circumcised, allowed his hair and beard to grow long":** Entry for Anno 839 in the Annals of the Cloister of St. Bertin, in Marcus, *The Jew in the Medieval World: A Source Book: 315–1791*, pp. 353–354.

93 **"While we, with all the humanity and goodness which we use toward them":** Riché, *Daily Life in the World of Charlemagne*, p. 128.

93 **"Can light consort with darkness?" the pope asked:** Stow, *Alienated Minority*, p. 30. Pope Stephen's text is II Corinthians 6:15–16.

94 **The recently deceased Pope Hadrian had also cited scripture:** Stow, *Alienated Minority*, p. 31. Hadrian cited I Corinthians 5:9–13.

94 **"Although apostolic teaching reminds us especially to do good for our brethren":** Bachrach, *Early Medieval Jewish Policy in Western Europe*, p. 89.

94 **"since they [the Jews] live among us we should not be hostile to them":** Ibid., p. 99.

94 **"Rise, pipe, and make sweet poems for my lord!":** Godman, *Poetry of the Carolingian Renaissance*, p. 113.

95 **if the Jews were not an integral part of ancient Rome:** Benbassa, *The Jews of France*, p. 4.

95 **"The heathen peoples come prepared to serve Christ":** Godman, *Poetry of the Carolingian Renaissance*, p. 153, lines 37–44.

96 **The nuances of Andalusian politics can baffle modern historians:** For
 an accessible, informative, and current overview of al-Andalus, see Meno-
 cal, *The Ornament of the World*, p. 9. Menocal comments: "Many aspects of
 the story are largely unknown, and the extent of their continuing effects
 on the world around us is scarcely understood, for numerous and complex
 reasons. The conventional histories of the Arabic-speaking peoples follow
 the fork in the road taken by the Abbasids. At precisely the point at which
 the Umayyad prince sets up his all-but-declared caliphate in Europe, the
 story we are likely to be told continues with the achievements of the Ab-
 basids, who did indeed make Baghdad the capital of an empire of material
 and cultural wealth and achievement."

96 **"a most beautiful tent":** Scholz and Rogers, trans., *Carolingian Chronicles*,
 p. 76.

97 **"When he arrived at the palace of Aachen, he received an embassy of
 the Greeks":** Ibid.

99 **"To the noblest of birds, the eagle, the goose cackles its greeting":** Al-
 lott, *Alcuin of York*, letter 100, p. 109.

6: BLOOD OF THE MARTYRS

104 **To Christians, Rome was the Eternal City:** Romans were referring to
 their city as the Eternal City as early as the second century after Christ.
 See Hetherington, *Medieval Rome*, p. 1. For a history of the notion of Rome
 as eternal from antiquity to the Renaissance, see Pratt, "Rome as Eternal,"
 pp. 25–44, especially pp. 31–32.

104 **Seedy Venetians prowled the markets:** Llewelyn, *Rome in the Dark Ages*,
 p. 181.

104 **"sex-hungry and ignorant Swiss, Bavarians, or Franks":** Krautheimer,
 Rome: Profile of a City, p. 81. For more on the interesting diversions along
 the pilgrimage road, see Llewelyn, *Rome in the Dark Ages*, p. 181.

104 **"O brothers, how beautiful must be the heavenly Jerusalem"**: Hetherington, *Medieval Rome*, p. 7.

104 **"O noble Rome, mistress of the world"**: Brittain, trans., *Penguin Book of Latin Verse*, p. 155. "O Roma Nobilis" dates from the ninth or tenth century.

106 **"Meanwhile, some malign, wicked, perverse and false Christians"**: Davis, trans., *The Lives of the Eighth-Century Popes*, pp. 184–185.

107 **"When Pope Leo in Rome was riding on horseback from the Lateran"**: From the entry for the year A.D. 799 in the Royal Frankish Annals. Scholz and Rogers, trans., *Carolingian Chronicles*, p. 77.

107 **"In the same year some Roman relatives of the blessed pope Hadrian incited the people"**: Turtledove, trans., *The Chronicle of Theophanes*, p. 155.

108 **"But afterward, like really impious heathens"**: Davis, trans., *The Lives of the Eighth-Century Popes*, pp. 185–186.

109 **Atzuppius, a name that may have been of Greek, southern Italian, or even Arabic origin**: Davis, trans., *The Lives of the Eighth-Century Popes*, p. 179, n. 1.

110 **"Now the sun flees, and the night seizes the daylight"**: Dümmler, ed., *MGH Poetae Latini aeva Carolini I*, p. 374, lines 324–331. This translation is my own. For an alternative translation, see Dutton, *Carolingian Civilization: A Reader*, pp. 55–56. Dutton comments that the poet is often considered to be Einhard.

111 **"When almighty God in his customary mercy displayed this great miracle"**: Davis, trans., *The Lives of the Eighth-Century Popes*, p. 186.

111 **"But through the efforts of Albinus, his chamberlain"**: Scholz and Rogers, trans., *Carolingian Chronicles*, p. 77.

112 **"When he saw that the supreme pontiff was able to see and speak"**: Davis, trans., *The Lives of the Eighth-Century Popes*, p. 187.

113 The church, he said, "has been cast into disorder by the manifold wickedness of the ungodly": King, *Charlemagne: Translated Sources*, pp. 320–321.

114 "There have hitherto been three persons of greatest eminence in the world": Allott, *Alcuin of York*, letter 103, p. 111.

116 By 799, a palace and church compound were proof that Karl had started to spread Christendom: Charlemagne began building at Paderborn during the 770s. See Mayr-Harting, "Charlemagne, the Saxons, and the Imperial Coronation of 800"; and Bullough, *The Age of Charlemagne*, p. 171.

117 "Then they gathered spear-shafts in hand, and breastplates thrice-twined": Dümmler, ed., *MGH Poetae Latini Aevi Carolini I*, pp. 378, lines 469–484. This translation is my own. An alternative translation can be found in Dutton, *Carolingian Civilization: A Reader*, p. 57.

118 Leo...saw cavalry on trained warhorses, the forerunners of later knights: Riché, *The Carolingians*, p. 309.

118 They could point to a tradition of victory: For a fascinating and comprehensive overview of the Frankish army, see Bachrach, *Early Carolingian Warfare: Prelude to Empire*.

119 "Now Pope Leo approaches from without": Dümmler, *MGH Poetae Latini Aevi Carolini I*, pp. 378–379, lines 494–505. This translation is my own. An alternative translation can be found in Dutton, *Carolingian Civilization: A Reader*, p. 57.

119 "They greeted and embraced each other in tears": Davis, *The Lives of the Eighth-Century Popes*, p. 189.

120 "to lay false charges after the holy pontiff and send them after him to the king": Ibid., p. 188.

120 "As for the long and wearisome journey to Rome": Allott, *Alcuin of York*, letter 104, p. 112.

122 "The previous letter, which reached us in your name": Allott, *Alcuin of York*, letter 65, p. 79.

7: PRAYERS AND PLOTS

123 **Abbots and merchants posted night watchmen in their vineyards:** During the ninth century, Wandalbert of Prüm, in "De Mensium Duodecim Nominibus Signis Culturis Aerisque Qualitatibus," says that September is the time "to place watchmen in the vineyards, / Who are able to stop wandering thieves from access / And to lay hold of cunning foxes by snare and net." See Hammer, *Charlemagne's Months and Their Bavarian Labors: The Politics of the Seasons in the Carolingian Empire*, appendix, p. 54.

124 **Did the Holy Father really have, across his eyes, a scar as pure and white as any dove?:** The latter rumor appears in Notker, Vol. 26; see Thorpe, trans., *Two Lives of Charlemagne*, p. 122. For further speculation on the deeply held superstitions of Carolingian peasants, largely based on Anglo-Saxon charms, see chap. 1, "The Peasant Bodo," in Power, *Medieval People*, pp. 18–38.

124 **Karl was known to send alms to poor Christians in Africa and the Middle East:** For Einhard on Charlemagne's foreign almsgiving, see Thorpe, trans., *Two Lives of Charlemagne*, p. 80.

124 **or did it come with the blessing of Harun al-Rashid?:** Joranson is skeptical about the idea that a patriarchal embassy from Jerusalem required the approval of the caliph. Buckler is similarly skeptical but is more inclined to believe that the later embassy from Jerusalem, sent to Charlemagne in Rome in 800, probably required the approval of the caliphate. See Joranson, "The Alleged Frankish Protectorate in Palestine," and Buckler, *Harunu'l-Rashid and Charles the Great*, p. 29.

125 **"Wido presented to him the weapons of the leaders":** Scholz and Rogers, trans., *Carolingian Chronicles*, p. 78.

125 **That year, he lost two of his greatest heroes:** For more about Eric and
 Gerold, see Ross, "Two Neglected Paladins of Charlemagne: Erich of
 Friuli and Gerold of Bavaria."

126 **"Wastes and shrinks the enfeebled limbs of the beasts":** Wandalbert
 of Prüm, quoted in Hammer, *Charlemagne's Months and Their Bavarian Labors*,
 p. 54.

126 **"Cursed is the ground for thy sake":** Genesis 3:17–19 (King James Ver-
 sion).

127 **"King Karl was at the coast to go fishing":** St. Amand Annals, in King,
 Charlemagne: Translated Sources, p. 162.

127 **"At this time we first discern the great swells of the ocean surge":** Wan-
 dalbert of Prüm in Hammer, *Charlemagne's Months and Their Bavarian Labors*,
 appendix, p. 55.

128 **Alcuin was quite willing to make the 250-mile journey north from
 Tours that April:** Duckett places Alcuin at Saint Riquier that Easter. See
 Duckett, *Alcuin, Friend of Charlemagne*, p. 227.

128 **the king's son Louis, who rode north from Aquitaine:** According to the
 entry for 800 in the Lorsch Annals, Charles and Pepin were with Char-
 lemagne, and Louis arrived later. See King, *Charlemagne: Translated Sources*,
 p. 143.

129 **"The lovely maiden Liutgard joins their ranks":** Theodulf, "On the
 Court," in Godman, *Poetry of the Carolingian Renaissance*, p. 155, lines 83–91.

129 **Alcuin refers to "Liutgard and the children":** Allott, *Alcuin of York*, letter
 139, p. 144.

129 **She had given the Frankish court no children and was said to have suf-
 fered frequent illnesses:** Some of the more interesting speculation about
 Liutgard can be found in Cabaniss, *Charlemagne*, pp. 76, 90–92.

130 **"Do not mourn for another's happiness"**: Allott, *Alcuin of York*, letter 96,
pp. 105–107.

131 **"You want to gawk at multitudes in Tours and Rome?"**: The original
Latin can be found in Dümmler, ed., *MGH Poetae Latini Aevi Carolini I*,
p. 555. This colloquial translation is my own. For an alternative transla-
tion, see Dutton, ed., *Carolingian Civilization*, p. 92.

131 **At the beginning of the ninth century, a monk at Salzburg illustrated
a manuscript**: A good color reproduction of the Salzburg "labors of the
months" can be found in Bullough, *The Age of Charlemagne*, plate 58, p. 144.
A full discussion of the labors in their political context can be found in
Hammer, *Charlemagne's Months and Their Bavarian Labors*. For a discussion of
the later medieval calendar tradition, see Henisch, "In Due Season: Farm
Work in the Medieval Calendar Tradition."

132 **"So, then, it was done," he later wrote**: Duckett, *Alcuin, Friend of Char-
lemagne*, p. 238.

134 **"As to your wish to reproach me for preferring the sooty roofs of
Tours"**: Allott, *Alcuin of York*, letter 71, p. 87.

135 **"I understand that there are many rivals.... If I remember rightly, I
once read in the canons of St. Silvester"**: Ibid., letter 102, p. 110.

135 **Although Alcuin had no way of knowing it, both texts were forgeries**:
Collins, *Charlemagne*, p. 143.

136 **Also familiar to educated Franks was a document now known as the
Donation of Constantine**: For the text of the Donation, see Bettenson,
ed., *Documents of the Christian Church*, pp. 98–101. For brief discussions of
the Donation of Constantine in the context of Charlemagne's corona-
tion, see Riché, *The Carolingians*, p. 71; and Bullough, *The Age of Charlemagne*,
p. 32.

8: KARL, CROWNED BY GOD

138 **Most of the mosaic is an eighteenth-century reconstruction based on a seventeenth-century restoration:** For a large color photograph of the *Triclinio Leoniano,* see *Carlo Magno a Roma,* p. 15; illustrations of the mural can be found on pp. 176–181, accompanied by Italian text. For more on the mosaic, see Krautheimer, *Rome: Profile of a City,* p. 115; for a mention of the mosaic as a component of the Carolingian Renaissance, see Moreland and Van de Noort, "Integration and Social Representation in the Carolingian Empire," p. 330. A good overview of the mosaic and its history through primary sources, with illustrations, can be found in Dutton, *Carolingian Civilization,* pp. 50–54. Dutton also refers, briefly, to the depiction of Charlemagne on this mosaic in his fascinating *Charlemagne's Mustache and Other Cultural Clusters of a Dark Age,* p. 25. A longer critical history of early scholarly interest in the mosaic is Herklotz, "Francesco Barberini, Nicolò Alemanni, and the Lateran Triclinium of Leo III: An Episode in Restoration and Seicento Medieval Studies."

139 **as they lounged on couches and drank together in the Lateran triclinium:** A description of Leo's triclinium can be found in the *Liber Pontificalis,* Vol. 39; see Davis, trans., *The Lives of the Eighth-Century Popes,* pp. 197–198. The description is also translated in Dutton, *Carolingian Civilization,* p. 50. For a history of palace tricliniums, see Lavin, "The House of the Lord: Aspects of the Role of Palace Triclinia in the Architecture of Late Antiquity and the Early Middle Ages."

140 **"Go ye therefore and teach all nations":** Matthew 28:19–20 (King James Version).

141 **Centuries earlier, emperors had been received there before formally entering the city:** Collins, *Charlemagne,* p. 145.

141 **"On the next day he sent the banners of the city of Rome to meet him":** Scholz and Rogers, trans., *Carolingian Chronicles,* p. 80.

142 Nobles, priests, and lesser churchmen remained standing, in keeping
 with Frankish custom: The details in this account of Charlemagne's syn-
 od in Rome are pointed out in Wallach, "The Roman Synod of December
 800 and the Alleged Trial of Leo III," *Diplomatic Studies in Latin and Greek
 Documents for the Carolingian Age*, pp. 328–352.

143 "And there the king convened a great gathering of bishops and abbots":
 From the Lorsch Annals. Pertz, ed., *MGH SS 1, Annales et chronica aevi Caro-
 lini*, p. 38. This translation is my own.

144 "We dare not pass judgment on the apostolic see which is the head of all
 God's churches": Davis, trans., *The Lives of the Eighth-Century Popes*, p. 190.

144 "I follow the precedents set by my venerable predecessors as pontiffs":
 Ibid.

145 "It is no more useful to go to Rome than it is to live correctly": Theo-
 dulf of Orléans, in Dümmler, ed., *MGH Poetae Latini Aevi Carolini I*, p. 557.
 This colloquial translation is my own.

146 Glancing down, the king beheld silver floor tiles near the altar; staring
 up, he admired a magnificent chandelier: Krautheimer, *Rome: Profile of a
 City*, p. 112.

146 Outside, Karl and his entourage could admire the Egyptian obelisk:
 Hetherington, *Medieval Rome*, p. 43.

147 Alcuin wrote the city off as "a great mass of cruel ruins": Ibid., p. 33.
 The complete original poem by Alcuin can be found in Dümmler, ed.,
 MGH Poetae Latini Aevi Carolini I, p. 230; the excerpt here is from lines
 37–38.

147 Romans were becoming comfortable with the eastern custom of allow-
 ing saints' relics inside the city walls: Krautheimer, *Rome: Profile of a City*,
 p. 113.

148 "He hated the clothes of other countries, no matter how becoming they might be": Thorpe, trans., *Two Lives of Charlemagne*, pp. 78–79.

149 Instead, it harked back to a core concept of Frankish law and of Germanic law in general: the oath: Riché, *The Carolingians*, p. 121.

149 "I have no knowledge of these false allegations which those Romans who wickedly persecuted me bring against me": Davis, trans., *The Lives of the Eighth-Century Popes*, p. 190. The accuracy of this version of the oath is confirmed by Wallach, "The Genuine and the Forged Oath of Pope Leo III," *Diplomatic Studies in Latin and Greek Documents from the Carolingian Age*, pp. 299–327. According to Cabaniss, *Charlemagne*, p. 161, n. 54, "Wallach's article was a reply to Howard Adelson and Robert Baker, 'The Oath of Purgation of Pope Leo III in 800,' *Traditio* VIII (1952), 35–80. Both positions should be carefully studied."

149 the assembly burst into celebratory chanting: Wallach discusses the spontaneous intonation of the Te Deum in "The Genuine and Forged Oath," *Diplomatic Studies in Latin and Greek Documents*, p. 331.

150 Zacharias ... had been given specific directives by Karl, and he would have been able to talk about serious matters with George: Grabois, "Charlemagne, Rome, and Jerusalem," p. 804.

150 Beyond its role in biblical history, the Church of the Holy Sepulchre was also the headquarters of the patriarch and a site of pilgrimage: Ibid., p. 797.

151 Symbolically if not actually, Patriarch George of Jerusalem was transferring his loyalty from Constantinople to the Franks: Collins, *Charlemagne*, p. 146.

151 They required the approval of the caliph, Harun al-Rashid: Buckler, *Harunu'l-Rashid and Charles the Great*, pp. 30–31. However, more recently, Grabois, "Charlemagne, Rome, and Jerusalem," p. 806, also affirmed that the "sovereign power at Jerusalem was the Abbasid caliph" and that "Pa-

triarch George had to request the permission of Harun al-Rashid, before sending the keys." Collins, *Charlemagne*, pp. 146–147, 152, cites Grabois, echoing the notion that the coronation involved long-term planning and diplomatic wrangling with Jerusalem and Baghdad. For one scholar who disagrees that the patriarch of Jerusalem necessarily required the caliph's approval, see Joranson, "The Alleged Frankish Protectorate in Palestine."

151 **"Have a Frank as a friend, never as a neighbor":** Dutton, ed. and trans., *Charlemagne's Courtier: The Complete Einhard,* p. 26.

151 **They seem to have known that the next day, December 25, would be no ordinary Christmas:** Collins suggests that the sending of the keys may have been "a transfer of former loyalty" and that "[i]f this be a reasonable supposition, then it has to be accepted that the patriarch was aware that a new emperor was about to be made." Collins, *Charlemagne*, p. 146.

152 **Those who pushed their way to the front, and those who could read, found a Latin inscription in the arch above:** Descriptive details of the basilica of Saint Peter are based on Bannister, "The Constantinian Basilica of Saint Peter at Rome."

153 **if Karl "had known in advance of the pope's plan, he would not have entered the church that day":** Dutton, ed. and trans., *Charlemagne's Courtier,* p. 33.

154 **The day before, he had become, in theory, defender of the holy places in Jerusalem:** Collins, *Charlemagne*, p. 146.

154 **The gesture imitated the anointing of David in the Old Testament:** Riché, *The Carolingians,* p. 78.

155 **"anointing him with olive oil from head to foot":** Turtledove, trans., *The Chronicle of Theophanes,* p. 155.

155 **the malefactors were quickly found guilty of** *laesa majestatis:* Bullough, *The Age of Charlemagne,* p. 183.

156 Campulus turned on Paschal and rebuked him: "It was a bad moment when I first saw your face": Davis, trans., *The Lives of the Eighth-Century Popes*, p. 192.

156 "Say no more, Winter, you terrible squanderer of wealth": Godman, *Poetry of the Carolingian Renaissance*, pp. 148–149, lines 45–51.

158 "So every day I used to hang upon the words of our visitors": Allott, *Alcuin of York*, letter 67, p. 84.

159 "For this is the people who while small in number are great in strength": Drew, trans., *The Laws of the Salian Franks*, p. 171.

159 "Karl, the most serene Augustus crowned by God the great peaceful emperor": For an interesting discussion of this title, see Ohnsorge, "The Coronation and Byzantium," in Sullivan, ed., *The Coronation of Charlemagne*, pp. 80–91.

159 *Renovatio Romani imperii*, "Restoration of the Roman Empire": Bullough, *The Age of Charlemagne*, p. 184.

159 True, the population of the city was not what it once was: One estimate of the Roman population between the ninth and thirteenth centuries is approximately 40,000 to 80,000 people; see Hetherington, *Medieval Rome*, p. 37. Another estimate is 30,000 to 50,000 at the beginning of the ninth century; see Russell, *Late Ancient and Medieval Population*, pp. 73, 93.

9: AN ELEPHANT AT AACHEN

161 "This," wrote one modern traveler, "is the land of Ifriqiyeh": Zéraffa, *Tunisia*, p. 7.

162 They cultivated fields, dammed wild rivers, and raised rows of columns: Franck and Brownstone, *Across Africa and Arabia*, p. 73.

162 **Ages later, the Franks' descendants came here too:** For a fine and informative visual tour of the Maghreb, see Wood and Wheeler, *Roman Africa in Colour.*

162 **its hills were haunted by nomadic Berbers and its plains by Roman ghosts:** Kennedy, *The Early Abbasid Caliphate,* p. 76.

162 **According to tradition, the Prophet's Companions had prayed away the snakes and scorpions:** Ibn Khaldun, cited in Zéraffa, *Tunisia,* p. 178.

162 **Isaac passed camel caravans heading the other way, laden with hunting hawks and panthers or less exotic commodities such as tanners' leaves and African felt:** *The Investigation of Commerce,* attributed to Al-Jahiz, cites as imports "from Barbary and the borders of Maghrib: panthers, *salam* leaves, felts, and black hawks." See Lopez and Raymond, *Medieval Trade in the Mediterranean World,* p. 28.

162 **the price was 40,000 dinars paid annually to the caliph's treasury:** Saunders, *A History of Medieval Islam,* p. 115. See also Bosworth, trans., *The History of al-Tabari, Volume 30: The Abbasid Caliphate,* p. 174.

163 **Abul Abaz ate voraciously:** Basic facts about elephant care come from *The National Geographic Book of Mammals,* Vol. I, pp. 190–197; and Nowak, *Walker's Mammals of the World.* An interesting book about elephants' behavior and their relationship to humans is Scigliano, *Love, War, and Circuses: The Age-Old Relationship between Elephants and Humans.*

163 **"They reported that Isaac the Jew, whom the emperor four years earlier had dispatched with Lantfrid and Sigimund":** Scholz and Rogers, trans., *Carolingian Chronicles,* p. 82.

164 **The emperor spent much of the spring making changes in Lombard law:** Cabaniss, *Charlemagne,* p. 103.

164 **Only four years earlier, he had been a subordinate, probably an interpreter:** Buckler, *Harunu'l-Rashid and Charles the Great,* p. 21, suggests that

Isaac was probably an interpreter. Agus, *The Heroic Age of Franco-German Jewry*, p. 37, suggests that Isaac's usefulness involved his ability to mobilize the support of Jewish communities along the way. Glick, *Abraham's Heirs*, pp. 50–51, suggests that Isaac probably began as interpreter but took control after the death of Lantfrid and Sigimund, and also stresses his access to Jewish communities. Bachrach, *Early Medieval Jewish Policy in Western Europe*, p. 74, speculates that if Isaac were the leader of the embassy, then he may have had a staff, consisting of other Jews, who could perform chores, and that they would have been multilingual. On the other hand, Stow, *Alienated Minority*, p. 45, believes that Isaac was not originally Charlemagne's ambassador, a post that was reserved for a Christian.

165 **"The warm humor is lacking among them"**: From al-Masudi, c. 947, in Lewis, ed., *A Middle East Mosaic*, p. 30.

165 **One modern Saudi etiquette manual cites an anecdote about Frankish ambassadors**: Cuddihy, *Saudi Customs and Etiquette*, p. 40.

165 **Unimpressed by their visitors, Abbasid historians said absolutely nothing about ambassadors from Aachen**: On the silence of Muslim sources, see Buckler, *Harunu'l-Rashid and Charles the Great*, p. 41.

165 **Except for one biography of a Christian saint that mentions a relic-seeking monk**: For the saint's life, see "Ex Miraculis S. Genesii," in Waitz, ed., *MGH Scriptorum*, Vol. 15, Part 1, pp. 169–172. From June 30, 2003, through September 28, 2003, an exhibition about Isaac's journey, focusing on Baghdad, Jerusalem, and Aachen, was displayed at Aachen. Two German-language publications accompanied the exhibition; see Dressen, Minkenberg, and Oellers, *Ex Oriente: Isaak und der weiße Elefant: Bagdad-Jerusalem-Aachen*. For a summary of the exhibition, see Zeier, "Baghdad-Jerusalem-Aachen: On the Trail of the White Elephant."

165 **Here Isaac saw the great mosque built from pieces of old Roman buildings**: For photos and a brief history of the Great Mosque of Kairouan, which was built c. A.D. 725 and significantly enlarged later, see Wood and

Wheeler, *Roman Africa in Colour*, pp. 156–158. For a visitor's tour of Kairouan, see Anthony, "The Fourth Holy City."

166 **Strolling along the waterfront and wandering down shady lanes:** Brown, *Augustine of Hippo*, p. 65.

167 **legates sent to Irene by Karl and Pope Leo had come with a marriage invitation:** Turtledove, trans., *The Chronicle of Theophanes*, p. 158.

167 **even when Irene had roared out of church on Easter Monday in a chariot drawn by four white horses:** For a concise analysis of Irene's adaptation of the Easter ceremony of distributing largesse, see Herrin, *Women in Purple*, pp. 114–115.

169 **"We call those Christian emperors happy who govern with justice":** Augustine, *The City of God* 24, in Walsh et al., trans., *City of God: Abridged for Modern Readers*, p. 118.

170 **In their lust for luxuries, the Romans also butchered elephants:** Scullard, *The Elephant in the Greek and Roman World*, p. 261.

170 **"Of Africa and India they were natives," wrote Saint Isidore of Seville:** Ibid., p. 235.

170 **A floor mosaic on Sicily, once a way station for Roman trade:** Franck and Brownstone, *Across Africa and Arabia*, p. 73. The mosaic, which dates from c. A.D. 300, is in Piazza Armerina.

170 **One Roman consul was said to have disguised his raft as a farmyard:** Scullard, *The Elephant in the Greek and Roman World*, pp. 151–152. The story is from Pliny.

170 **merchants still had boats big enough to do the job; some were large enough to require dozens of crewmen:** Hodges and Whitehouse, *Mohammed, Charlemagne, and the Origins of Europe*, p. 95. By 800, Venice was

already shipping massive amounts of cargo—including slaves, timber, and weapons—to the Muslim world; see Lewis and Runyan, *European Naval and Maritime History, 300–1500*, p. 62.

171 **on the North Sea, merchant ships, some of them sixty feet long, could carry twenty-four tons of cargo:** Bachrach, *Early Carolingian Warfare*, p. 252. Bachrach specifically cites the Utrecht boat.

171 **"Again, the heavy anchor summons me to sail this doubtful course":** This translation is my own. The original Latin can be found in Godman, *Poetry of the Carolingian Renaissance*, pp. 197–199; and in Dümmler, ed., *MGH Poetae Latini Aevi Carolini*, I, p. 366. Alternative translations can be found in Godman as well as in Dutton, *Carolingian Civilization*, p. 55.

171 **the miseries of medieval sea travel:** Ohler, *The Medieval Traveller*, p. 45.

172 *O Saint Nicholas, save us from the wind and storms:* Ibid., pp. 45–46, adapted.

172 **For many of the sailors, this pleasant town was probably home:** The current medieval church on the promontory at Portovenere dates from A.D. 1256. It was built atop a Christian temple, which in turn had been a pagan temple, presumably to Venus, as in "Portus Veneris."

174 **It had caught Karl's eye in Ravenna during his return trip from Rome:** For more on the city of Ravenna in its medieval Italian context, see Wickham, *Early Medieval Italy: Central Power and Local Society 400–1000*.

174 **The mighty Ostrogoth now symbolically defended the palace but obscured the priorities of the new Roman empire:** Bullough, *The Age of Charlemagne*, p. 166.

175 **"He gave much thought to how he could best fill the gaps":** Thorpe, trans., *Two Lives of Charlemagne*, p. 81.

175 "The oath through which I promise, from this day forward, that I am
 faithful to my lord": Pertz, *MGH LL, Capitularia regum Francorum*, pp. 98–
 99. This translation is my own. For an alternative translation of this sec-
 tion of the Special Capitularies for the *missi* of 802, see Loyn and Percival,
 The Reign of Charlemagne: Documents on Carolingian Government and Administration,
 p. 81. For more about the ins and outs and ultimate ineffectiveness of
 Charlemagne's oaths, see Ganshof, "Charlemagne's Use of the Oath," in
 The Carolingians and the Frankish Monarchy, pp. 111–124.

176 "Everyone on his own behalf should strive to maintain himself in God's
 holy service": General Capitulary for the *missi*, spring 802, section 3, in
 Loyn and Percival, *The Reign of Charlemagne*, p. 75. For a discussion of how
 this oath expanded the use of oaths as an instrument of government, see
 Collins, *Charlemagne*, pp. 154–156.

176 Karl's sparsely populated empire spanned nearly 400,000 square miles:
 Riché, *The Carolingians*, p. 130.

177 "At the same time, he directed that the age-old narrative poems": Ein-
 hard, in Thorpe, trans., *Two Lives of Charlemagne*, pp. 81–82.

178 "A common, unsummoned gloom and depression settled on everyone":
 Turtledove, trans., *The Chronicle of Theophanes*, p. 159.

178 In October 802, Karl's men in Byzantium watched as the storm broke:
 The Royal Frankish Annals indicate that Karl's envoys were in Constantinople
 when Irene was deposed. Theophanes says that they witnessed the event.

178 "To God, through Whom Emperors reign and dynasts rule the world":
 Turtledove, trans., *The Chronicle of Theophanes*, pp. 159–160.

179 "O holy band of maidens and fruitful grafts of my teaching": Tread-
 gold, "The Unpublished Saint's Life of the Empress Irene (BHG 2205),"
 p. 247.

179 **The new emperor was competent enough:** Ostrogorsky, *History of the Byz-antine State*, pp. 186–196, offers a fairly positive assessment of Nikephoros that counters the perspective of Theophanes, who favored the monks and Irene and was virulently opposed to Nikephoros.

180 **One Egyptian novel from the late nineteenth century described the adventures of a Persian noble:** *Hadarat al-Islam fi dari'l-salam*, printed in Cairo in 1888. Buckler, *Harunu'l-Rashid and Charles the Great*, pp. 25–26, n. 2, describes the novel and cites a brief Russian summary of it.

180 **Two modern children's books about Abul Abaz also eliminate Isaac:** Hodges, *The Emperor's Elephant*; and Tarr, *His Majesty's Elephant*. Amid the scholarship about Isaac and Carolingian Jews, cited in this chapter and elsewhere in this book, one of the more unusual works is Zuckerman, *A Jewish Princedom in Feudal France, 768–900*. Using later literary sources, Zuckerman believes that a large Jewish principality existed in southern Gaul and northwestern Spain and was jointly supported by Charlemagne and Harun al-Rashid, and he argues that "Isaac" was really Count William of Toulouse. Other historians do not concur; for an important review of Zuckerman's book by Bachrach, who calls it "a grotesque in fool's gold," see Bachrach, *American Historical Review* 78:5 (1973), pp. 1440–1441.

181 **These were the outlandish tales that people told about far-off places:** "Wonders of the East," in Swanton, trans., *Anglo-Saxon Prose*, pp. 228–229.

181 **market-square urchins, especially the ones who swallowed their tongues and claimed to have been mutilated by Greeks:** Bosworth, *The Mediaeval Islamic Underworld: The Banū Sāsān in Arabic Society and Literature*, Part I, pp. 36, 87.

181 **At Tours, misunderstanding led to rioting:** For more on the "case of the escaped convict," see Allott, *Alcuin of York*, pp. 120–126; Duckett, *Alcuin, Friend of Charlemagne*, pp. 290–294; and Wallach, "The Quarrel with Charlemagne Concerning the Law of Sanctuary," in *Alcuin and Charlemagne: Studies in Carolingian History and Literature*, pp. 103–126.

182 **Asked about the name Abul Abaz, Isaac could offer as many explanations as modern scholars do:** Several of these options are discussed by Dutton, "Appendix I: The Name of the Elephant," in *Charlemagne's Mustache*, pp. 189–190. "God only knows" was the response I received from an Islamic historian who first suggested "servant of the Abbasids" as a possibility.

182 **elephants are excellent swimmers, as was the most excellent and honorable emperor:** Scullard, *The Elephant in the Greek and Roman World*, p. 22; *National Geographic Book of Mammals*, p. 187.

182 **Muslims spoke about the Ethiopian war elephant who knelt and refused to attack Mecca:** See Sura 105, "The Elephant," in the Quran. Good explications of this sura can be found in Scigliano, *Love, War, and Circuses*, p. 83; and in Sells, trans., *Approaching the Qur'an: The Early Revelations*, pp. 120–121. For the story of the elephants at Constantinople, see Scullard, *The Elephant in the Greek and Roman World*, p. 259.

182 **"an elephant in a dream indicates a noble or generous, gentle, courteous and patient king":** Quotation from the fourteenth-century writer Ad-Damiri, who was from Cairo, cited in Scigliano, *Love, War, and Circuses*, p. 84.

10: LITTLE MEN AT THE END OF ALL THINGS

185 **Lothar ... had the mustache of his grandfather:** For two contemporary portraits of Lothar I see black-and-white plates I.16 and I.18 in Dutton, *Charlemagne's Mustache*, pp. 34–36. For a color plate of Lothar's portrait from the Lothar Gospels, see Mütherich and Gaehde, *Carolingian Painting*, plate 25.

185 **Also present was his thirty-seven-year-old brother, a man with too few troops to go it alone:** Riché, *The Carolingians*, p. 160, mentions that Louis had only a few troops and was facing problems on the Saxon-Slavic border.

186 **"Wars call. On all sides, a terrible battle is born"**: Angelbert, "The Battle of Fontenoy," in Godman, *Poetry of the Carolingian Renaissance*, pp. 262–265. This translation is my own. Note that this Angelbert is not the Angilbert of Karl's court.

188 **"He left the whole of Europe flourishing"**: Scholz and Rogers, trans., *Carolingian Chronicles*, pp. 129, 155.

188 **at the exact moment Nithard wrote about the battle, he beheld a solar eclipse**: Ibid., p. 154.

189 **"He bore the death of his two sons and his daughter with less fortitude than one would have expected"**: Thorpe, trans., *Two Lives of Charlemagne*, p. 74.

190 **"Be not dismayed by the signs in the sky at which the nations shudder"**: Carolingian interest in this biblical passage is evident in the Astronomer's Life of Louis. See Cabaniss, trans., *Son of Charlemagne*, p. 113. The reference is to Jeremiah 10:2.

190 **"Woe to you, Rome, and your people"**: Latin text of the complete poem can be found in Godman, *Poetry of the Carolingian Renaissance*, pp. 206–211. This translation is my own. For a performance of this piece by Benjamin Bagby, "A solis ortu usque ad occidua (Lament on the Death of Charlemagne, 814)," see track 11 on the Sequentia/Dialogos CD *Chant Wars*.

191 **"Never did he raise his voice in laughter"**: Thegan, "Life of Louis," in Dutton, ed., *Carolingian Civilization*, p. 146.

192 **Louis ordered most women to leave the palace**: The Astronomer's Life of Louis. See Cabaniss, *Son of Charlemagne*, pp. 54–56.

192 *What sort of emperor, what son of Karl the Great, scatters his family across all of Francia?*: For a pleasant and dramatic narrative biography of Louis the Pious, see Duckett, *Carolingian Portraits: A Study in the Ninth Century*, pp. 20–57.

192 **the new emperor rejected the old Frankish stories and poems:** Thegan, "Life of Louis," in Dutton, ed., *Carolingian Civilization,* p. 145.

192 **"Louis, by Order of Divine Providence, Emperor and Augustus":** Riché, *The Carolingians,* p. 146.

192 **" 'Explain this, I beg you!' Then said the guide":** Walahfrid Strabo, "Visio Wettini: Charlemagne in Hell," in Godman, *Poetry of the Carolingian Renaissance,* pp. 214–215. This translation is my own.

193 **Fortunately for Francia, Louis continued some of his father's works:** Ganshof, "Louis the Pious Reconsidered," in *The Carolingians and the Frankish Monarchy,* pp. 266–267.

193 **Under Louis, Frankish Jews enjoyed even more protections:** Glick, *Abraham's Heirs,* pp. 52–53.

193 **For the sake of the economy, he also forbade markets to be held on Saturday, the Jewish Sabbath:** Bachrach, *Early Medieval Jewish Policy in Western Europe,* p. 98. See also Benbassa, *The Jews of France,* pp. 9–11.

194 **The plan, devised during the third year of Louis's reign, seemed simple enough:** Ganshof, "Some Observations on the *Ordinatio Imperii* of 817," in *The Carolingians and the Frankish Monarchy,* pp. 273–276.

194 **Six years later, in 823, a son was born to Louis and his new wife, Judith:** For more on Judith, see Ward, "Caesar's Wife: The Career of the Empress Judith, 819–829," in Godman and Collins, eds., *Charlemagne's Heir: New Perspectives on the Reign of Louis the Pious (814–840),* pp. 205–227.

195 **"Christian law is violated":** Angelbert, "The Battle of Fontenoy," in Godman, *Poetry of the Carolingian Renaissance,* p. 263.

195 **When the war-weary brothers met near Verdun in 843:** Ganshof, "On the Genesis and Significance of the Treaty of Verdun (843)," in *The Carolingians and the Frankish Monarchy,* pp. 289–302.

195 Beyond bloodshed, the price was a dismantled empire: Riché, *The Carolingians*, pp. 172, 184.

196 "Flourished then an excellent realm, its crown aglow": Florus of Lyon, "Lament on the Division of the Empire," in Godman, *Poetry of the Carolingian Renaissance*, pp. 264–273, lines 41–54, 69–80. This translation is my own.

197 Florus and his generation watched as the empire collapsed into smaller kingdoms that were increasingly unable to talk to each other: Riché, *The Carolingians*, pp. 172–179.

197 From 843 on, only the pope, the church, and the shared interests of knights and nobles provided a tenuous sense of unity: Barraclough, *The Crucible of Europe: The Ninth and Tenth Centuries in European History*, p. 20. See also Fichtenau, *The Carolingian Empire*, p. 187.

197 "We are little men at the end of all things": For the original Latin, see Dümmler, ed., *MGH Epistolae Karolini Aevi II*, p. 61, letter 23.

198 the "birth certificate" of modern Europe: Riché, *The Carolingians*, p. 168.

198 Within decades of Karl's death, no one could remember the location of his tomb: Bullough, *The Age of Charlemagne*, p. 202. See also Morrisey, *Charlemagne and France: A Thousand Years of Mythology*, p. 7.

199 "Straightway an angel with whom he wont to talk": Sayers, trans., *The Song of Roland*, stanza 179, p. 145.

199 "Let the deeds of your ancestors encourage you and incite your minds": Robinson, ed., *Readings in European History*, Vol. I, pp. 312–316. For another translation and other versions of this speech, see Peters, ed., *The First Crusade: The Chronicle of Fulcher of Chartres and Other Source Materials*, pp. 1–16.

200 "a chimera and a skeleton": Heer, *The Holy Roman Empire*, p. 224.

201 French schoolboys celebrated him as the patron of scholars each year: Morrisey, *Charlemagne and France: A Thousand Years of Mythology*, p. 299. See also Giscard d'Estaing, "Speech by Valéry Giscard d'Estaing, Chairman of the European Convention, Charlemagne Prize, Aachen, 29 May 2003."

201 The French kept the enemy out, but at great cost to both sides: Ousby, *The Road to Verdun: World War I's Most Momentous Battle and the Folly of Nationalism*, p. 7.

201 Historians have noted that the officers of Verdun became the generals of World War II: Horne, *Death of a Generation: From Neuve Chapelle to Verdun and the Somme*, p. 115.

202 Hitler admired Karl for founding a "First Reich," and he deliberately built a home near a mountain believed to be the resting place of Karl der Grosse: Speer, *Inside the Third Reich*, p. 86.

203 "for the most valuable contribution in the services of Western European understanding": "International Charlemagne Prize," City of Aachen Web site: www.aachen.de/en/sb/pr_az/karls_pr/charlemagne_prize/charlemagne_prize.html.

203 the six founding countries... covered the same area as his Frankish empire: Trausch, "Consciousness of European Identity after 1945," in Jansen, ed., *Reflections on European Identity*, p. 25.

203 "That night the Emperor, sleepless with the cares": Longfellow, "Emma and Eginhard," from *Tales of a Wayside Inn, Part Third*, in *The Complete Poetical Works of Henry Wadsworth Longfellow*, p. 297.

204 rising from bed to shake off a prophetic dream: In addition to Karl's supposedly prophetic dream about Pope Leo, mentioned in chap. 6, see

also "The Vision of Charlemagne" in Dutton, ed., *Carolingian Civilization*, pp. 423–424.

204 **"a voluntary union of the European peoples without constraint":** "International Charlemagne Prize," City of Aachen Web site: www.aachen. de/en/sb/pr_az/karls_pr/charlemagne_prize/charlemagne_prize.html.

204 **"punish wrong-doers, guide the straying, console the sorrowing and advance the good":** Allott, *Alcuin of York*, letter 103, p. 111.

204 **Never a sound sleeper:** See Einhard in Thorpe, trans., p. 78: "During the night he slept so lightly that he would wake four or five times and rise from his bed."

205 **"He was not recumbent like the bodies of other dead, but seated on a throne":** The Chronicler of Novalesa, c. A.D. 1025, quoted in Morrisey, *Charlemagne and France*, p. 7.

206 **Nearby is an ancient throne the emperor may have used:** For a charming look at Aachen by a recent tourist, see Atiyah, "Holy Emperors! It's the Birthplace of Europe."

206 **"Someone touched the ghostly remains: They disintegrated into dust":** Chateaubriand, *Mémoires d'outre-tombe*, quoted in Morrisey, *Charlemagne and France*, p. 4.

Bibliography

Adler, Elkan Nathan, ed. *Jewish Travellers in the Middle Ages: Nineteen Firsthand Accounts.* New York: Dover, 1987.

Agus, Irving A. *The Heroic Age of Franco-German Jewry.* New York: Yeshiva University Press, 1969.

Ahsan, Muhammad Manazir. *Social Life under the Abbasids, 170–289 A.H./786–902 A.D.* New York: Longman, 1979.

al-Udhari, Abdullah, trans. *Modern Poetry of the Arab World.* New York: Penguin, 1986.

Alchermes, Joseph. "Constantine and the Empire of New Rome," in Linda Safran, ed., *Heaven on Earth: Art and the Church in Byzantium*. University Park: Pennsylvania State University Press, 1998, pp. 13–38.

Allott, Stephen. *Alcuin of York: His Life and Letters*. York: William Sessions, 1974.

Anthony, John. "The Fourth Holy City." *Saudi Aramco World*, January–February 1967: 30–36.

Ashtiany, Julia, T. M. Johnstone, J. D. Lathan, R. B. Serjeant, and G. Rex Smith, eds. *'Abbasid Belles-Lettres*. Cambridge History of Islamic Literature. New York: Cambridge University Press, 1990.

Atiyah, Jeremy. "Holy Emperors! It's the Birthplace of Europe." *Independent*, February 19, 2003, Features: 21.

Augustine, Saint. *City of God: Abridged for Modern Readers with a Foreword by Vernon J. Bourke*, trans. Gerald D. Walsh, S.J., et al. New York: Image/Doubleday, 1950.

Bacharach, Jere L. *A Near East Studies Handbook, 570–1974*. Seattle: University of Washington Press, 1974.

Bachrach, Bernard S. "Review of *A Jewish Princedom in Feudal France, 768–900*, by Arthur J. Zuckerman." *American Historical Review* 78, no. 5 (1973): 1440–1441.

———. *Early Medieval Jewish Policy in Western Europe*. Minneapolis: University of Minnesota Press, 1977.

———. *Early Carolingian Warfare: Prelude to Empire*. Philadelphia: University of Pennsylvania Press, 2001.

Bagby, Benjamin. "A solis ortu usque ad occidua (Lament on the Death of Charlemagne, 814)." Sequentia and Dialogos. *Chant Wars*. Deutsche Harmonia Mundi/Sony BMG compact disc, 2005.

Bannister, Turpin C. "The Constantinian Basilica of Saint Peter at Rome." *Journal of the Society of Architectural Historians* 27, no. 1 (March 1968): 3–32.

Barraclough, Geoffrey. *The Crucible of Europe: The Ninth and Tenth Centuries in European History.* Berkeley and Los Angeles: University of California Press, 1976.

Benbassa, Esther. *The Jews of France: A History from Antiquity to the Present,* trans. M. D. DeBevoise. Princeton, N.J.: Princeton University Press, 1999.

Bettenson, Henry, ed. *Documents of the Christian Church,* 2nd ed. New York: Oxford University Press, 1963.

Bleiberg, Edward. *Tree of Paradise: Jewish Mosaics from the Roman Empire.* New York: Brooklyn Museum, 2005.

Bloch, Marc. *Slavery and Serfdom in the Middle Ages,* trans. William R. Beer. Publications of the Center for Medieval and Renaissance Studies 8. Berkeley: University of California Press, 1975.

Bonnassie, Pierre. *From Slavery to Feudalism in South-Western Europe,* trans. Jean Birrell. New York: Cambridge University Press, 1991.

Bonner, Michael. "Al-Khalifa Al-Mardi: The Accession of Harun Al-Rashid." *Journal of the American Oriental Society* 108, no. 1 (January–March 1988): 79–91.

Bosworth, C. E. *The Mediaeval Islamic Underworld: The Banū Sāsān in Arabic Society and Literature,* Part 1, *The Banū Sāsān in Arabic Life and Lore.* Leiden: E. J. Brill, 1976.

———, trans. *The History of al-Tabarī,* Vol. 30, *The ʿAbbāsid Caliphate in Equilibrium.* Albany: State University of New York Press, 1989.

———. "Byzantium and the Arabs: War and Peace between Two World Civilizations," in *The Arabs, Byzantium, and Iran: Studies in Early Islamic History and Culture.* Aldershot, Hampshire: Variorum, 1996, chap. 13, pp. 1–23.

————. "The Concept of *Dhimma* in Early Islam," in *The Arabs, Byzantium, and Iran: Studies in Early Islamic Culture.* Aldershot, Hampshire: Variorum, 1996, chap. 6, pp. 37–51.

————. "Some Remarks on the Terminology of Irrigation Practices and Hydraulic Constructions in the Eastern Arab and Iranian Worlds in the Third–Fifth Centuries A.H.," in *The Arabs, Byzantium, and Iran: Studies in Early Islamic History and Culture.* Aldershot, Hampshire: Variorum, 1996, chap. 3, pp. 78–85.

Brittain, Frederick, trans. *Penguin Book of Latin Verse.* London: Penguin, 1962.

Brown, Giles. "Introduction: The Carolingian Renaissance," in Rosamund McKitterick, ed., *Carolingian Culture: Emulation and Innovation.* New York: Cambridge University Press, 1994, pp. 1–51.

Brown, Peter. *Augustine of Hippo: A Biography.* Berkeley: University of California Press, 1967.

Buckler, F. W. *Harunu'l-Rashid and Charles the Great.* Monographs of the Medieval Academy of America 2. Cambridge, Mass.: Medieval Academy of America, 1931.

Bulfinch, Thomas. *Legends of Charlemagne, or Romance of the Middle Ages.* Boston, Mass.: J. E. Tilton, 1864.

Bullough, Donald. *The Age of Charlemagne.* New York: Putnam, 1966.

————. "Charlemagne's 'Men of God': Alcuin, Hildebald, and Arn," in Joanna Story, ed., *Charlemagne: Empire and Society.* New York: Palgrave/Manchester University Press, 2005, pp. 136–150.

Butt, John J. *Daily Life in the Age of Charlemagne.* Daily Life through History Series. Westport, Conn.: Greenwood, 2002.

Cabaniss, Allen, trans. *Son of Charlemagne: A Contemporary Life of Louis the Pious.* Syracuse, N.Y.: Syracuse University Press, 1961.

————. *Charlemagne*. Twayne's Rulers and Statesmen of the World Series 15. New York: Twayne, 1972.

————. "Charlemagne and His Children," in *Pedigrees of Some of the Emperor Charlemagne's Descendants*, Vol. 2, comp. Aileen Lewers Langston and J. Orton Buck, Jr. Baltimore, Md.: Genealogical Publishing, 1986, pp. 1–9.

Cameron, Averil, and Judith Herrin, eds. and trans. *Constantinople in the Early Eighth Century: The Parastaseis Syntomi Chronikai*. Columbia Studies in the Classical Tradition 10. Leiden: E. J. Brill, 1984.

Carlebach, Alexander. "The Religious Legacy of German Jewry," in Gertrude Hirschler, ed., *Ashkenaz: The German Jewish Heritage*. New York: Yeshiva University Museum, 1988, pp. 209–266.

Carlo Magno a Roma. Rome: Città del Vaticano: Musei e Gallerie Pontificie, 2001.

Charanis, Peter. "Observations on the Demography of the Byzantine Empire," in *Studies on the Demography of the Byzantine Empire: Collected Studies, with a Preface by Speros Vryonis Jr.* London: Variorum Reprints, 1972, Vol. 1, pp. 2–19.

Christiansen, Eric. " 'Big Daddy of Europe?' Review of *Charlemagne: Father of a Continent* by Alessandro Barbero." *Spectator*, October 9, 2004: 49–50.

Collins, Roger. *Charlemagne*. Toronto: University of Toronto Press, 1998.

————, ed. *Charlemagne's Heir: New Perspectives on the Reign of Louis the Pious*. Oxford: Clarendon, 1998.

Cuddihy, Kathy. *Saudi Customs and Etiquette*. London: Stacey International, 2002.

Davis, Raymond, trans. *The Lives of the Eighth-Century Popes (Liber Pontificalis): The Ancient Biographies of Nine Popes from A.D. 715 to A.D. 817*. Translated Texts for Historians, Vol. 13. Liverpool: Liverpool University Press, 1992.

Dawood, N. J., trans. *The Koran*. New York: Penguin Classics, 1956.

Deanesly, Margaret. *A History of the Medieval Church, 590–1500.* New York: Routledge, 1969.

Dmytryshyn, Basil, ed. *Medieval Russia: A Source Book, 850–1700,* 3rd ed. Chicago: Holt, Rinehart and Winston, 1991.

Dressen, Wolfgang, Georg Minkenberg, and Adam C. Oellers. *Ex Oriente: Isaak und der weisse Elefant: Bagdad-Jerusalem-Aachen: Eine Reise durch drei Kulturen um 800 und heute.* Mainz: Verlag Phillip von Zabern, 2003.

Drew, Katherine Fischer, trans. *The Laws of the Salian Franks.* Philadelphia: University of Pennsylvania Press, 1991.

Duckett, Eleanor Shipley. *Alcuin, Friend of Charlemagne: His World and His Work.* New York: Macmillan, 1951.

————. *Carolingian Portraits: A Study in the Ninth Century.* Ann Arbor: University of Michigan Press, 1962.

Dümmler, Ernst, ed. *Monumenta Germaniae Historica Poetae Latini Aevi Carolini I.* Berlin, 1881.

————, ed. *Monumenta Germaniae Historica Epistolae Karolini Aevi II.* Berlin, 1895.

Dutton, Paul Edward, ed. *Carolingian Civilization: A Reader.* Peterborough, Ontario: Broadview, 1993.

————, ed. and trans. *Charlemagne's Courtier: The Complete Einhard.* Readings in Medieval Civilizations and Cultures 2. Peterborough, Ontario: Broadview, 1998.

————. *Charlemagne's Mustache and Other Cultural Clusters of a Dark Age.* New York: Palgrave Macmillan, 2004.

Edwards, Cyril. "German Vernacular Literature: A Survey," in Rosamund McKitterick, ed., *Carolingian Culture: Emulation and Innovation.* New York: Cambridge University Press, 1994, pp. 141–170.

Eidelberg, Shlomo. "Evolution of the Term 'Ashkenaz,' " in Gertrude Hirschler, ed., *Ashkenaz: The German Jewish Heritage*. New York: Yeshiva University Museum, 1988, pp. 1–2.

———. "The Origins of Germanic Jewry: Reality and Legend," in Gertrude Hirschler, ed., *Ashkenaz: The German Jewish Heritage*. New York: Yeshiva University Museum, 1988, pp. 3–10.

El-Hibri, Tayeb. *Reinterpreting Islamic Historiography: Hārūn al-Rashīd and the Narrative of the ʿAbbāsid Caliphate*. Cambridge Studies in Islamic Civilization. New York: Cambridge University Press, 1999.

Farmer, Sharon. *Communities of Saint Martin: Legend and Ritual in Medieval Tours*. Ithaca, N.Y.: Cornell University Press, 1991.

Fichtenau, Heinrich. *The Carolingian Empire*, trans. Peter Munz. Medieval Academy Reprints for Teaching 1. Toronto: University of Toronto Press, 1978.

Franck, Irene M., and David M. Brownstone. *Across Africa and Arabia*. Trade and Travel Routes Series. New York: Facts on File, 1991.

Ganshof, F. L. *The Carolingians and the Frankish Monarchy: Studies in Carolingian History*, trans. Janet Sondheimer. Ithaca, N.Y.: Cornell University Press, 1971.

Giscard d'Estaing, Valéry. "Speech by Valéry Giscard d'Estaing, Chairman of the European Convention, Charlemagne Prize, Aachen, 29 May 2003." http://european-convention.eu.int/docs/speeches/9190.pdf.

Glick, Leonard B. *Abraham's Heirs: Jews and Christians in Medieval Europe*. Syracuse, N.Y.: Syracuse University Press, 1999.

Godman, Peter. *Poetry of the Carolingian Renaissance*. London: Duckworth, 1985.

Grabois, Aryeh. "Charlemagne, Rome, and Jerusalem." *Revue Belge de Philologie et d'Histoire* 54, no. 4 (1981): 792–809.

Gutas, Dimitri. *Greek Thought, Arabic Culture: The Graeco-Arabic Translation Movement in Baghdad and Early 'Abbāsid Society (2nd–4th/8th–10th Centuries).* London: Routledge, 1998.

Haefele, Hans F., ed. *Notker der Stammler, Taten Kaiser Karls des Grossen. Monumenta Germaniae Historica Scriptores rerum Germanicarum,* Nova series 12. Berlin, 1959.

Hammer, Carl I. *Charlemagne's Months and Their Bavarian Labors: The Politics of the Seasons in the Carolingian Empire.* British Archaeological Reports International Series 676. Oxford: Archaeopress, 1997.

Heer, Friedrich. *The Holy Roman Empire.* New York: Praeger, 1968.

Henisch, Bridget Ann. "In Due Season: Farm Work in the Medieval Calendar Tradition," in Del Sweeney, ed., *Agriculture in the Middle Ages: Technology, Practice, and Representation.* Philadelphia: University of Pennsylvania Press, 1995, pp. 309–336.

Herklotz, Ingo. "Francesco Barberini, Nicolò Alemanni, and the Lateran Triclinium of Leo III: An Episode in Restoration and Seicento Medieval Studies." *Memoirs of the American Academy in Rome* 40 (1995): 175–196.

Herrin, Judith. *Women in Purple: Rulers of Medieval Byzantium.* London: Weidenfeld and Nicolson, 2001.

Hetherington, Paul. *Medieval Rome: A Portrait of the City and Its Life.* New York: St. Martin's, 1994.

Hirschler, Gertrude, ed. *Ashkenaz: The German Jewish Heritage.* New York: Yeshiva University Museum, 1998.

Hitti, Philip K. *Capital Cities of Arab Islam.* Minneapolis: University of Minnesota Press, 1973.

Hodges, C. Walter. *The Emperor's Elephant.* London: Oxford University Press, 1975.

Hodges, Richard. "Charlemagne's Elephant and the Beginnings of Commoditisation in Europe." *Acta Archaeologica* 59 (1988): 155–168.

———. "Charlemagne's Elephant." *History Today* 50, no. 12 (December 2000): 21–27.

Hodges, Richard, and David Whitehouse. *Mohammed, Charlemagne, and the Origins of Europe: Archaeology and the Pirenne Thesis.* Ithaca, N.Y.: Cornell University Press, 1983.

Horch, Daniel. *The Angel with One Hundred Wings: A Tale from the Arabian Nights.* New York: St. Martin's, 2002.

Horne, Alistair. *Death of a Generation: From Neuve Chapelle to Verdun and the Somme.* New York: American Heritage, 1970.

Howell, Wilbur Samuel. *The Rhetoric of Alcuin and Charlemagne: A Translation with an Introduction, the Latin Text, and Notes.* New York: Russell and Russell, 1965.

"International Charlemagne Prize." City of Aachen Web site, English version. March 2006. www.aachen.de/en/sb/pr_az/karls_pr/charlemagne_prize/charlemagne_prize.html.

Irwin, Robert, ed. *Night and Horses and the Desert: An Anthology of Classical Arabic Literature.* New York: Anchor, 1999.

Jones, A. H. M. *Constantine and the Conversion of Europe.* Medieval Academy Reprints for Teaching 4. Toronto: University of Toronto Press/Medieval Academy of America, 1978.

Joranson, Einar. "The Alleged Frankish Protectorate in Palestine." *American Historical Review* 32, no. 2 (January 1927): 241–261.

Kantorowicz, Ernst H. *Laudes regiae: A Study in Liturgical Acclamations and Medieval Ruler Worship.* Berkeley: University of California Press, 1958.

Kartsonis, Anna. "The Responding Icon," in Linda Safran, ed., *Heaven on Earth: Art and the Church in Byzantium.* University Park: Pennsylvania State University Press, 1998, pp. 58–80.

Kennedy, Hugh. *The Early Abbasid Caliphate: A Political History.* Totowa, N.J.: Barnes and Noble, 1981.

————. *The Court of the Caliphs: The Rise and Fall of Islam's Greatest Dynasty.* London: Weidenfeld and Nicolson, 2004.

Kilpatrick, Hilary. "Monasteries through Muslim Eyes: The Diyārāt Books," in David Thomas, ed., *Christians at the Heart of Islamic Rule: Church Life and Scholarship in ʿAbbasid Iraq.* Boston: Brill, 2003, pp. 19–37.

King, P. D. *Charlemagne: Translated Sources.* Lancaster, Lancashire: University of Lancaster, 1987.

Krautheimer, Richard. *Rome: Profile of a City, 312–1308.* Princeton, N.J.: Princeton University Press, 1980.

Laistner, M. L. W. *Thought and Letters in Western Europe A.D. 500 to 900,* 2nd ed. Ithaca, N.Y.: Cornell University Press, 1966.

Lassner, Jacob. *The Topography of Baghdad in the Early Middle Ages: Text and Studies.* Detroit, Mich.: Wayne State University Press, 1970.

Lavin, Irving. "The House of the Lord: Aspects of the Role of Palace Triclinia in the Architecture of Late Antiquity and the Early Middle Ages." *Art Bulletin* 44, no. 1 (1962): 1–27.

Leclercq, Jean, O.S.B. *The Love of Learning and the Desire for God: A Study of Monastic Culture,* trans. Catharine Misrahi. New York: Fordham University Press, 1961.

Le Strange, Guy. *Baghdad during the Abbasid Caliphate from Contemporary Arabic and Persian Sources.* Oxford: Clarendon, 1900. (Reprint, Curzon Press/Barnes and Noble, 1972.)

Lethaby, W., and H. Swainson, trans. Procopius, *De Aedificis.* From *The Church of St. Sophia Constantinople.* New York, 1894, pp. 24–28. The Medieval Sourcebook: www.fordham.edu/halsall/source/procop-deaedI.html.

Lewis, Archibald, and Timothy J. Runyan. *European Naval and Maritime History, 300–1500.* Bloomington: Indiana University Press, 1990.

Lewis, Bernard, ed. *A Middle East Mosaic: Fragments of Life, Letters, and History.* New York: Modern Library, 2001.

Linder, Amnon, ed. and trans. *The Jews in the Legal Sources of the Early Middle Ages.* Detroit, Mich.: Wayne State University Press/Jerusalem: Israel Academy of Sciences and Humanities, 1997.

Llewelyn, Peter. *Rome in the Dark Ages.* New York: Praeger, 1970.

Longfellow, Henry Wadsworth. *The Complete Poetical Works of Henry Wadsworth Longfellow.* Boston and New York: Houghton, Mifflin, 1894.

Lopez, Robert S., and Irving W. Raymond. *Medieval Trade in the Mediterranean World: Illustrative Documents Translated with Introductions and Notes.* Records of Civilization, Sources and Studies. New York: Norton, 1955.

Loyn, H. R., and John Percival. *The Reign of Charlemagne: Documents on Carolingian Government and Administration.* New York: St. Martin's, 1976.

Lupack, Alan, ed. *Three Middle English Charlemagne Romances: The Sultan of Babylon, The Siege of Milan, and The Tale of Ralph the Collier.* TEAMS Middle English Texts Series. Kalamazoo, Mich.: Medieval Institute, 1990.

Lynch, Joseph H. *The Medieval Church: A Brief History.* New York: Longman, 1992.

Mango, Cyril, and John Parker. "A Twelfth-Century Description of St. Sophia," in Cyril Mango, *Studies on Constantinople.* Aldershot, Hampshire: Ashgate Publishing/Variorum, 1993, Vol. 17, pp. 233–245.

Mango, Cyril, and Roger Scott, trans. *The Chronicle of Theophanes Confessor: Byzantine and Near Eastern History A.D. 284–813.* Oxford: Clarendon, 1997.

Marcus, Jacob R. *The Jew in the Medieval World: A Source Book: 315–1791.* New York: Atheneum, 1969.

Martin, Bernard. *A History of Judaism,* Vol. 2, *Europe and the New World.* New York: Basic Books, 1974.

Marzolph, Ulrich, and Richard van Leeuwen, eds. *The Arabian Nights Encyclopedia.* Santa Barbara, Calif.: ABC-CLIO, 2004.

Mayr-Harting, Henry. "Charlemagne, the Saxons, and the Imperial Coronation of 800." *English Historical Review,* 111, no. 444 (November 1996): 1113–1133.

McAuliffe, Jane Dammen, trans. *The History of al-Tabarī,* Vol. 83, *ʿAbbāsid Authority Affirmed.* Albany: State University of New York Press, 1995.

McKitterick, Rosamund, ed. *Carolingian Culture: Emulation and Innovation.* New York: Cambridge University Press, 1994.

Meisel, Anthony C., and M. L. del Mastro. *The Rule of St. Benedict.* Garden City, N.Y.: Image, 1975.

Menocal, María Rosa. *The Ornament of the World: How Muslims, Jews, and Christians Created a Culture of Tolerance in Medieval Spain.* New York: Little, Brown, 2002.

Mernissi, Fatima. *The Forgotten Queens of Islam,* trans. Mary Jo Lakeland. Minneapolis: University of Minnesota Press, 1993.

Moreland, John, and Robert Van de Noort. "Integration and Social Representation in the Carolingian Empire." *World Archaeology* 23, no. 3 (February 1992): 320–324.

Morrisey, Robert. *Charlemagne and France: A Thousand Years of Mythology,* trans. Catherine Tihanyi. Laura Shannon Series in French Medieval Studies. Notre Dame, Ind.: University of Notre Dame Press, 2003.

Mütherich, Florentine, and Joachim E. Gaehde. *Carolingian Painting.* New York: George Braziller and Metropolitan Museum of Art, 1976.

National Geographic Book of Mammals. Washington, D.C.: National Geographic Society, 1981.

Nicolle, David, and Angus McBride. *The Age of Charlemagne.* Men-at-Arms Series 150. London: Osprey, 1984.

Nowak, Ronald M. *Walker's Mammals of the World.* Baltimore, Md.: Johns Hopkins University Press, 1999.

Obank, Margaret, and Samuel Shimon, eds. *A Crack in the Wall: New Arab Poetry.* London: Saqi, 2001.

Ohler, Norbert. *The Medieval Traveller,* trans. Caroline Hillier. Rochester, N.Y.: Boydell, 1989.

Ohnsorge, Werner. "The Coronation and Byzantium," in Richard Sullivan, ed., *The Coronation of Charlemagne: What Did It Signify?* Boston, Mass.: Heath, 1959, pp. 80–91.

Ostrogorsky, George. *History of the Byzantine State,* trans. Joan Hussey. New Brunswick, N.J.: Rutgers University Press, 1969.

Ousby, Ian. *The Road to Verdun: World War I's Most Momentous Battle and the Folly of Nationalism.* New York: Doubleday, 2000.

Ousterhout, Robert. "The Holy Space: Architecture and the Liturgy," in Linda Safran, ed., *Heaven on Earth: Art and the Church in Byzantium.* University Park: Pennsylvania State University Press, 1998, pp. 81–120.

Perl, Eric D. " '... That Man Might Become God': Central Themes in Byzantine Theology," in Linda Safran, ed., *Heaven on Earth: Art and the Church in Byzantium.* University Park: Pennsylvania State University Press, 1998, pp. 39–57.

Pertz, Georg Heinrich, ed. *Monumenta Germaniae Historica Scriptores 1, Annales et Chronica Aevi Carolini.* Hannover, 1821.

————, ed. *Monumenta Germaniae Historica Leges* (in Folio) *1, Capitularia regum Francorum.* Hannover, 1835.

Peters, Edward, ed. *The First Crusade: The Chronicle of Fulcher of Chartres and Other Source Materials.* Philadelphia: University of Pennsylvania Press, 1971.

Power, Eileen. *Medieval People.* New York: HarperCollins, 1992.

Pratt, Kenneth J. "Rome as Eternal." *Journal of the History of Ideas* 26, no. 1 (January–March 1965): 25–44.

Riché, Pierre. *Daily Life in the World of Charlemagne,* trans. Jo Ann McNamara. Philadelphia: University of Pennsylvania Press, 1978.

————. *The Carolingians: A Family Who Forged Europe,* trans. Michael Idomir Allen. Philadelphia: University of Pennsylvania Press, 1993.

Robinson, James Harvey, ed. *Readings in European History,* Vol. 1. Boston, Mass.: Ginn, 1904. Medieval Sourcebook: www.fordham.edu/halsall/source/urban2a. html.

Ross, James Bruce. "Two Neglected Paladins of Charlemagne: Erich of Friuli and Gerold of Bavaria." *Speculum* 20, no. 2 (April 1945): 212–235.

Roth, Norman. *"Dhimma:* Jews and Muslims in the Early Medieval Period," in Ian Richard Netton, ed., *Studies in Honour of Clifford Edmund Bosworth.* Boston, Mass.: Brill, 2000, Vol. 1: *Hunter of the East,* pp. 238–266.

Runciman, Steven. *Byzantine Civilization.* New York: Meridian, 1958.

Russell, Josiah Cox. *Late Ancient and Medieval Population.* Philadelphia, Pa.: Transactions of the American Philosophical Society, Vol. 48, part 3, 1958.

Safran, Linda, ed. *Heaven on Earth: Art and the Church in Byzantium.* University Park: Pennsylvania State University Press, 1998.

Sassoon, David Solomon. *A History of the Jews in Baghdad.* Letchworth, Hertfordshire: Alcuin, 1949.

Saunders, J. J. *A History of Medieval Islam.* London: Routledge and Kegan Paul, 1965.

Sawa, George D. "The Survival of Some Aspects of Medieval Arabic Performance Practice." *Ethnomusicology* 25, no. 1 (January 1981): 73–86.

Sayers, Dorothy, trans. *The Song of Roland.* New York: Penguin Classics, 1957.

Scholz, Bernhard Walter, and Barbara Rogers, trans. *Carolingian Chronicles: Royal Frankish Annals and Nithard's Histories.* Ann Arbor: University of Michigan Press, 1972.

Schwartz, Howard, and Anthony Rudolf, eds. *Voices from the Ark: The Modern Jewish Poets.* Yonkers, N.Y.: Pushcart, 1980.

Scigliano, Eric. *Love, War, and Circuses: The Age-Old Relationship between Elephants and Humans.* New York: Houghton Mifflin, 2002.

Scullard, H. H. *The Elephant in the Greek and Roman World.* Aspects of Greek and Roman Life. Ithaca, N.Y.: Cornell University Press, 1974.

Sells, Michael, trans. *Approaching the Qur'an: The Early Revelations.* Ashland, Ore.: White Cloud, 1999.

Simonsohn, Shlomo. "The Hebrew Revival among Early Medieval European Jews," in Saul Lieberman, ed., *Salo Wittmayer Baron Jubilee Volume on the Occasion of His Eightieth Birthday.* Jerusalem: American Academy for Jewish Research, 1974, Vol. 2, pp. 831–858.

Speer, Albert. *Inside the Third Reich.* New York: Macmillan, 1970.

Steves, Rick. *Rick Steves' Germany, Austria, and Switzerland 2003.* Emeryville, Calif.: Avalon Travel, 2003.

Stone, Brian, trans. *King Arthur's Death: Alliterative Morte Arthure and Stanzaic Le Morte Arthur.* New York: Penguin, 1988.

Story, Joanna, ed. *Charlemagne: Empire and Society.* New York: Palgrave/Manchester University Press, 2005. See especially Joanna Story, "Charlemagne and the Anglo-Saxons," pp. 195–210.

Stow, Kenneth R. *Alienated Minority: The Jews of Medieval Latin Europe.* Cambridge, Mass.: Harvard University Press, 1992.

Sullivan, Richard, ed. *The Coronation of Charlemagne: What Did It Signify?* Boston, Mass.: Heath, 1959.

———. *Aix-la-Chapelle in the Age of Charlemagne.* Norman: University of Oklahoma Press, 1963.

———, ed. *"The Gentle Voices of Teachers": Aspects of Learning in the Carolingian Age.* Columbus: Ohio State University Press, 1995.

Swanton, Michael, trans. *Anglo-Saxon Prose.* London: Everyman, 1993.

Tarr, Judith. *His Majesty's Elephant.* New York: Jane Yolen Books/Harcourt Brace, 1993.

Thomas, David, ed. *Christians at the Heart of Islamic Rule: Church Life and Scholarship in ʿAbbasid Iraq.* Boston, Mass.: Brill, 2003.

Thorpe, Lewis, trans. *Two Lives of Charlemagne.* New York: Penguin Classics, 1969.

———, trans. *Gregory of Tours: The History of the Franks.* New York: Penguin Classics, 1974.

Trausch, Gilbert. "Consciousness of European Identity after 1945," in Thomas Jansen, ed., *Reflections on European Identity*. European Commission Forward Studies Unit Working Paper, 1999.

Treadgold, Warren T. "The Unpublished Saint's Life of the Empress Irene (BHG 2205)." *Byzantinische Forschungen* 8 (1982): 237–251.

———. *The Byzantine Revival 780–842*. Stanford, Calif.: Stanford University Press, 1988.

Tritton, A. S. *The Caliphs and Their Non-Muslim Subjects*. Islam and the Modern World 14. London: Frank Cass, 1970.

Turtledove, Harry, trans. *The Chronicle of Theophanes*. Philadelphia: University of Pennsylvania Press, 1982.

Ullmann, Walter. "The Coronation and Papal Concepts of Emperorship," in Richard Sullivan, ed., *The Coronation of Charlemagne: What Did It Signify?* Boston, Mass.: Heath, 1959, pp. 70–79.

Vita Alcuini, W. Arndt, ed., in *Monumenta Germania Historica*, Scriptorum XV: I, 182–197. Hannover, 1887.

von Grunebaum, G. E. *Classical Islam: A History 600–1258*, trans. Katherine Watson. London: George Allen and Unwin, 1970.

Waitz, Georg, ed. *Monumenta Germaniae Historica Scriptorum* XV:I. Hannover, 1887.

Wallace-Hadrill, J. M., trans. *The Fourth Book of the Chronicle of Fredegar with Its Continuations*. New York: Thomas Nelson, 1960.

———. *The Long-Haired Kings*. Medieval Academy Reprints for Teaching 11. Toronto: University of Toronto Press, 1982.

———. *The Frankish Church*. Oxford: Clarendon, 1983.

Wallach, Liutpold. *Alcuin and Charlemagne: Studies in Carolingian History and Literature.* Cornell Studies in Classical Philology 32. Ithaca, N.Y.: Cornell University Press, 1959.

———. *Diplomatic Studies in Latin and Greek Documents from the Carolingian Age.* Ithaca, N.Y.: Cornell University Press, 1977.

Ward, Elizabeth. "Caesar's Wife: The Career of the Empress Judith, 819–829," in Roger Collins and Peter Godman, eds., *Charlemagne's Heir: New Perspectives on the Reign of Louis the Pious.* Oxford: Clarendon, 1998, pp. 205–227.

Watson, Andrew M. *Agricultural Innovation in the Early Islamic World: The Diffusion of Crops and Farming Techniques, 700–1100.* New York: Cambridge University Press, 1993.

Wendell, Charles. "Baghdad: *Imago Mundi,* and Other Foundation-Lore." *International Journal of Middle East Studies* 2, no. 2 (April 1971): 99–128.

Wickham, Chris. *Early Medieval Italy: Central Power and Local Society 400–1000.* Ann Arbor: University of Michigan Press, 1989.

Wiet, Gaston. *Baghdad: Metropolis of the Abbasid Caliphate,* trans. Seymour Feiler. Norman: University of Oklahoma Press, 1971.

Willibald. *Life of Boniface,* trans. C. H. Talbot, 1954. Medieval Sourcebook: www.fordham.edu/halsall/basis/willibald-boniface.html.

Wood, Roger, and Mortimer Wheeler. *Roman Africa in Colour.* London: Thames and Hudson, 1966.

Ye'or, Bat. *Islam and Dhimmitude: Where Civilizations Collide.* Madison/Teaneck, N.J.: Fairleigh Dickinson University Press, 2002.

Young, M. J. L., J. D. Latham, and R. B. Serjeant, eds. *Religion, Learning, and Science in the ʿAbbasid Period.* Cambridge History of Arabic Literature. New York: Cambridge University Press, 1990.

Zeier, Kristin. "Baghdad-Jerusalem-Aachen: On the Trail of the White Elephant." *Deutsche Welle* Web site, July 21, 2003. www.dw-world.de/dw/article/ o,,923561,00.html.

Zéraffa, Michel. *Tunisia*, trans. R. A. Deam. New York: Viking, 1965.

Zuckerman, Arthur J. *A Jewish Princedom in Feudal France, 768–900*. New York: Columbia University Press, 1972.

Illustration Credits

Index

Page numbers in *italics* refer to illustrations in the text.